In this extended collection, real women cope with the milestone events of women's lives—birth, marriage, death—and the rich experiences of their faith, their relationships, whether they fit in, and whether they are blessed. The writers confront events with terrifying frankness and honesty. They find happy solutions, or they don't. Even as they suffer through their problems, in joy or sorrow, solving them or not, they produce a written record. Kudos to Segullah for encouraging and publishing these accomplished writings.

— CLAUDIA BUSHMAN
author, *Contemporary Mormonism*

This collection of essays, bracingly honest and deeply compassionate, unmade me. While there is surely some truth to Thoreau's claim that the mass of us live lives of quiet desperation, it is also true that breaking this silence can be powerfully redemptive. These essays name—and, thus, help heal—the troubles at the heart of life.

— ADAM S. MILLER
author, *Letters to a Young Mormon*

I yearn for long afternoons speaking deeply with a friend whose insights awaken and expand me, who can probe with me the mystery, poignancy and magic that is our human experience. In this book I found a chorus of such voices, women whose words are eloquent and musical. [...] These essays comfort and awaken, and most of all let us explore the tender interior lives of others whose journeys are as complicated and beautiful as our own.

— MAURINE PROCTOR
editor, *Meridian Magazine*

In a time aching for the words of women, *Seasons of Change* has answered the call. One of those rare books full of both grace and movement, each voice, each unique perspective seemed to me another shade of my own heart.

— MEG CONLEY
writer, megconley.com

SEASONS

OF

CHANGE

SEASONS

OF

CHANGE

STORIES OF TRANSITION

from the writers of Segullah

edited by

Sandra Clark Jergensen &
Shelah Mastny Miner

El Cerrito, CA

SEASONS OF CHANGE: Stories of Transition from the Writers of Segullah
edited by Sandra Clark Jergensen & Shelah Mastny Miner

Anthology copyright 2017 Peculiar Pages
Contributions copyright 2017 Individual contributors

ISBN: 978-0-9911892-8-1 (paperback)
ISBN: 978-0-9861271-7-5 (ebook, all formats)

Editors: Sandra Clark Jergensen & Shelah Mastny Miner
Cover art: Leslie Graff
Book design and digitization: Elizabeth Beeton

Published By:
PECULIAR PAGES
115 Ramona Avenue
El Cerrito, CA 94530
PeculiarPages.com

in collaboration with

B10 Mediaworx
PO Box 1233
Liberty, MO 64069-1233
b10mediaworx.com

CONTENTS

CONTENTS

FOREWORD

For over a decade, Segullah has been sharing women's stories in our journal, blog, and publications. Our first two anthologies, *The Mother in Me* and *Dance With Them*, focused on narratives of motherhood. While those stories are profound, we wish to recognize a broader scope of experience in our third offering. There are so many ways we learn, share, and are reshaped through a spectrum of transitions. We crave the catharsis of writing through the change. We write trying to understand the cycles of life and embrace our reshaped selves.

Joining the Church or re-examining our faith; falling in love or sharing a marriage bed for many years; sending children out on their own or taking estranged parents back into our lives; illness, divorce, and new careers—all of these changes (and more) force us to examine, regroup, and adapt.

THE WORLD IS NEW AGAIN.

When we sat down to organize our collection, our initial impulse was to look at life's transitions through a basic chronology of a woman's life. However, as we read the stories included here we found ourselves resisting that first urge and looking beyond the linear, because lives aren't easily compartmentalized. We dug deeper and found themes and words that underlie the chronology of these narratives—new ways to define the emotions and feelings behind transitions that many of us will see as familiar and others still have on the horizons of their lives. Seasons of change force seeing the world in a new light, redefining how we feel and what we know.

WORDS ARE NEW AGAIN.

When Teresa Hirst's family is struck with the double whammy of illness and unemployment, the power of a gift card and what it could be used to buy becomes a potent symbol of **measurement** in the short essay "Three Dollar Attribute."

Terresa Wellborn's poem "When Got Baked Pot Pie" is a perfect example of **welcome**. As she welcomes twins to her home, she is shown the compassion of God in the helping hands of those around her.

In "Ice Cream with Superman and Kafka," an essay by Jennifer Quist, we see the author struggling not only with the **cycle** of her brother-in-law's mental illness, but also with her motives as his caretaker.

The theme of **hunger** is immediately evident in Jessie Christensen's essay "Brownies and a Bottle of Peaches," where she looks at the ways cooking and food have been present in many of the transitions of her life.

Kel Purcill tells a story of **acceptance** in the essay "Blue Polish," in which she embraces her son's quirky ways.

Though Anna Sam Lehnardt expected to serve a mission, her life follows other paths and she accepts **reversal** in her essay "Uncalled For."

Emily Bishop Milner draws out several definitions of **entropy** in her essay "Unclean," where a messy house stands as a symbol of her mental state.

Through "Lessons From the Valley of the Shadow," Linda Hoffman Kimball demonstrates **exchange** when she supports her husband through cancer that should have been fatal, showing that when terror and hope walk hand in hand, perspectives change in unexpected ways.

In Angela Hallstrom's short story "Field Walking," the narrator is **grappling** with losing a pregnancy and the vision of how her family's life might have been that was lost with the child.

Liz Garcia's poem "To My Children, Who Will be Asked What They Are" explores the thoughts of a white woman **grafting** multicultural children into her family.

In our final category, Rosalyn Collings Eves relates her **connection** to place, how the transitions of time and experience of a honeymoon, miscarriage, and family reunions in southern Utah have imbued the red rocks with sacred memory.

Through these and the other stories in the collection, we hope not simply to share our experiences, but recognize that some of our most challenging changes have also brought us newfound abilities, more empathy, and more capacity to connect with each other. Our new worlds of understanding, and the words we use to share them, bring us together wherever we are.

INTRODUCTION

My thirtieth birthday came thick in the lonely year: the first year after a move, where real-life friendships are moored at a harbor you've set sail from. All I really wanted was to be back in Maryland with the people who knew me, the ones I loved and had bonded with through our years of being there for each other. Stuffing candles into the cake my husband baked, I lamented that none of them could be present.

Craving contact and connection, I eagerly joined the Segullah staff when the opportunity came that same month. The community of women writing, editing, and coming together in a magic corner of the internet eased the hollow ache I felt. The proximity of my new circle of friends didn't reach out to me as old friends had, but this stripped-down friendship, without the complications of who was bringing a salad and scheduling when we could meet, meant we logged on whenever we could. We worked together on our literary projects and messaged about our real lives on the periphery.

The sisters of Segullah stretched me as a writer and editor, a thinker, and a friend. The necessity of putting my thoughts and ideas into margin notes, message boards, blog posts, and journal edits forced me to clarify my ideas, sharpen my wit, and concentrate my ramblings. The constraints of our communication forced me to up my game. I grew to love the Segullah women before I ever had a chance to meet them in person.

Each year since, I've gone to the annual retreat and meetings to join the women who have become friends and guides. Though they couldn't replace my need for local friends, Segullah offered a place for me. Still, I wasn't sure I belonged, wasn't sure I was as capable, as experienced as the women I interacted with. But as I look back and see the transitions that have come in the wake of this work, I'm surprised at the experience I've gained; these friends and colleagues have raised my capacity, capability, and sense of community. It's a gift—a present—and better than most any tangible gift I've been given, to be present here with them, and share that with all who join us in writing and reading.

—Sandra Clark Jergensen

My parents are convinced that I won my college scholarship based on a single piece of paper. The application required that we list the books we'd read in the last year and left a space of about ten lines in which to write. But that wasn't nearly enough room. I sat down and typed out a list that covered the entire front of the page and most of the back. When I came to campus to interview, all any of the professors wanted to talk about was my reading list.

A few years later, I took a job as an English teacher and assumed that my role would be to enthuse about my love of literature. If I could somehow convey how much the work of Katherine Paterson, Orson Scott Card, and Harper Lee meant to me, my students couldn't help but fall in love with words.

Instead, I found that my primary role was to teach writing. I realized that falling in love with words meant more than simply falling in love with reading. We started each class with journals, which we transformed into personal narratives. We talked a lot about "entering into a conversation" while doing scholarly writing. We wrote thesis statement after thesis statement after thesis statement, and drilled using transitions as we moved from one phase of our writing to another.

But I wasn't a writer, just a writing teacher.

Years later, at home with my kids, I discovered blogging. Every afternoon I would put the baby down for a nap, park the preschoolers in front of the television, and write about what was going on in our day. I was dark and sarcastic and witty, and ran back and forth to the computer all day long to check for comments.

But I wasn't a writer, just a blogger.

I joined Segullah and had my first essays published. I won an essay contest. I went back to graduate school to learn how to write fiction. I wrote a novel. I wrote another one. I still didn't see myself as a writer. I wasn't earning an income from writing, so I didn't think I could claim it.

A few months ago, I heard my daughter telling her friend that I was "mostly a mom, but also a runner." It's true, I run most days, but I've never won a race. I've never earned more than a pair of socks from the effort. However, I have no problem calling myself a runner.

If I can claim runner, I can claim writer as well. As I've given myself permission to lay claim to the title, I've started to see myself more in that light. Sitting down at the laptop to create a story isn't escapism, it's work. When we give ourselves permission to call ourselves something, it imbues us with a new sense of purpose and seriousness. This transition to becoming a writer is something each of us included in this collection has gone through in order to be able to bring these stories to you. And, as someone whose first love will always be reading, I'm excited to have a role in the publication of a book I would also love to read.

—Shelah Mastny Miner

MEASUREMENT

THREE DOLLAR ATTRIBUTE

TERESA HIRST

We took our IKEA gift card with us on date night to spend Christmas cash.

Ten years ago we'd most likely head for those bigger items, the things we wanted to accrue: the bookshelves, bedding, nightstands, or decorative wall hangings.

This night we went straight to the bins of three-dollar items, the things we wanted to replace: measuring cups, potholders, spatulas, plastic dishes, and strainers.

Once home, my youngest daughter—who'd visualized us buying a new lamp for her room—unwrapped the bright red measuring cups with delight and volunteered to bake.

Three-dollar items that generally had not received our notice or resources for a long time became treasures of everyday life when they did.

My architect husband designed and built us a home—the big dream we had worked toward from early marriage. Then, in the economic climate of the recession, the construction industry halted. Our income dropped suddenly by half and then again. For four years, any income we earned paid for necessities like the mortgage, utilities, food, and fuel for our vehicles.

My dream home with its convection oven and miles of quartz countertop felt like a pieced-together home where adjustment meant much more than making do with broken or missing measuring cups.

Of course we sought answers to the big questions in prayer, in conversations as a couple, in the temple—like many do in a challenge. We expected big answers.

I scoffed at the small answers that came. Wait. Adapt. Be patient.

When we eat three times a day, the pantry depletes. Turning on the lights means an electricity bill is due once a month. And the gas tank empties just from fulfilling the essential commitments.

Trying to meet basic needs without a normal income invited daily frustration and anxious motivation. We worked and worried for that big solution that didn't appear.

However, waiting on the Lord is not a small answer. Patience is not a three-dollar attribute.

But I valued these answers as insignificant. The only ones I cared to know—the answers that would relieve my suffering—were how to fix the problem and when it would be over.

What now sounds like pride was really a desperate reaction. How could we replace, repair, or maintain anything, whether it was three dollars or three hundred dollars?

I was coming unto Christ in all the ways I knew how. But my "natural man" method

of coping included habits of fear, worry, and anger that actually took me away from His comfort and peace.

How did those habits work against me? I responded to any bad news with expected negative emotions, allowing my internal anxiety to swell and match the grave external circumstances. I trusted in the tangible over that which could not be seen, looking to sugary treats rather than finding a peace-filled spirit to soothe the negativity that stirred within me. I talked endlessly with (or more likely at) my husband to uncover a solution and, instead, revealed a harsh tone of blame.

In such a crisis, how could patience help?

When I asked that question as a retort to answers received in the temple, my obvious defiance surprised me. I had forgotten, even in that most sacred place, to always remember Him.

I almost missed seeing the quiet signs of divine love that in sum became the big answer. Little miracles or small gestures, which had initially looked like three-dollar evidences of care, continued to appear and became so much more in my heart.

Friends brought chicken for our freezer multiple times, allowing me to also feed the missionaries in our far-flung ward. Gas cards from family took us to reunions, diminishing our isolation. A job for me didn't replace my husband's income but provided sustenance and opportunities to give back. A homemade Valentine's card from my husband meant more to me than a dozen roses.

Gratitude caused me to remember God. Then He helped me replace my anxious reactions with patience until remembering became my first response.

In the economies of life, the apparent three-dollar answers build slowly and steadily into the solutions we seek.

In time, more answers brought a new career in a new place. We moved away from our big dream and toward smaller but sweeter joys like the gift to replace a broken cup so we could more easily measure the sugar.

COMING UP FOR AIR

MELODY NEWEY

I.

My little sister may not win her battle with cancer.
When she speaks I hear the surf begin to roar,
a tide inside threatens to push me over.
I dive beneath the surface, search for a place
where answers hide, where a perfect orb
layered in all the right words glows iridescent
inside a crusted shell, waiting to be found, freed,
rolled between fingers, warm and comforting.
I want to string it alongside others I've found for her.
But I lose my breath, come back up for air.

II.

My son marries his love. I am Mother of The Groom,
buy the only strand of pearls I've ever owned.
For the first time (in the middle of the desert)
I feel the ocean against my breast,
a hundred little suns rise in the palm
of my hand. I let go my grown child,
hold on to this moment, these drops of light,
these worlds of wonder.

III.

My mother dies, her life unstrung.
Before she passed I thought I had all the answers
to how she lived, why she died, how God and
everything and everyone is linked together:
One Eternal Round. I kneel by the bed,
wait for echoes of her voice, breathe deep
underwater quiet, hear whispers from a velvet box—
What you know is smaller than a pearl.
The truth is bigger than the universe.

BEAUTIFUL ASHES

KYLIE NIELSON TURLEY

My dad's measured words turn my skin cold with their clipped consonants, tidy vowels, and careful enunciation. The cancer has spread. Slumping against the wall, I cradle the news weakly in my mind, then hand the cellphone to my husband, shaking my head slowly, sliding down the wall to the floor, my face oddly pale in the bedroom mirror. *Like a tragic heroine in a third-rate film,* I think vaguely, except I am no actor. This is no screenplay. I slink into bed and nod off. Then jerk awake. One day gone. However many days remain, there is one day less.

"Terminal," the second-opinion doctors confirm. "Weeks. Maybe six months." So we think eight months. Perhaps a year? Irrational hope cushions the blow, but denial can only stretch so far, which is why all seven daughters and one son come home for Father's Day. It is June 2012, and we know it will be his last. But he grabs the old .22 rifle and marches outside to shoot a pesky skunk on Saturday morning, and he insists on driving me on the ATV over to the pond Saturday afternoon to save me from more pain in my hands. We should be forgiven for not knowing that Saturday evening is the last meal he will eat in his life. Suddenly and violently ill, he cannot eat breakfast or come to church, not Father's Day, nor ever again. Seven daughters, one son, and a wife sit in our old spots on the front row in the Second Ward. He is at home in bed. I am forty years old. I have never seen my dad spend an entire day in bed.

Writings on death tend toward sentimentalism because last days really are that melodramatic, that ridiculously wretched with meaning. A glossy magazine tells me that cancer is a "gracious gift of time"—time to set things right, to heal relationships, to finish the undone. But terminal time is paradoxical: days flash by and seconds are interminable. I begin marking time on my mental calendar: June 10 (last Sabbath day at church); June 16 (last meal); June 17 (last Father's Day); June 23 (last "Happy Birthday" phone call to me); July 7 (last time I see my dad alive); July 11 (last). For forty years I have meandered casually through sacred dates, not knowing their import. Now the calendar is marked with "last moments." These sentimental seconds are vultures; they circle above my calendar, waiting to spiral down and peck square dates, feeding on carrion-like memories.

During the dying days, decisions take on vast significance. I fuss about each one. Am I supposed to cry or be strong? Go home and fret as if I am a helicopter mom, and my dying father and devastated mother are the children? Or stay a state away, granting them intimate space for mourning? My dad has never died before; I don't know how to do this. I search for the right words—ones that will slice death down to size, but I cannot find them, so I wander in contradictions. I speak in reverent whispers in every room in my parents' home, even in the basement where I could not possibly disturb them, but when I am right next to my dad's bed, I long to rip out handfuls of hair and shriek, "I am watching someone I love starve to death!" How can I let cancer eat my dad's intestines, heart and remaining kidney while he eats nothing?

"Stereotype," I label myself as the clichés flood my thoughts. I really would pay anything or do anything to lessen my dad's pain. I despise cancer and its ruthlessness. Yet I am also flooded with guilty shame. I can barely admit this to myself: I would choose for him to suffer longer. I abhor this process, and I would prolong it indefinitely. I am like a miser with money, clinging to every millisecond of my dad's dying. I hoard his words and waking moments. I love his gaunt, sleeping bones. Do you want to know my appalling secret? I will miss it. The dying. Days lived in the shadow of death crackle with intense, soul-stripping simplicity. Sorrow burns like acid. Each moment scorches me into awareness and clarity. I sit in the blue-cushioned chair next to my parents' bed and watch in horror as my dad's body shrivels. I am more passionately alive than I have ever been.

The enormity of sorrow surprises me. I firmly believe in life after death, so my feelings strike me as faithless and extreme. A friend says she is jealous. I picture her shrugging sheepishly as she apologizes into the phone, "I wish I were like you, like your family. I love my dad, but when he dies, I will not be that sad." I feel a flare of compassion for her and a strange pride in my grief. At my dad's bedside three days later, I tell him, "I am glad that I am sad. It means, 'I love you.'" Choking out the words alleviates the clawing anxiousness in my stomach, the queasy *Does he know I love him?* lodged in my throat. Fifteen minutes later, the nausea begins again. Emotion is a flu virus; I must purge myself of the words over and over again. *I love you. Do you know that? I love you.*

Beneath the sorrow, I uncover an ignorant and bizarre prejudice; for some reason, I assume it is easier for "old" people to cope with death. Apparently, I think that love fades over the years like natural hair color, emotion leeches from relationships like bone density, and time saps love like age saps muscular strength. How silly. Watching my dad die robs me of logic and strips years from my age. I am an insecure teenager whose hands are too big, who walks with awkward and practiced steps, who thinks everyone in junior high is staring at her.

The hospice nurse cheerfully puts my dad's arm in a blood pressure cuff, then

pronounces that she has never seen a patient so alert after twenty-three days with no food and little water. My dad's vital signs are stable, his attention unfailing, even his sense of humor intact. The nurse asks if anything makes his pain worse. He scratches his head with spindly fingers. "Hmm. I don't know. Being alive?" He smiles at his wit and tells my mom where to find new batteries for the nurse's electronic monitor: family room desk, second drawer. I freeze, a gawky thirteen-year-old fretting about what to do, then I jolt into motion, grabbing at a book just so I can hold it but my gangly arms and graceless hands knock it to the floor. Should I go find the batteries or giggle at the joke? I laugh too late, too loud, then march stiffly out of the room. I emerge from my pink-and-purple-flowered childhood bedroom ten minutes later, pretending no one can see my blotchy neck and puffed eyes. I re-tell my dad's joke to a neighbor later that afternoon, and we laugh in short, high-pitched barks.

I am sitting on the carpeted basement steps of my own home at 6:45 a.m. on July 11 with a phone tucked between my shoulder and ear, listening to my mom's soft words. During the last few weeks, I have imagined this phone call numerous times, and now I live the moment. My mother is a widow. I am fatherless. I imagined I would cry, be compassionate, but I sound robotic and monotone. I say, "Okay. Okay," in response to everything. When she hangs up, I simply sit listening to the dial tone for thirty or forty seconds because pushing "off" requires limitless energy.

A day later tightness wraps around my ribs like a corset. I vaguely wonder if the constriction will actually break bones, but I do not care enough to follow the thought. Drained and remote, I find myself in rooms. I do not know why I am there. I sit listening to conversations. Minutes or hours later I realize I do not know what anyone is talking about. Or why they are talking at all. Merchandise, music, and movies are harsh and glaring. I withdraw, pulling away from bright lights and loud sounds, from the worldliness of the world and the liveliness of living.

"*He is gone.*"

The thought slams me, a rock-hard punch in the gut. My mind recoils. The words crush my chest. I cannot breathe oxygen through this wet-cement air. Faith was supposed to mean crying a few graceful tears, enduring some pretty and proper emotion, but I dry heave sobs, choking and gulping. My stomach clenches so hard that I suck in and lean over. I think I might throw up. Someone should have warned me that the stupid words people say about "broken hearts" are not just metaphors. My body hurts.

My mom decides we should confront the realities of death. "We will bury him," she announces and swallows, clarifying, "ourselves." So we do. We deed a portion of earth to the state of Wyoming in perpetuity for a family cemetery. We arrange to bury him by the pond, the first filled grave out of forty-eight plots. The image of his burial is picturesque, even beautiful, but the sounds shear my skin off my bones. The metal shovel blade grates piercingly as it slices into the rocky pile of Wyoming dust. The dirt slumps onto my

father's coffin with a dull, echoing thud, tossed by my brother's strong heave. Heat withers me, and my hair whips in the wind. Two weeks ago, this seemed like the faith-first, straightforward way to bury my pragmatic dad. But two weeks ago, I did not understand that burying my dad means he is dead. Life-and-death distance lies between me and the shovel, and I am struggling to make my feet walk it. *Dear God, I cannot pick up that wooden-handled shovel and throw dirt on my dad.*

But this is not about me. It is about my dad, a practical and unflinching worker. It is about my mom, the pillar of stone standing motionless and apart from the other mourners. I bite my lip, then take a step toward the shovel, careless of my strappy sandals, black dress, and grandmother's pink silk scarf. When I grip the tool in my lightly calloused hands, I find the heft comfortable and comforting. My hands shake, but the shovel weighs me down to earth, to home, to memories of blisters on my palms and the summer jobs that formed them, to work and tools, and to my dad who taught me of such things and the habitual dark line of soil and grease beneath his fingernails. I hesitate above the home-crafted casket with my shovelful of grave dirt and the prickle of a splinter jabbing my thumb. This moment is surreal; we do not bury our dead in this country, in this century. I have seen old westerns with scenes like this, but never once in my forty years did I consider how it would feel to bury someone I love with a shovel from the barn. Now I know. It feels better to work.

When dirt fills the grave, my brother-in-law strips off his tie and polished shoes. He waits for a ghost of a smile from my mother, then hikes barefoot up the sagebrush hill to the top of the zip-line and clips on the handle. The mechanized whirring alerts everyone, and all turn to see him rip down the zip-line in Sunday attire, barreling into the murky pond water. My sister cringes at the irreverent splash and reverberating ripples, annoyance about dry cleaning the water-logged suit trousers piercing her sorrow. But the clothes were already ruined. My brother-in-law does not stand around when there is a job to be done, nor does the assistant funeral director, a fresh-faced boy of twenty-something. Trying desperately to look mature and solemn in his dark suit and sunglasses, he was observing our familial burial from a respectful distance when he suddenly muttered, "I wasn't raised to watch other people work." Stalking forward, he grabbed a shovel and sweated out thirty minutes of hard labor to cover the coffin of a man he never met. I like him for that.

Sympathy cards quoting Ecclesiastes 3:1-4 flood the mailbox: "To everything there is a season, a time for every purpose under the heaven ... " The verses seemed beautiful before cancer grew in my dad's kidney and heart; now they seem flaccid and lukewarm. A time to weep, and a time to laugh? A time to mourn, and a time to dance? I hate the soft-handed equivocations and spineless platitudes. I want an all-powerful *Thou shalt weep,* an authoritative dictate. I want alert obedience shocked out of me.

Well-meaning people say, "How are you? How is your mother?" I stare blankly. I see their lips move. I hear words. But it is a complicated inquiry and I fumble, confused that

social etiquette calls for answers to such puzzling questions. *How am I?* I have no idea. I end up standing vacantly, no matter whether I am beside the Braeburn apples in the fruit aisle or in the front row in gospel doctrine class or in the hallway outside my son's fourth-grade classroom. Sometimes I brush my cheeks with my fingertips and realize I am crying. If I put my face under a microscope, would it be flat and expressionless or wrinkled with tears and pain? A month later, I ponder *how I am,* and anger flashes. *Why would anyone ask such a thing?*

Slowly, my automatic answer begins to return. "Fine," I respond. "I'm fine. She's fine." I am. She is. We get up, do chores, make meals, talk on the phone, go to church—her in Wyoming, me in Utah. I function most days as if nothing different happened last summer and acquaintances have no idea anything did. Yet "not fine" moments ambush me all year long. In October, green leaves turn vibrant yellow and orange, then spiral down dead in the gutters. I hate their brittle crunch. Autumn turns snowy, and I cringe at the flippant hyperbole I hear around me: "Mom, I am starving to *death*" and "It is so cold that I almost *died.*" In Sunday school, the teacher asks, "Is anyone *dying* to say the closing prayer?" At school, my student says, "You would *die* if you saw what she wore yesterday." In January, icy cold seeps under doors, frosts windows, chills our heated home. On the eighteenth, the day before my dad's birthday, I finally watch the three home movies filmed the month before his death, his body skeletal and frail, his mind distressingly aware. He tells random stories, gives advice, and grows noticeably skinnier in each segment.

In March, the grass turns brilliant green, and I feel teary all day. I do not know why.

I expect to cry on my first Father's Day without my dad and on July 11, exactly one year after he died. But I do not know what to call that day. Death Day? Anniversary? Memorial Day? Is everything about death and dead bodies? I want a new word and I want a new day, not July 11.

A few months after my dad died, I discovered 3 Nephi 12:4. With stunning omniscient power, God promises to comfort "*all* they that mourn," regardless of faith or worthiness or reason for mourning. I want my comfort. I go to church, thinking that is where comfort should be. The hymn glibly suggests I "drop my burdens at His feet and carry a song away." I resent the Pollyanna-esque promise and rebel, refusing to sing. No one notices. I sit in my small pocket of silence and picture me gathering all of the sadness and the suffering, and stuffing it all into my gigantic, forty-inch black canvas duffel. I zip up the hurt, drag the load to the Lord by its cushioned shoulder strap and plop it at His feet. *Good riddance,* I tell Him, jabbing my index figure down at the baggage. *Here's my pain!* Then, with a cheerful wave, I trot away. It is a nice idea, but I do not understand how to do it.

I pray. Every morning, every meal, every night. Nothing of consequence comes out, and even less comes in. Then one day in March, I say, *I miss my dad,* and suddenly, the

words are real, and I am sobbing and choking so wildly that my nose drips onto my bedspread, but all I can do is repeat, "I miss my dad. I miss my dad." It is an unreasonable, repetitive, single-sentenced howl of a prayer. I am not petitioning, thanking, or praising God. I am stating the obvious, probably boring the Father of All and wasting His time, if He even has Time. But the words are genuine in a way I have rarely been and even more rarely expressed; real from the split ends of my hair to my crinkled toenail. *I miss my dad* is true.

No angel appears, no fire burns in my heart or mind, and I do not delete my dad's contact information from my cell phone or re-watch my dad's last video. My stomach hurts when my teenage son bounds out the door to high school wearing my dad's pin-striped button-down over a sloppy blue T-shirt. Nothing in my circumstances has altered because I prayed. But I begin praying differently. Instead of my typical magic-wand, give-me-what-I-want (please) wanting, I just talk. I tell my Father in Heaven that I am sad and that I hurt, that I feel upset and wrong. I speak aloud for the first time since childhood. "*My mom is lonely. I worry about her. I do not know how to help.*" I know God knows these things, but I tell Him anyway: "*I miss my dad. I need him here.*" Sometimes I am angry and bossy, "*I want my dad back. So do my sisters and brother.*" And some days I whisper words that I worry are sacrilege, "*Father-God, I do not mean to offend, but could you step aside? Could I talk to my dad? For just a minute?*"

I officially plan to be faithful and "nice cry" on my first Father's Day without my dad, but I feel ill and grumpy. Sitting in the front room torturing myself with old photos, I hear a whimper squeak out of my throat. I paste an "I'm fine" smile on my face, walk to the front door, fling it open, step through, and yank it shut. I stalk down the sidewalk, veer left by the railroad tracks, and march beside the overgrown ditch bank. When the hard-packed gravel trail grows less traveled, I claw up some soil. "*Dirt,*" I declare to my handful, "*you have been cursed for my sake.*" I fling it upward. The soil pelts me on the way down and scatters, gritty in my hair and on my dress. "*Unto dust shall ye return,*" I tell the dirt, trying to brush off my clothing and shake out my hair. My fingernails were tattered before, but now they are dark-rimmed and grimy. I stop walking and stand, speckled with dirt, missing my dad on Father's Day.

A while ago, I found the scripture that says I should live "in love, insomuch" that I should "weep for the loss of them that die ... " (D&C 42:45). I was looking for a command to weep, but this one confuses me. Is loving the law and weeping the consequence? Or are they both commandments? Is this obedience I feel as I flick muddy flecks off my dress and absorb the smell of wet weeds and old train engine exhaust? Is this the price of loving? A quick intake of breath that will cloud every glance in family photos, shadow holidays and weddings, dull days for the rest of my life? Gravel pokes my feet, city lights twinkle, and traffic murmurs distantly.

I want to walk forward, to escape the pain and the past with vigorous motion, but

tonight pain pauses me on a grubby trail lined with litter and weedy, dried bushes. My breathing slows and I hesitate. I sense something different, something other than what I hear, see, and smell. It approaches more gently than the pressure of July's calm, dead air; more transitory than ripples in murky pond water; yet more constant than the flow of days and cycle of faded seasons. I linger in liminality, wavering on a threshold between breaths, before healing, below logic, beside pain.

Standing beside industrial train tracks in my spattered Sunday dress, I spread my grimy hands open, palms up in front of me, and weigh the vast oppositions I supposedly have always known: love and death; God and me; expectations and experience; sorrow and eternity; cancer and my dad. I see that my mistake was anticipating a simple Sunday school swap: joy for my mourning, beauty for my ashes. Expectations hid God from me, a God who does not leave me comfortless. Or sorrowless.

I am not happy to find this opposition-loving God. How am I to have faith in a Father who sends me to the cemetery beside the pond, knowing it will break my heart and blister my spirit into contrition? How am I supposed to walk through the valley of the shadow of love and not fear? Am I expected to open my arms and embrace shoveling dirt onto my dead dad? I do not understand how to have clean hands when Wyoming grit grinds so deep that the stains will never get out. July 11ths cannot help but splinter my soul and scorch my easy faith into a pile of ashes; they make me doubt God's love as I never have before.

"I don't like this," I say. Then I look at my grimy hands and say it louder. I feel like yelling. What on earth does He want from me? But I am afraid I may already know. My God is the God of the grave. He hears the prayers of all who mourn as distinctly as I heard dirt thud on my dad's coffin. I am as certain as I am sad. And I am sad. I miss my dad.

Exhaling in a gasp, I dislodge muddy particles, which tumble back to earth. I should laugh at my melodramatic meta-moment, but I also want to kick the oil-stained ground beneath my feet or sit sobbing like a pouty teenager until someone comes to find me—all possible, but tonight I choose dirt. With a rib-stretching breath of polluted train air, I tilt my head back and stretch forth my arms. For a moment I feel like I am swelling as wide as eternity, fingertips brushing loneliness and love, weeping and healing, then I whirl down and scrape up more dark dust with my fingernails. My throwing arm is weak, my hands lightly calloused; it does not take a genius to know this handful of God-cursed dirt will barely take flight before it boomerangs, splattering me again with mud and grime.

I cock back my mud-filled right hand and aim for a flickering star just visible in the gray dusk.

This, I tell myself, *I will throw even higher.*

MEASURING MY DAYS: COFFEE SPOONS AND CONJUNCTIONS

LISA RUMSEY HARRIS

The poetic melancholy of "The Love Song of J. Alfred Prufrock" sings to me each fall and winter in short, sixteen-week bursts. Rather than coffee spoons, my life is measured in semesters, each one a tightly packed drama of activity and emotion. I teach English 311: Writing About the Arts and Humanities, in which we write, tour museums, and have heated discussions about culture and art. To paraphrase Prufrock, in my classroom, students come and go, talking of Michelangelo.

To keep up with the pace, I tend to live the way I tell the students not to—staying up until four a.m. to grade papers instead of write them and surviving on vending machine trash food. I go native, living like a college student even though I have a real life (Three children. A dog. A patient husband who tries to pick up my slack.) beyond campus that demands my attention. As a part-time faculty member, I can't submerge myself into ideas and theories like the students do. This isn't my only reality.

At the semester's end, when I come up for air, it is a wrenching relief to walk away. Relief, because I'm old and tired. Living like a twenty-something wears on my thirty-something bones. Wrenching, because I know my life won't brush theirs again. If we do cross paths, it won't be the same. I feel empty, entirely spent. To create order in my classrooms, I neglect it in my home, leaving a wake of entropy behind me. "When Mommy gets research papers graded ... " turns into "When Mommy's semester ends ... ". Carpets go unvacuumed, lunches go unmade, and occasionally permission slips for field trips go unsigned. And after it ends, I'm left with what? My contribution to my students' lives has been reduced to a capital letter on their transcripts. Do they have any idea what this has cost me? Especially this semester?

My secret burns beneath my heart, where her heart beats too. These weeks have been milestones for her development. Her facial features formed while my students slogged through research papers. Now, with finals over, she can see the light that filters in from outside my womb, even though her eyes are sealed shut. As my students complete the semester, she has completed her first trimester.

My lips, like her eyes, are sealed. This time I decided not to tell my class that I was pregnant. I learned my lesson the hard way: student evaluations during my last pregnancy. "We suffered because she was pregnant," one student claimed. Suddenly every perceived lowered grade was attributed to my "irritability." I decided not to share this surprise transition in my life with this semester's class. I fought the nausea, gritted my teeth, and prayed for strength to get through the semester.

This baby is a surprise. And that is an understatement. I told friends, "Unless an angel comes down and personally asks me to have another child, I am done." I didn't see an angel. But maybe the Lord sent me one anyway. Maybe this is my own tiny angel, come to comfort me in my old age. Because I am old now, or maybe I just feel old. I didn't think I was until this revelation baby. Doing the math made me cry in my closet for an hour. Thirty-nine when she is born, so how old will I be when she goes to kindergarten? How old will I be when this baby graduates? Old Old Old! It made me think of Sariah (both Sariahs actually—the wife of Abraham, and Lehi's wife, who had older children when she bore Jacob and Joseph in the wilderness) and Elizabeth, the mother of John: all past bearing age. It must have been so hard for their bodies to go through the demands of pregnancy, something their husbands would not have understood. But like each of those women, my prayers were answered. I held down my lunch during class and kept the hardship of the pregnancy out of the classroom. It wasn't easy though. Pregnancy never is for me, this time or last.

During my last pregnancy, I identified with Hannah, who received a child as an answer after years of praying. Eight years. That's how long we prayed for a child and waited. That prayer was answered with Clara. But after Clara, we were done. My husband and I agreed. But the Lord had other plans.

Before this semester began, a wise friend told me, "If you want to make God laugh, tell him your plans." Her counsel, given over slices of chocolate cake, proved to be prophetic. I responded with a courtesy smile, and then launched into my five-year plan: "This summer, we should plan a trip to England," I said. "And then I should start looking into PhD programs so I'm ready when Clara goes into kindergarten ... ". The irony of her words still stings, even now.

I mourned. Selfishly, I know. I have friends who have yearned for a child and received only silence instead of answers. I knew that in an academic sense. But at a visceral level, childbirth was too fresh for me—enough time to heal, but not to forget. For me, the physical challenges, while daunting (especially since my last birth was a high-stress, emergency C-section) didn't compare to the mental and emotional challenges. It took me a year to emerge from the cage of postpartum depression. I had just begun to feel joy again. And I was afraid of returning.

Sitting in my car before class, these thoughts crowded my mind. The car has become a sacred place for me: the space between being a teacher at my office and being a mother at home. The parking structure next to my office has transformed into a bit of a personal temple, a place where I pour out my heart to the Lord, where I listen to Holy Scripture,

where I receive revelations. There, in the in-between, He has soothed my soul. It was there when I was, like Prufrock, "preparing a face to meet the faces I would meet," that He answered my prayer.

Through my tears, the Lord's quiet answer came. *Not all of life is either–or. Sometimes it could be "and."* That was it. *And.* Three letters. I wanted a sonnet or a soliloquy. But all I received was a conjunction. I was disappointed until I considered what it meant.

A conjunction implies a continuation, not an end. Conjunctions connect future, past, and present into one eternal round. Stories end without *and.* As an English teacher, I know the importance of conjunctions and how unappreciated they are. So unobtrusive they're almost invisible, conjunctions work like road signs, telling us to go forward or take a detour.

Maybe that's the problem. I wasn't looking for a conjunction. I was only thinking in terms of "when this is over, I will ... ". But God holds many things in their courses at the same time: planets and galaxies, cells and subatomic particles—both important, both structured. And His work is never finished. It continues—after death, before life, before time itself began. I am one of His works. An eternal being, without beginning or end. Can anyone measure immortality? Eternal life? Every sentence that God writes could start with *and. And* may be the Lord's greatest conjunction.

How does the Lord measure time? Spoons (like Prufrock)? Semesters (like school)? Trimesters (like pregnancy)? I don't think so. I wonder if it's sometimes in minutes. As in, "Please Lord, let me get through the next five minutes without throwing up in front of this class." Or sometimes decades. Like the near decade we spent petitioning the Lord for another child? In any case, I'm no closer to understanding. And that makes me frustrated and impatient. Does He see how worried and anxious time makes me?

I think He must know. He must be trying to teach me to trust *His* timing. That's what I'm supposed to do, I know. Perhaps I am needlessly worrying about time and how to measure it. When I look back through my life, I really don't measure it in numbers, hours, or seconds. I have endured thousand-year days (especially at the end of a pregnancy). I have also wished to stretch a fleeting golden moment (just the length of a baby's sigh) and live in it forever. Kneeling at an altar in the temple and being sealed to my husband took mere minutes, and yet it will have efficacy throughout all time. The number of ticks on the clock that comprise those moments is irrelevant to their importance. The time passes, as it always will, whether it is measured in coffee spoons, heart-beats of an unborn child, semesters or trimesters. And I will still be.

My dreams don't have an expiration date. I can keep learning, traveling, writing, teaching, and growing beyond the grave, into the next life. But my ability to bear this child and usher her into mortality does have a time limit. She needs to come. And she needs to come now. This moment is one of the most important nows, for both of us. The refrain from Prufrock returns to me, as I consider this idea: "And indeed there will be time ... ".

When the new semester begins, I will not be there. Instead of standing before students, I will be transitioning from pregnancy into labor and delivery, and those hazy, sleep-deprived days that come with nursing a newborn. Instead I will hold my new, tiny revelation, and I will trust the Lord. He is the master of time and more importantly, *and.*

GUARDING
YOUR GROWING SEASON

JULIE NELSON

The frayed sewing tape
measured yearly growth—
pencil-lined hatches
up the door's vertebrae
marking inches, feet.
The frame is smudged
and warmed with the pulse of years
pressed against its skin.

At fourteen your height
stretched five foot nine—
our distance from toe to crown,
equal. The tape curled on pale linoleum
with a shiver up its yellow spine.
To be sure, we stood back to back,
then eye to eye.

And now, ten more seasons are
concealed within my furrowed frame,
as your green vine creeps
toward swelling fruit.
Soon, ripening will ready
in your own budding body
in the curve of hips and lips
and damp seeds clustered to burst
by moonlight.

This fall, a marriage
marks a grafting of your flesh
to another. Lines etch
my waning vision and spine,
bent with the bitter
and redolent tang
of our pruning.

Go, my darling daughter, go.
Mark how your own cord
will lengthen, strengthen,
your blushing core soften
after seasons of yellow harvests.

WELCOME

TO GO HOME

CATHERINE KEDDINGTON ARVESETH

Tiptoeing out of the extra bedroom where my boys were asleep, I quietly closed the door. As it clicked shut I heard the last chime of the grandfather clock. Eleven. I sighed and traced my hand along the wall then turned down the darkened hallway of my childhood home.

An hour earlier we had tumbled through the front door, dumping blankets, bags, and pillows in the entryway. My brother Dave had found sleeping bags for my girls, gathered their things up with his strong hands, and without asking how he could help, put them to bed downstairs. His bedroom door was closed now.

My five-year-old boys had bounced up and down on the bed, somersaulted across the floor, tussled, tickled, and tried my last bit of patience until eventually, they gave up and gave in to sleep, Gordon's head at the foot of the mattress, Spencer sprawled on the floor.

I could hear my parents talking quietly in their room, soft lamplight seeping out from under the door.

I changed into my pajamas, brushed my teeth, turned down the covers in my old bedroom, but couldn't sleep. So I walked out to the kitchen.

White light from a strand of Christmas bulbs scalloped along an outside fence cast shadows on the kitchen table. My dad had tidied the scene, set out the grill and frying pan for tomorrow's breakfast. By morning, the table would be crowded with his children and grandchildren filling plates with buckwheat pancakes, fresh bacon, and scrambled eggs. The granite countertops gleamed a shiny black, starlight trickling in from a skylight in the ceiling.

I padded into the living room and turned on the Christmas tree, set in its familiar spot. It gleamed gently in the northwest corner, tiny lights reflecting in the large window. Climbing into a red wing chair, I tucked my feet up onto the cushion and hugged my knees.

It was the day after Christmas. Earlier that evening the main sewer line to our street had backed up into our basement. It had come up out of the toilet and tub downstairs, contaminating a large section of carpet and tile, rendering all toilets, showers, and sinks unusable.

My husband called a disaster clean-up service and suggested we sleep at my parents' house for the night while he stayed to meet the cleaning crew and handle the horrible mess. Knowing we wouldn't survive long without facilities, we had snatched up a few nighttime necessities and piled into the car.

I nestled deeper into the chair, trying to find a comfortable position for my back.

Somehow I had injured it a week earlier and the neural sensation I was experiencing made me suspect a disc tear.

I had muscled through Christmas but wasn't moving like myself. Two months earlier, one week after my fortieth birthday, I landed in the ER with a kidney stone. There was still blood in my urine. A gynecological visit that month led to an appointment at the women's cancer center. Minor surgery pending. All that, in combination with general holiday exhaustion, and I was a mess.

Now the house was a mess too. It wasn't just the sewer. It was the dishwasher flooding the kitchen floor a few days earlier. A cracked window the day after that. Wooden trim falling down from kitchen cupboards. And a vacuum cleaner that went kaput. All of this in one week?

The growing list of health concerns and house disasters had become comical. And yet I wasn't laughing.

I was tired and in pain. I had forced a smile and pulled out my iPhone to snap photos. I mean, it was Christmas. But sometimes it's the stuff behind the picture of five kiddos in Christmas PJs that has to be talked about. Because it gives context. It provides a story rather than a moment. And in this case, all the discomfort and disorder jumbled together, made for circumstances in which I was about to feel something I hadn't felt in a very long time.

As I sat there, huddled in the stillness, a vision of sorts opened before me. Memories from my childhood danced around the tree. Christmas after Christmas played out in my mind. Sparkling right in front of me, like an aura of candlelight pressed against quiet darkness.

I saw stockings stuffed to overflowing, the Sesame Street playground, the Cabbage Patch dolls, and the year we found two saddles and saddle blankets propped up on one side of the tree. I felt the fire blazing in the fireplace and could hear us singing about birds in the wilderness on the stairs, my sisters hopping and twirling in anticipation until it was their turn to see if Santa had come.

I smelled orange rolls warm from the oven. I heard the sound of wrapping paper crackling. And I felt that feeling. That magic and wonder of Christmas as a girl.

In a rush of vision and emotion, I felt the total safety of being together with my siblings and parents as I grew up in this home. How remarkable it was to establish a life there, to have a childhood there, to grow up on this hillside with a valley view.

I looked out the window at the city lights and curled deeper into the red wing chair, overwhelmed with nostalgia. Then I felt something familiar, but old. Something forgotten. So startling I began to cry.

It was the feeling of being a child.

Day after day I had been caring for my children and family. You know how it goes—Mom holds everything together. Mom meets everyone else's needs before her own. Mom makes sure things keep rolling, gifts are bought, school projects are finished, and all the moving parts ... keep moving. Mom cleans, folds, cooks, Band-Aids, reads, sings, tucks in. She cares until she's limp and then she cares some more.

But for a few minutes that evening, I wasn't Mom. I was a child again.

My parents had let all six of us come banging into the house with our bags and blankets because we had nowhere else to go. My mother had put fresh sheets on my bed. My dad, who had just retired from forty years of emergency medicine, sat down beside me to discuss my health concerns. Both had come to our aid, like parents do for small children who can't care for themselves. And I felt like I'd been lifted out of our trouble and placed on mommy's hip or daddy's shoulders, where I could see from a better place and let someone else do the holding.

I forgot how heartening it is to be cared for. To have somewhere safe to go when you feel broken, lacking, and hurt. I forgot how it felt to go home.

The next morning I woke rested in body and spirit. My sisters and their children arrived for breakfast and we stood at the kitchen counter buttering pancakes and pouring orange juice. I told them about my experience the night before. About the sewer problem, my back, the other doctor visits, and how our parents and brother had come to our rescue. How I'd slipped into the living room after everyone else had gone to bed to sit by the tree.

This was their home too. They understood the memories, the feelings. They could see in their minds the same scenes of years now gone.

Mom and Dad listened and my sisters agreed. Our growing up was marvelous, even magical.

Now we were grown. We had traveled the world, seen families who didn't love, didn't nurture, didn't care, and we could appreciate how unusual this was. This gift of growing up with so much security, so much kindness.

My dad, in his wisdom, sat on a bar stool next to us and joined the conversation. He said, "I believe what you felt last night was just a taste of what it will feel like to go home to our Heavenly Parents."

My sisters and I choked back more emotion. We could feel the truth of what he said.

I glanced into the kitchen and noticed a long piece of twine strung across the kitchen wall. I smiled at my dad's ingenuity. He had clothes-pinned plastic drinking cups to the twine. Each with a family member's name on it so we could reuse our cups and find them easily. Everyone was there. Everyone had a cup with their name on it.

Isn't that heaven? A cup for all of us? A place for each of God's children? A home that is truly home?

We moved through the morning, fed children, washed dishes, laughed, and held babies. Doug finally joined us to report that the sewer mess was contained, carpet ripped up, fans drying. The cracked window was taped, the carpet in the kitchen was almost dry, and he had borrowed a vacuum cleaner from his parents. My dad had written me an order for an MRI and I had a list of physicians to call. We were moving forward.

Two days later we stuffed our pillows and blankets into the back of the minivan and drove home. To the home my children know.

A few months later, I read the first sentence in Scott Peck's book, *The Road Less Traveled*: "Life is difficult."

He continues, "This is a great truth, one of the greatest truths ... because once we truly see this truth, we transcend it. Once we truly know that life is difficult—once we truly understand and accept it—then life is no longer difficult ... the fact that life is difficult no longer matters."

Most of us do not fully see this truth. We moan about our problems, noisily or subtly, Peck says, as if life were generally easy, as if it *should* be easy.

On that day after Christmas, I had moaned, maybe noisily. But what I didn't know then was that it was only an introduction to difficult. In the next year, my mother would lose function on the left side of her body, requiring full-time care—an enormous job for my father and family. A good friend from college would succumb to the challenges of a life-long lung disorder, leaving his wife and two children husbandless, fatherless. I would sit in a hospital room, my arm clutched around the shoulders of a grieving friend as her husband held their two-month-old baby in his arms, breathless, discolored, and suddenly gone.

There are no words for loss like this. For this kind of difficult.

Only Jesus. He is the only word, the only comfort, the only way out of disappointment, hurt and pain.

His promise? "I will not leave you comfortless. I will come to you ... If a man love me, he will keep my words: and my Father will love him, and we will come unto him, and make our abode with him" (John 14:18, 23).

James also knew something of loss and compressed trouble when he wrote, "My brethren, count it all joy when ye fall into many afflictions; Knowing this, that the trying of your faith worketh patience. But let patience have her perfect work, that ye may be perfect and entire, wanting nothing" (James 1:2 – 4).

Many afflictions. Many sorrows. Many losses. All paired with patience because they have a perfect work to perform. A work, James says, that can change us, makes us more whole, so that in the end, we want only what God wants.

I believe this, that hardship and anguish can be used to teach us, to align our will more seamlessly with His.

I also believe in that glorious moment of return, when all the mess, anguish, and struggle of this life will melt away. When every wrong will be made right. Every loss restored. Someone will hold us. Loved ones will come for us, gather us in their arms, and we will know, without question, how well we have been cared for. During all of mortality. Even when we could not see it.

During that troubled Christmas week, the caring and presence of my parents reminded me I am still a child. A child in experience and learning. A child in relationship. Not just to earthly parents, but to heavenly parents who want my happiness. Who are aware of every heartache, every misstep, every letting go.

I picture those clothespins, holding every cup securely to the line, and imagine.

When we go home, we will find our name. We will know our place. We will belong.

ROOM AND BOARD

MELONIE CANNON

Her face is an open door
that I walk through
to find
cool conversation
by a middling fire,
the smell of warm bread
rises from her chest
and she asks me to sit

Her eyes are roomy chairs
Her smile a place to rest my feet

Her ears
the wide windows
permanently ajar
so an open-minded
honey breeze
can easily come and go

She built the house a long time ago
from recycled timber
and suffering stone
with mirrors like Roman glass
to reflect the fragmented parts
of self
into one shimmering whole.

The roof is of slick bone.
The incessant rain slides off
the sides
and fills her cupped palms
like waiting cisterns.

There is a deep garden
through the back door
a place of thick and coiling
ideas,
the sacred vines that
conclude in surges of color,
a claret apple
or a goddess pear
to be plucked and shared
slice by slice.

Her voice is my guest bed
and the wise words—
white linen
to pull up crisply and tuck
under my chin

Closing my eyes,
I rest in this house—
a safe place for weary travelers.

EMERALD GRASS AND MAY SKIES

TRACY McKAY

For the dozen-odd years since I joined the Church, I've been sort of an outlier. All of my experiences with the organized church and with my church community have been through the lens of being an adult convert. Nothing about that is unique, of course—there are adult converts everywhere, and in probably every faith—but joining a church that revolves in a potent way around an idealized family makes those coming in poignantly aware of our shortcomings. (Yes yes yes, I know there is no such thing as a perfect Mormon family, and I know everyone wears their best faces on Sunday, and every family has problems and struggles and challenges. I get all that. But bear with me.)

When I first joined the Church, I experienced church as a woman with a nonmember husband. Then I experienced church as a woman with a husband who had joined, but to whom she was not sealed. I experienced having three babies not "born in the covenant." Only one of my children was blessed as a baby. I didn't understand what that meant until I was suddenly experiencing church as a divorced mother, and two of my children were not listed on the records of the Church anywhere. I experienced church as a single mother. I experienced church where I had to find someone to baptize my children because there was no family to whom the responsibility could be given. I experienced church as a single woman dating while juggling three children and full-time college. I had never sat in a sacrament meeting with pews of people related to me. I had been a member of the Church for almost ten years before I heard someone give thanks for me over the pulpit. I remember it stunningly because only in that moment did I realize it was a first. I burst into tears.

There have been tremendous kindnesses and generosity along the way. I have experienced the very best my church community can offer in love and support. My children have been valued. Wonderful friends have cared for us and included us in their families and in their holidays. Loving friends walked with my children into the baptismal font, and countless hands have tenderly and richly blessed us. I attended the temple with friends I count as family and with whom I have shared profound spiritual experiences. It has been a rich and complex journey, and I wouldn't trade the perspective and joy for anything.

Because of the lens through which I experienced church, I have been guilty of being cynical at times. It's hard being a convert. It's hard being in an unsealed marriage, hearing

constantly about the pinnacle of Mormon life, temple marriage. It's hard being divorced. It's hard being all these complicated things, hearing constantly about the importance of family, and feeling like no matter what, you fall short. I have been, at times, critical of our myopic focus on one type of family. It's particularly painful for children, for singles, for divorced people, and for the myriad of folks who, for one reason or another, fall outside the idealized family structure.

The family I come from is wonderful. I enjoy close relationships with all my siblings and extended family, and while my parents do not understand my Mormon conversion or my raising my children in the Church, they love us tremendously. Because being Mormon is a large part of my identity, my family simply cannot relate to some of my life. The warp and weave of a Mormon life is understandably foreign to them. They do not understand our vernacular, our idiosyncrasies, our vocabulary, our shorthand, or our rhythms. The Mormon rhetoric of the family is even more alienating to families outside Mormonism. Imagine how parents who have spent decades loving and building their family would feel at some of our expressions. My mother is already worried about her grandchildren's weddings—and I can't blame her. In many ways, I have straddled two worlds. My children are also going to have to manage that tension. It's made me, at times, raw and kind of prickly. I'm aware of my faults, probably never more so than now.

This last weekend I experienced something I had previously only seen with my nose pressed to the glass on the outside. I experienced belonging to a Mormon family.

My husband and I flew to Utah for a family baby blessing. It was a slingshot trip for us from the Metropolitan DC area to Salt Lake City, but it was important for him to be there for his sister. The weekend was happy and boisterous and full of the commotion and laughter found in any big family—my husband is one of seven children. It was lovely and welcoming and wonderful. But I want to focus on two experiences that tectonically shifted my spirit and my perception.

The first was early Sunday morning, Memorial Day weekend.

Out in the vast yard of the homestead near Cache Valley, one of my sisters-in-law was gathering fresh-cut flowers into white buckets from the Aggie Creamery. There were mums and irises and hydrangea and wildflowers overflowing the buckets onto the kitchen counters, as they were sorted into bouquets. There were siblings and children and dogs bouncing around the enormous kitchen with the air of a holiday. Some had already headed off to different cemeteries; siblings talked about who was going where, and what time to meet at the main family memorial. All of the dead would be visited this day.

I had never ... This was an utterly foreign land to me. My family are cremated. My beloved grandma had her ashes scattered at sea, and the Golden Gate Bridge where we stood on the day she left is her memorial in my heart. I can count the funerals I have attended on two fingers.

Heading up Cache Valley toward Old Main, we pass the Logan Temple, where several of Jon's siblings were married, and where we are considering our own sealing. We

turn into the Logan City Cemetery, where there is a sea of flowers, peppered with laughing children, balloons, visiting family, and more flowers. Fresh, vibrant flowers are everywhere. The cemetery is full of cars and families, and people are working on their loved ones' headstones. We park the car, and Jon takes my hand and walks towards "our people." At the family plot, I meet more family members, and there is an air of celebration with contemplation. There are children, and mothers nursing while sitting on familiar markers. The kids know the stories of the lives marked here; they are nearly as familiar as anyone living. I am suddenly choked up. Jon walks me around, introducing me to folks living and dead, and quietly shows me the swath of rich emerald grass close to the rest of the family that bears no marker. It's for us, hopefully far in the future, but there it is, bright and shining in the May sunlight, overlooking Cache Valley on the northern end of the Wasatch Front. This is where I will someday lie. There is, literally, a place for me.

Tears constrict my throat; there is something deeply meaningful and comforting in this beautiful certainty. It is like finding something I didn't know I was missing. Whatever shape life may take, whatever happens between now and ... then ... there is this place. And there are the stories that will be told, the flowers that will be brought, and the children who will go on laughing and playing above the beautiful green lawn and beneath the splendid May skies.

We rejoined the family and gathered our armsful of flowers and went in search of the family members to whom they belonged. No one was forgotten.

And I understood a little bit more about what family means.

Later that afternoon, washed and spiffed and in our Sunday best, we entered a chapel in Brigham City. Half the congregation was family. Row after row of family—smiling, happy faces greeting each other, leaning over the pews and chatting quietly, happy to see one another, and warmly welcoming me, the newest spouse. I found my sister-in-law and helped her tie the booties I had knitted on her son's tiny wiggling feet. The baby would be held in his father's tartan plaid, dressed in a beautiful outfit his grandmother had made him, and in booties my hands had knit.

The service was no different than any Mormon Sunday in any chapel anywhere. When it was time to bless the baby, seven brothers and their fathers stood up, buttoned their jackets, and formed a circle. My breath again caught in my chest and my eyes stung. This baby, so precious, so loved—all babies are, or should be, of course—but the men who will mentor, care for, and raise him up were literally holding this baby in a circle of love. It was a visible proclamation and manifestation of the child's relationship to the world.

What a profound blessing. And it had nothing to do with the words (though they were beautiful) spoken of actual blessing by his earthly father.

And I understood yet a little bit more about what family means.

Several years ago, I wrote:

We talk about our congregations being our ward-families. I hang onto this out of necessity. It's mostly true. Sort of. But family isn't supposed to all disappear when some lines are redrawn on a map—and when your ward is your only family, that's exactly what

happens. Then again, family isn't supposed to disappear when one person finds faith, either. Imperfections, it seems, are the norm both inside and outside the Church. And those Sundays when a lesson is particularly painful or difficult or handled ham-fistedly by a hopefully well-meaning person and hurts me or my children, I wonder which imperfections are harder, and if I chose the better part.

Then I remember where the light comes from and why I can even make it ... Here is where I found my long-sought answers and there is no reasoning or rationale or hurt feelings that will change that fact.

I am keenly aware of the imperfectness and the flaws inherent in systems—all systems, including the Church—and of course I haven't forgotten the tensions, issues, and problems that accompany so much of that family focus. But for today, I am grateful for the additional facets given to my vision, the additional nuance that broadens my compassion not in only one direction, but in all ways and places.

I am grateful to this magnificent family—both my earthly families and the family of the Church—for folding me and mine in, for showing us with their actions what they mean by love, and for the healing they are working on my hurt soul. I did choose the better part.

I think I am just starting to understand.

GATHERING SHEAVES

JES S. CURTIS

As a child I used to listen to the story of Ruth on a cassette tape while I was falling asleep. I admired Ruth's guts—she could have gone back to her own mother, but she didn't. She followed Naomi to Bethlehem. Even as a child I knew that losing a husband would be devastating, but took comfort in knowing that the Lord had other plans for Ruth's life besides bitterness, despair, loneliness, and starvation.

No mention is made in the Bible, but it must have been a long journey. Perhaps they walked or rode a donkey, sand getting into their shoes, each of them weary and travel-worn. And they weren't walking toward family to welcome them home, they were widows who would have to fend for themselves. I can imagine they were already starving—their smocks catching on their jutting ribs, hunger following them like a shadow. Ruth did what she could to save them by gleaning barley from a field. I see her stuffing broken stalks into a turned-up apron. I see her scurrying behind broad men with scythes who sweep the barley down in one smooth motion, and Ruth ducking in to scratch off the grain left behind on floor of the earth.

The story in the Bible is slight, but the shunning from the other women gleaning the field is implicit. Maybe it's in the way Ruth looks—maybe it's in her clothes or in the way she twists and pins her hair. Maybe it's the shape of her nose, her lips. She is a stranger, left with nothing except a little tingle of faith at the back of her throat.

I feel like Ruth, scratching along the ground for enough. Enough strength, enough courage, enough independence. To be as bold and without guile as Ruth, seeing my life stretch before me without a husband to stand by me. My husband didn't leave me a widow. He simply left me. I watched him pack a duffel bag and walk out the front door. I sat on the steps holding our son and daughter while he walked away. He didn't come back. He left me alone, the chaff blowing by me, carrying away bits of myself. And I, like Ruth, am to make a new life from ashes and dust.

Before he left, I was ordinary—just a family of four. Nothing remarkable, just comfortable and safe. But now that he's gone, people see me differently. I'm not a family. I'm one of those who are broken, trying to make broken work. I'm alone in the empty belly of divorce.

On the Sundays without my children I sit on an empty pew, edging myself as close to the wall as possible. I'm invisible; I'm on fire with loneliness; I'm raw and open. My body blends into the maroon fabric of the pew. My arms and legs, still as stone, melt away. I

hold to the rituals of a Sunday afternoon, taking the bread and water, but it's hardly enough to fill me. I quietly hold myself together, trying to blend in, but knowing that I'll never be a family like those surrounding me.

I can hardly speak about him, the one who was my husband, my best friend, my anything and everything. This, I suppose, is the wages of his betrayal, to have my mouth sewn shut by grief.

After the leaving, my husband came back to stand in the house and comb through it like an empty field. We used a steno pad to divide our possessions—one side for him and one for me. I got the mixer and he got the blender. I had to trade the iron to get the vacuum. I keep finding his socks. I used to save them in a tangled pile. Now I just throw them away.

When I see his name on an email or on the phone, something inside me drops. Moments come piling on top of me, smothering me in memories. There was the time he jumped across a room to catch our son's vomit in a bowl. The time we climbed so high we were in the middle of a cloud. The time I sat next to him after yet another leg surgery and fed him grilled cheese sandwiches. The time he held my hand during the symphony. The time we climbed Yellow Pine to the peak, stepping carefully around mountain asters.

Is this how Ruth felt when she left with Naomi? Like she was dividing herself into a hundred thousand pieces?

It could have been easy for Ruth to let things slip through her fingers. It could have been easy for her to surrender to hunger and loneliness. But she didn't. She went and laid at the feet of Boaz, taking a risk for herself and Naomi. And Boaz is kind to her, despite her past. Despite the loneliness, despair, hunger, weariness, he notices her. All of her. She says to him, "Why have I found grace in thine eyes, that thou shouldest take knowledge of me, see I am a stranger?" Ruth has found her personal savior, a man with grace in his eyes and in his work. In a place where she felt lost, she is discovered.

Boaz says to her, "The Lord recompense thy work, under whose wings thou art come to trust." She must have felt such relief, she must have cried. In that moment she realizes that despite the grueling journey, she has been walking under the wing of the Lord. And that's when Ruth says this: "Thou has comforted me, and for that thou hast spoken friendly unto thine handmaid, though I be not like unto one of thine handmaids."

Her words are lightning striking me up inside. This stranger sees through her. He sees through her grief. He sees through her desperation. He sees her, in her glory as a daughter of God. As one worth saving. It stops her story from being one of despair to one of redemption.

And so I find refuge in her story. She wasn't like all of the other women, but she was not overlooked by the Lord. Her life may not have been easy, but she wasn't forgotten by the Lord. I know I feel like I'm walking blindly through my own personal upheaval, but, like Ruth, I am walking under the wing of the Lord. And that is who I trust.

WHEN GOD BAKED POT PIE

TERRESA WELLBORN

After I home-birthed twins, God changed.
He left Kolob, unfurled an olive branch
and led me, breasts milk-swollen, to their morning cries at four.
Bamboo blinds shut, every sleep wish quixotic.

How God's hands grew: one holding my empty belly,
the other shampoo, rinse, water.
He became the crying mouths, the nipple bleed,
my hair in two back knots, my nanny nieces with quiet voices,
chiaroscuro faces.

He fetched mail,
bought groceries,
unpacked,
unfurled,
resurrected,
anointed.

He baked pot pie one afternoon.
I cried. It was dinner.

CYCLE

EBBING TIDE

MELISSA McQUARRIE

I'm rinsing plates and stacking them in the dishwasher when my ten-year-old, Miranda, walks into the kitchen wearing her Ariel nightgown, her damp hair falling over her shoulders. In the last six months she has sprouted out of her jeans and shirts, her angles and straight lines softening into curves, and her legs seem suddenly long under her nightgown. I make a mental note to buy her some new pajamas. I watch her as she crosses the kitchen and comes to stand beside me at the sink. Her face is tense and serious. "Nikenzie was talking to me today about the weird things that happen to your body when you become a teenager," she says, "and I'm feeling really freaked out." I ask her what Nikenzie has been saying, and her cheeks flush as she mumbles that she can't remember. "Has she been talking about girls getting their periods?" I ask. She shrugs and looks away. I dry my hands on a dishtowel and lead her to the couch, where we sit close together and I stroke her hair. I should have had this talk with her two years ago, but she is my youngest child and I can't seem to keep up with her too-rapid growth. That, and I'd rather have my fingernails ripped off than have the sex talk. To my credit, I've made a few half-hearted attempts to have the talk with her, but each time she has refused to listen, covering her ears and insisting, "I don't want to know!" and running from the room.

But now she seems ready to listen, so for the next few minutes I explain what periods are, doing my best to achieve a confident, reassuring, no-big-deal tone. As I'm nearing the end of my spiel Miranda interrupts me. "You're saying that blood is going to come out of my body every month? Blood? *Every month?!*" Her eyes are wide, filling with tears. This is the child who just last month threatened to kill herself if we didn't buy her a puppy—by now I am used to her life-or-death declarations and her wide swaths of emotion. I tuck a strand of hair behind her ear and smile. "Every woman has periods, and when you start yours it will be a sign that you're growing up!" I know I sound a little too perky. She starts to cry. "I never want to grow up!" she wails. "Never ever!" A second later she stops mid-sob. "How long will I have to have periods?" she asks. "Oh, only until you're about fifty," I say. She bursts into another round of tears.

Something tells me this is not the time have the rest of the talk. But I can't postpone it for long. Whether she likes it or not, my little sprite is on the cusp of young womanhood, that moon-sliver of time between childhood and adolescence. In the blink of an eye, this little girl will be gone.

Puberty: "The stage of becoming physiologically capable of sexual reproduction, marked by ... development of secondary sex characteristics, and, in girls, the first occurrence of menstruation."

I, too, was ten when I learned about periods. My family and I lived in Emu Plains, Australia, where every autumn the fifth-grade girls and their mothers attended a special maturation evening at school. The night of the maturation meeting I put on my favorite pair of bellbottoms, pulled my hair up into a ponytail, and applied lip gloss before jumping in the car. When my mother and I entered the school auditorium, I tugged her to the front of the room, smiling at the other girls, who were whispering and fidgeting in their seats. A stout woman with gray hair introduced herself as Nurse Kelly. For the next half hour, as she told us about body hair and changing breasts and "menstruation"—I practiced saying the word silently to myself—I listened, sitting straight in my chair with my hands clasped in my lap. Then it was time to watch a film. Nurse Kelly invited all of the girls to the front of the room so that everyone could see, and we sat cross-legged on the carpet as the lights were turned off and the film began. While cartoons and diagrams flitted across the screen, a man's voice droned unfamiliar words like "uterus" and "testes," and I coughed and squirmed while the girls sitting next to me giggled. After the film, Nurse Kelly gave each of us a little paper sack containing a pad and a sanitary belt and a pamphlet called "Your Changing Body." Cookies and lemonade followed, and then my mother and I drove home. "Do you have any questions?" my mother asked once we were in the car. I shook my head. I was mystified as to how the wriggly sperm got to the egg, but I didn't want to seem stupid. And I was more interested in what would happen to me in a few years. I had just learned that every month I would bleed, and I thought about that all the way home.

Later that night, after my mother had explained how the sanitary belt and pad worked, I studied the pamphlet Nurse Kelly had given us and then tucked the sack away in my underwear drawer for safekeeping.

Fast forward four years. My eleventh year had come and gone, then my twelfth and thirteenth, and the sack stayed in my drawer. Now I watched for the telltale signs—a streak of blood on my underwear, tender breasts, achiness in my abdomen. Any day now, my mother told me. I'd see a friend at school putting a little packet into her pocket before going to the bathroom and I'd feel a rush of jealousy. Though none of my friends talked about periods—a wall of silence seemed to surround this subject—I was sure I was the only girl who hadn't had one.

That summer my friend Vicky George's parents rented canoes for her fourteenth birthday party, and Vicky and I and five other friends paddled up the river near my house to picnic and swim in a nearby canyon, where a mountain stream cascaded over sandstone boulders before eddying into the river. At the mouth of the canyon, weathering had formed swimming holes deep enough for diving, filled with water so clear we could see pebbles glinting on the sandy bottoms. We spread our towels on the sandstone slabs,

stripped down to our swimsuits, and jumped into the pools, which were tepid in the afternoon sun.

All of us except for Julie, who said she didn't want to swim. Instead she sat on her towel and watched us dive and splash while our whoops and laughter echoed off of the canyon walls. Later, as we were drying ourselves in the sun and Vicky was passing around vegemite sandwiches, gone warm and mushy in the heat, Linda leaned over to Julie and asked, "Are you having your period?" Silence. All of us looked at Julie, who flushed and nodded. Linda said, "I just finished mine, thank goodness, so I was able to swim today." And just like that, the wall tumbled down. Everyone was eager to share. My friends lamented the discomfort of cramps and the inconvenience of wearing pads. "I'm still too afraid to try tampons," Fiona said, and everyone nodded. They talked about the horrors of unexpected periods and leaky pads. "Once I was at a softball match with my dad," said Julie, "and I was wearing a white skirt, and all of a sudden I felt something wet on the back of my skirt, and I looked and it was blood and I thought 'Not again!' I just wanted to die!! Luckily I had a cardigan to tie around my waist." From there they jumped to rumors and cautionary tales. "I heard there was this one girl, and she was at school, and suddenly she fainted and then she woke up in a pool of blood—she'd just started her period that very moment!" "I heard there was this one girl who didn't start her period until she was nineteen." "My mum's cousin knows a girl whose periods last for two whole weeks!"

Along with the other girls, I exclaimed and laughed and shuddered, but I was the only one who didn't share a period story of my own. I was still an outsider.

Miranda and I are driving to her sixth-grade maturation, which is supposed to be a review of fifth-grade maturation with a little more information thrown in. But Miranda didn't attend her fifth-grade maturation. She is the only child of mine who skipped it. At the time she had just learned about communicable diseases and germs at school and she was so alarmed by bodily processes and sickness and blood that the mere mention of disease would make her hyperventilate. A paper cut would send her screaming out of the room. When she brought home the permission slip for fifth-grade maturation and handed it to me with tear-filled eyes, her breathing already accelerating, I told her she didn't have to go and took her out for ice cream that day instead. But now she is in sixth grade and she already knows about periods. We still haven't had the rest of the sex talk, but she still covers her ears and cries when I bring it up. She's eleven, for heaven's sake. You'd think I'd have a better handle on this since she's my fourth child. As far as maturation goes, though, I have been firm this time: I have assured her that she won't be learning anything new and that I will be sitting right next to her, and I've reminded her that all of the girls in her class will be there. "Really, it's no big deal," I said.

But apparently it is a big deal. Last night she was begging me not to make her go. Now, we pull into the school parking lot and she grabs my hand. I pat it and lead her out

of the car, into the school, and down the hall to the gym, hearing the buzz of chatter as we approach. The room is filled with girls and their mothers. Some girls are slumped in their chairs while others are smiling and swinging their legs, chatting with the girls sitting next to them. Nikenzie motions for Miranda to come sit by her, but Miranda makes me walk to a different row. "I don't want to be sitting by my friend while they talk about that stuff!"

During the next half hour Miranda nestles close to me while one of the mothers, who is also a nurse, stands at the front of the room and talks about body odor and pubic hair and periods and the importance of showering. Nothing is new. Miranda fidgets and squirms during the presentation, but she doesn't run out of the room screaming; she doesn't even cry. When it is over she turns to me with a relieved smile. "I already knew about all that stuff," she says. I exhale. As far as I'm concerned, sixth-grade maturation was a huge success.

> *Menstruation: "The monthly process of discharging blood and other matter from the womb that occurs between puberty and menopause in women and female primates who are not pregnant."*

I was fourteen and seven months when I finally started my period. I was at Mutual, which back then was called "MIA," one Tuesday night, and Sister Jarman was teaching us how to make candles. I'd felt cramping in my lower abdomen all day but hadn't paid it much attention. While our candles were cooling, I went to the bathroom, and that's when I noticed the brown staining on my underwear. Could it be? I checked my underwear twice more while I was at MIA; by the time I got home, the brown staining had changed to a red streak. I found my mother ironing in the kitchen. "I think I started my period," I told her. I was trying to sound nonchalant, but I couldn't stop a smile from spreading over my face. After my mother hugged and congratulated me and reminded me how to use the pad and belt, I went to my room and took the sack out of my drawer. Nurse Kelly would have been proud.

The next day at school, as I walked through the halls and sat in my classes and ate lunch on the lawn with my friends, a shiver of thrill ran through me every time I remembered the new secret I was carrying. Now I was the one who smuggled a pad into her pocket before going to the toilet. That night, dressed in my flannel nightgown, I wrote the following in my diary: "Last night at MIA I started my period for the first time. Today I had stomach cramps and could hardly eat anything and felt tired. I guess every month now I'm going to be uncomfortable for a few days. But that's part of being a woman I guess. I'm glad I've started my period, though. It's a very personal part of growing up."

For months, I welcomed each sloughing of the uterine lining as proof of my new womanhood. After about a year, my period became just another annoyance that I had in common with my girlfriends and, later, with my college roommates and mission

companions. Like every girl, I had the occasional accident (thank goodness for the handy sweatshirt that could be tied around the waist) and my share of comedic mishaps—used pads ending up in the mouth of the family dog, a tampon accidentally flung across the room while I retrieved a brush from my purse. On my mission in Peru, I once opened a care package from home in front of my Peruvian district leaders, only to find a sixth-month supply of tampons. I'd never seen elders disappear so quickly.

Embarrassing moments aside, periods were just part of the routine, a necessary nuisance hardly worth thinking about.

I'm serving Miranda apple slices and cheese after school. She has that worried look on her face again. My guess is that she has a question about something she learned at sixth-grade maturation, although she hasn't mentioned it since we attended it two weeks ago. I start the soup I'm making for dinner while she finishes her snack, figuring she'll confide in me when she's ready.

As she's finishing her last apple slice it finally comes out. "I'm worried I might be pregnant," she says.

I stop chopping celery and turn to face her, keeping my voice steady as I ask her why she thinks she might be pregnant. She tells me that her cousin Josie, who is one year older and in seventh grade, claimed last week that doing gymnastics causes pregnancy. As does ballroom dancing. "Trust me," Josie had said. "I know what I'm talking about. I've had health class."

"Mom, I'm taking gymnastics," Miranda says, tears welling.

I take a deep breath. Where to start? "Your body can't randomly decide to get pregnant," I say. "For one thing, you haven't even started having periods yet. And pregnancy has nothing to do with gymnastics or dancing. Something has to happen in order for you to get pregnant—it's something that happens between a man and a woman—and that won't happen until you grow up and get married" (knock on wood, I think). She raises one eyebrow and frowns; it's the same look she gave me when she was in second grade and I assured her Santa Claus is real. Only this time I'm telling the truth. I say, "It's time for us to have a talk. I'm going to explain how babies are made." She jumps up from the kitchen table. "No! I don't want to hear it! I don't want to talk about it! Please don't make me have that talk." She's crying and covering her ears. I sigh. I know I'm going to have to pin her down—literally—and have the sex talk soon. But not today, not like this. I walk over to her, pull her hands away from her ears, and tell her that we don't have to have the talk right now, but we will very soon. I tell her again that there is no way she is pregnant. "I really do know what I'm talking about," I say. "Trust me on this. I've had a lot more health classes than Josie has." She raises her eyebrow and gives me that look again. But then she shrugs and runs outside to practice her soccer moves.

Fertility: "The ability to produce offspring; power of reproduction."

I didn't marry until I was almost twenty-eight. Lying in bed with my husband, Scott, on our honeymoon, fan whirring overhead, I realized I had only been pretending at womanhood until now. I marveled at the way my body responded to Scott's as we plunged into the pleasures of kisses and caresses and skin touching skin. During those first few weeks of marriage I learned to inhabit my body anew, to appreciate my womanly curves and my new surges of desire. Now, menstruation took on renewed significance. Not only did it become part of the new intimacy my husband and I shared and a mystery for him to unravel, but my cycle was finally fulfilling its purpose. I began to understand in a way I hadn't before that periods were just a means to an end—and the end, if we were trying to get pregnant, was to not have a period. Three months after we got married I stopped taking the Pill. Four weeks later, after two weeks of wondering and waiting and trying to decipher my body's subtle messages—was I more thirsty than usual? Were my breasts more tender?—I waited for my period to start. The day it was due I checked my underwear periodically, and each time I found no brown streak, no red stain. My body, suddenly unfamiliar and inscrutable, seemed to be keeping its own secret.

That night my husband and I drove to the Newport Beach marina and slept on his parents' boat. We curled up together on the little top bunk and listened to the moaning of the jetty horn and the creaking of the boat as waves lapped against the hull and rocked us to sleep. The next morning we slept in and then I woke to a ravenous hunger—and still no period. We didn't eat breakfast until eleven a.m.; by that time I was shaky and weak. Was this ravenous hunger another indication of pregnancy? After we returned to our apartment I tried to focus on putting away laundry and doing research for my master's thesis, but all I could think about was the possibility of cells dividing, a tiny embryo nestling in the pillowy lining of my uterus—which, for the first time since I had started menstruating, seemed to be staying put. The absence of blood was now the miracle. I lay in bed that night unable to sleep, my pulse thrumming and my toes curled in excitement. The next morning I took Scott to the airport for a business trip and then drove to the pharmacy and bought a pregnancy test. I hurried home and, with shaking hands, tore open the test, urinated on the stick, and then set it on the toilet and stared at it while my heart thudded and skittered. Three minutes later I watched in amazement as a pink line slowly crept across the stick. And just like that I stepped off the edge of the world into a vast new one.

I went on to have a baby, and, over the next nine years, three more. Pregnancy introduced me to grueling nausea and neverending heartburn, to hemorrhoids and aching joints and restless sleep. Natural childbirth (one word: epidural), mastitis, hair loss, weight gain. But during each pregnancy I marveled as my uterus grew from the size of a peach to the size of a watermelon. I relished my babies' first fluttering movements—the

tiny pops that grew into jabs and kicks and hiccups and little feet tucked under my ribs—and loved rubbing my round, taut belly. Sleeping with a newborn on my chest while I cupped her little bottom and felt her back rise and fall with my breathing. Nursing my baby in the rocking chair, moonlight streaming through the window, while I listened to his rhythmic suckling and felt the tugging on my breast. Sticky, open-mouthed kisses and soft hands on my cheeks and stout little legs standing on my lap. I embraced it all.

Miranda was born when I was nearly thirty-eight, and, though I told myself that we still had time to have one more child, I knew she would probably be my last. I spent my hospital stay after her birth holding her, kissing her velvety head and inhaling her new-baby scent, only putting her down to use the bathroom. The night after she was born, I left her in her bassinette wrapped in her pink-and-blue-striped blanket while I went to the bathroom to change my soaked, industrial-sized pad—though this was my fourth birth, the amount of blood seeping from my newly empty womb still surprised me. My milk hadn't come in yet, but I knew that within a day or so I would feel the familiar tingling in my breasts, which would then be swollen and painful and leaky as my body adjusted to Miranda's nursing patterns. All the while I would be bleeding as my body shed the remnants of my pregnancy, and there would be tears as I tried to cope with sleepless nights and a colicky baby. Early postpartum was never my favorite stage. Still, as I put on a fresh pad and then ran my hands over my slack tummy, I realized I was already grieving its end.

It's been several days since Miranda's "pregnancy" scare. She's supposed to be working on her pyramid project for school but she's sitting on one of the barstools in the kitchen, talking on the phone to Nikenzie. She drops her voice to a whisper when I enter the room. I suspect she's talking about a boy. I don't know who he is, but I know there is one. Yesterday, as we were driving home from school, out of the blue Miranda asked, "Did you like a boy when you were my age?" "Yes," I said, "I did. His name was Paul Stapleton." I was impressed that I'd remembered his name. Miranda said, "It's so annoying! I don't want to like a boy, but ... ughh!"

I watch her now as she tucks her hair behind her ear and giggles. She still has braces on her teeth—she'll be getting them off in another year—and freckles are scattered over her nose and cheeks. Her long legs, clad in soccer shorts, dangle off the barstool, and her feet are now as big as mine. "I bet Christopher likes you," she's saying to Nikenzie. "He always sits next to you when we carpool, and he teases you the most." Yesterday morning she was playing with her Barbies; this evening she's giggling about a boy.

It's time for Miranda to shower and get ready for bed, so I tell her to hang up the phone. "Mom," she says, after she gets off the phone, "when can I start shaving my legs? Look at my leg hair; it's gross." She sticks out one of her legs and shows me the fine, dark hair on her shins. I have noticed the darkening of her leg hair over the past few months, and I guess it's time to teach her how to shave. I just bought her deodorant last week after

I caught a whiff of body odor when she got in the car after school. As we walk upstairs I make a mental list: razor, training bra—it looks like she'll be needing one soon—and pads to put in her bathroom drawer for when she starts her period. After Miranda gets out her nightgown and clean underwear, she walks into the bathroom and closes the door. It's been years since I bathed her, years since I rubbed shampoo into her hair and soaped her back and sponged her smooth little-girl skin with the Little Mermaid washcloth. Now she showers with the door locked and won't undress while I'm in her room.

I pull back the covers on her bed and leave the room.

Perimenopause: "The period around the onset of menopause that is often marked by various physical signs (such as hot flashes and menstrual irregularity)."

After I weaned Miranda, I was pretty sure I was done having children. Several years into my forties, however, I was still toying with the idea of having another child. Through my married life, as I moved through the cycles of pregnancy, birth, lactation, and renewed fertility, I had learned to read the signs of ovulation and the hormonal waning to menstruation. When I wasn't pregnant or nursing, I could count on my period to start every twenty-seven days. A day or two late and I'd be excited or worried, depending on whether I wanted to be pregnant or not. But now my periods had started to become irregular, sometimes starting a day or two late, once, a whole week late, and I could no longer gauge pregnancy from a missed period. My newly irregular cycle meant that every couple of months I rode a rollercoaster of terror, suspense, and irrational hope, followed by more terror. With each of my children I had gotten pregnant easily; the longest Scott and I had to try to get pregnant was four months. So the idea that my fertility was waning didn't take hold until a year or so into perimenopause. In the meantime, I had so many pregnancy scares and took so many pregnancy tests (sometimes sending Scott to the store late at night, insisting I couldn't sleep until I knew one way or the other), that Scott joked that I was single-handedly keeping Proctor and Gamble in business. I lost count of the number of times I stood in the bathroom, sweating and shaking, heart pounding in my ears, as I steeled myself to take a pregnancy test and then almost wept with giddy relief when no pink line appeared.

Along with irregular periods came the hot flashes: surges of heat that started at the back of my neck and then swept over my entire body, leaving me perspiring and clammy and my clothes damp. They occurred multiple times a day. And night sweats that woke me up in a blaze of heat and forced me to kick off my covers and rip off my T-shirt, only to wake up a half hour later, shivering, in cold, damp sheets with my hair plastered to my neck. When my friends and I got together we'd lament the unpredictability of our periods, the heavy bleeding when we did have a period, the hot flashes, the irritability and mood swings. "There's no way I can go to the temple today and wear a white dress,"

Judy said one day at lunch. "I just started my period, and no matter how much protection I wear, I'm bound to have an accident." Kathryn talked about the recent river-rafting trip she'd taken with her husband and teenage son and a group of ten strangers. "I hadn't had a period in eight months," Kathryn said, "so I didn't even think about bringing any tampons. Guess who started her period on the second day there?" She then went on to tell us about how she had to borrow washcloths and towels from the other river-rafters until the guide had tampons flown in on a helicopter with the next load of food and other supplies. I never left home without a tampon after that.

When I was forty-five, Scott had a vasectomy and I no longer monitored my periods so closely. It was no big deal to miss a month or two. Or four. And then I started to forget how long it had been.

> *Menopause: "The time in a woman's life when menstruation diminishes and ceases, usually between the ages of 45 and 50. Also called 'change of life.'"*

We just got home from church, and Miranda has run upstairs, crying. It seems that in Miranda's Primary class today Sister Paul talked about the law of chastity—nothing too graphic, I'm sure—and Miranda came undone. She managed to make it through the rest of class and sharing time, but as soon as we got in the car she started crying. This was after she told me this morning at breakfast that she's worried again that she might be pregnant. She's now sobbing in her room. This is it, I decide. I walk upstairs and open her bedroom door and sit on her bed. "It's time," I say. "It's long past time. We're going to talk about how a woman gets pregnant and you're going to hear this." She is crying, hands locked on her ears, and she is writhing—actually writhing!—on her bed. Somehow I manage to pull her onto my lap, pull her hands away from her ears, and force her arms to her sides. Now she's whimpering, her head resting on my shoulder. I say, "This is how a baby is made," and I tell her in one sentence—the bare facts, straight and direct, no fuss. She goes still. I look down at her face, expecting to see horror, but instead I see relief. The tears have stopped. I hug her and then I talk about God's plan and the beauty of intimacy— I've been rehearsing this for months—and when I leave her room she's smiling. Several minutes later she comes downstairs to play with her brother.

While my children put together a Star Wars puzzle, I lie on the couch and wait for another hot flash to end. My hot flashes have become more and more frequent, and now I know why. Last week, at a routine checkup, I mentioned to my doctor that it had been at least eight months since I'd last had a period, maybe nine. My mother had irregular periods until she was in her late fifties and I expected to do the same, so I hadn't thought much of my eight-month lapse. My doctor suggested I have a blood test to check my hormone levels. Two days later his nurse called to tell me I'm officially in menopause. And just like that, at forty-nine, my years of menstruating are over. Though I really feel

no different inside than I did when I was forty-two, or thirty-two—or fourteen, for that matter—I have changed in some essential way. The monthly reminder is gone, my fertility ebbed away to nothing, and I've come back to the beginning: no red monthly stain. And although I'm not exactly sorry to see my periods end, I'm mourning the loss of something.

Later that night, I'm tucking Miranda in at bedtime. Her hair is damp from her shower and she is wearing the new pajamas I bought her yesterday. In her drawer are some pads, tucked away for when she needs them. "Don't forget about my soccer game tomorrow," she says. "I won't forget," I say. Tomorrow I will watch her run on the soccer field, lithe and long-legged, her honey hair flying behind her, while the secret inside her just begins to unfold. I smooth her hair on the pillow. My almost-woman child.

"I still don't want to grow up," she says. On her face is worry again, a tinge of fear.

"Don't fret, daughter," I say, smiling, cupping her sweet face. If only I could show her what is in store. I kiss her forehead, breathe in her scent. "Trust me on this," I say. "Growing into a woman is a wonderful thing. Just you wait and see."

ICE CREAM WITH SUPERMAN AND KAFKA

JENNIFER QUIST

JULY 1996

On my brother-in-law's nineteenth birthday, he bought himself a present—a blue T-shirt with the Superman crest on it. Anyone can wear a shirt like that today but back then they were new and special. Everywhere he went, he ran. And when he dashed through the park, past a mom and her kids, it couldn't be left unspoken, unshouted. A stranger's child called after him: "Superman!"

JULY 2011

Days before his thirty-fifth birthday, Superman walked out on his wife and little daughters. She knew he wouldn't send us word himself, so she was the one to tell my husband and me, her final act on his behalf. The ranting paranoia, the suicide smock at the hospital—it'd been a difficult year. Smoky, weedy mid-life crises can burn out of control. His flared into a drug-induced quasi-schizophrenic psychotic disorder, rare but not unheard of, controversial but not incontrovertible. Don't tell me cannabis is a plaything, a punchline. For him it's a chemical burn to the brain, an inferno of voices and fear, panic, and the irony of love waxing cold in the heat. Do not begin to tell me.

SEPT 2014

There's been trouble with his ex-wife's new husband—the troll who calls Superman an addict in front of the little girls though he's clean from anything but psychiatric medication. It's an accusation denied with a death threat and a foot-chase. No one was hurt but it happened in the street and with enough noise and rage to be criminal.

NOV 2014

Today, a judge reads Superman's home address aloud and asks him to confirm it for the court—silence. Superman turns from the bench to the gallery, finds my face, asks me right on the public record, "Is that my address?" They give us forms to complete and send us away.

Out on the sidewalk, Superman says, "Everything's crap, Jenn." He holds back the swear, overestimating my dislike of it.

I tell him, "We need to get you a mental health disability pension so you won't get evicted and you can stop eating at that soup kitchen." I'm all paperwork and blue ink and, "Is Zyprexa spelled with a Z or an X?"

He can't stand the applications for long. "This is exhausting. I need to sleep." Instead, I buy him something sweet to drink and we walk it off. Superman chatters, laughs, reminisces about calling the ambulance last summer when he was sure his lower body parts were rotting away, laughs some more.

A freezing rain has fallen and everything we tread on is invisibly slick. He slips and I throw my arm behind him, as if I could catch him. He finds his feet and we laugh again because he's a foot taller than me, twice my weight. If Superman had really dropped into my arms, I would have been smashed to the asphalt.

The truth is I never liked comic books. And anyways, being with Superman reminds me not of comics but of the Kafka I've read. *Metamorphosis* comes to mind like a fable, a warning. It's a horror story about a man—a brother—who becomes a beetle, putrefies, and dries to a husk. I'm not thinking of the story's beetle-man but of the girl, the sister no one asks to be his caretaker who does it anyway. I'm remembering her offering him rotting fruit on a sheet of newspaper, or beating her small fists against a tabletop. I'm remembering her territorial cleaning and tending, the way she cordons off his neediness, hoarding it, heady with the power of her own charity.

I'm fairly certain the story-girl and I have different hearts. Fairly certain, but watchful all the same. Will I know when I've come to Kafka's tipping point where service becomes self-serving—where my love for the brother I share with my husband is corrupted by my love for myself?

JAN 2015

Superman has an appointment at the mental health clinic so I call to remind him. A phone company robot answers, telling me the number is no longer in service. I explain to the phone company humans. "He's my brother-in-law. He's mentally ill. Just tell me how much he owes."

The phone is back online and he still doesn't answer it. I drive through the dusty, frozen innards of the city, to his neighborhood where the meth-ladies stand on the corners. I rehearse it in my mind, this drama I've acted out before, one

generation higher in my family of in-laws prone to psychiatric self-destruction. I will stoop to knock on his basement apartment's window. I'll bring the building manager to force door. I'll step over whatever Kryptonite I find there and call his name into the quiet, like I called his father's name, ten years ago, when his father was alone in a filthy little room, sick so long he was dead.

Let him answer the knock. Let him answer the knock this time. Please, let him answer the knock.

Superman comes to the window, opens the door for me. I plug in the phone he's jostled out of its socket, telling him his mother paid the bill, even though it was us.

Since I couldn't call to wake him up, he missed the psychologist's appointment. He says, "I already walked over there to reschedule. They told me to bring you next time." It's not a request.

EARLY FEB 2015

The psychologist tells me everything—things I already know as well as new elements, like Superman's reports of grasshoppers and roaches the size of fat cats inside his apartment. I learn that psychoses are called "thought disorders" now. Everyone has thoughts.

"My worst fear for him," I tell the psychologist, folding my arms like I'm stern, "is that something will happen and he'll vanish on me."

We are meeting for the first time but the psychologist already knows me. I am ambivalence itself. I sit in his office with my coat on, my purse in my lap. He knows I am thanked for nothing and held accountable for everything. "Yes," he tells my brother-in-law. "You need to stay in touch. You're very lucky to have her."

Superman vocalizes, but without any words. We hate what we've heard. He doesn't want to need this kind of luck. And I don't want to need this kind of praise.

Roaches—it's so cold in this part of Canada true roaches are rare. The creatures we have in their place are just beetles. They are closer and larger than I knew.

LATE FEB 2015

We go back to the courthouse. Superman keeps opening doors for me. It's clunky and I smirk as I call it out, asking if he means to be sweet.

"No. You go through first, as a test."

The prosecutors won't accept the plea Superman offers. He starts to lose it at the courthouse counter, with the social workers and clerks. "Hon, it's okay. Don't bother arguing with these people. There's nothing they can do." We set a date to come back one more time.

He says, "I think I scared them. Did you see them backing off?" By now, he might be scary to strangers. There's hardly anything left of his clean, new Superman look. He's massive in size, long-haired, bearded, with heavy dark eyebrows. But I say, "They don't scare easily at the courthouse." No, especially not when a small woman stands next to him, using only her voice to hold him down.

I've reread the Kafka story, to be sure I remember it correctly. I do.

I take him back to the apartment building that keeps getting fumigated for normal, tiny insects. He sits in the basement dimness in his court clothes—not Superman but part Reno Nevada missionary in his short-sleeved white shirt, part itinerant prophet in his beard, my husband's suffering brother in everything else. It won't do. He's starting to cry so I take him away again, for ice cream, because I have nothing else.

He sits in the café booth, pleasant, telling me about the two-tailed comet heading earthward, flying through the galaxy in the shape of a dragon. It has a magnetic field so strong it will wipe our memories away if we don't protect ourselves with lead helmets. He's surprised I haven't heard of it. It must be on the news. We search "comet two tails dragon" on my phone but nothing matches it. He laughs and mocks the weird soup kitchen dude who told him that story.

I laugh along. "Well, what's a crazy-guy theory without metal helmets? It's classic, right?"

"Yeah, I should have known," he says.

I sit across the table from him, and in my mind, Kafka's story-girl and I press our hands together, like images on either side of a pane of mirror glass. Charity must be a paradox. How can anyone give with true unselfishness when charity repays so swiftly and utterly, though often obliquely and abstractly? How can anyone's goodness be pure of vanity and power?

My brother-in-law's world is darker and more terrifying than mine. It's a Kafka story only with high superhuman tension instead of morbid ennui. He fears and suspects everything. He'll pass through a door only if he's following me. What he trusts is me. And I worry I am greedy for it.

If the beetle's sister were really here at our café table, to be sitting opposite me she'd have to be beside my brother-in-law. And next to me, would be her beetle-man. He would smell like the dirty hallways of my brother-in-law's apartment building. There'd be an apple rotting in a hole broken into the beetle's shell. As a student, I wondered if the apple was a Biblical allusion—something about Eve and Original Sin, another fundamental misunderstanding of loss and love and what everything costs.

I blink in the café. Giant insects—beetles, roaches—they're thought disorders, horror stories, psychoses. They're fantasies. True charity should be a fantasy too. It should be a paradox. It should be fraught with sophisticated, double-bound anxiety, self-consciousness, complicated postmodern politics.

And if charity were simply an exchange of need and power between two people, it would be all of those things. There would be nothing to love and brotherhood but Superman and me swapping ice cream and rancid fruit across a sticky tabletop in a downtown restaurant. But there is a third party. In every human relationship there is always a third party. Before I read Kafka, I read that when I am in the service of my broken Superman, I am only in the service of that holy third party. He is the great upender of paradoxes, the purifier of corruptible love, what makes my rotten offerings acceptable, His own.

IN TRANSIT

GLADYS CLARK FARMER FETZER

On August 20, 2010, I stepped off a plane in Qingdao, China to a world unlike what I had ever experienced. My senses were attacked by rapid-fire, nasal sounds; unintelligible brightly-lettered signs; and pungent aromas. Although I was experiencing serious jet lag, I was wide-eyed!

Six of us BYU teachers assigned to Qingdao University squeezed together and hugged our suitcases as we rode from the airport to the college campus in a tiny van, one designed for the ordinary small Chinese citizen. Even though I had been accepted into the BYU China Teachers' Program almost a year earlier, my fourteen months of reading and one hundred hours of training on the BYU campus had barely prepared me to step into a culture so different from that of France in 1963 – 1965 or England in 2005 – 2007, where I had served previous missions. Asia had never even been on my radar screen, yet the Spirit had clearly directed me to apply for this opportunity to teach abroad, and here I was.

We were dropped off at the Foreign Students' Dormitory at the far end of Qingdao University and given keys to our rooms. The contents of three previous BYU-occupied apartments were crammed into two, which included fifteen years of accumulated materials. I realized that de-cluttering and deep cleaning would be one of my first goals.

The small bathroom was full of posted signs. I learned that I would need to flush the toilet twice, and hold the handle down extra long the second time. But there was a shower. And a tub! As I read the sign on the wall I realized that I would have hot water only from seven to nine a.m. and six to eight p.m. And the warm water might change to scalding hot or intense cold without warning! But I just smiled ruefully and remembered the two years I had spent in France as a sister missionary in the early 1960s. At that time, I had to climb down stairs and go outside to use an outhouse, or (in better conditions) walk down the hall and use a communal toilet. I had even taken showers at a public bathhouse. Things could be worse.

In reality, I had been doing hard things all of my life. It's 1954. I'm twelve years old. I had had three sets of front teeth: the second set was oddly formed, and by the time the final set emerged, all of my teeth were badly out of alignment. My far-sighted parents had heard about a procedure to have teeth straightened and had driven one hundred miles from our farm village of Georgetown, Idaho to Pocatello, Idaho to find an orthodontist. My new braces needed to be tightened every fourteen days, and it was a two-hour trip each way to get to Pocatello. Busy with farm work and family demands, my parents put

me on the Bear Lake Stage (a small commuter bus). I was painfully shy and the prospect of spending the day by myself in what seemed to me like a very a big city made my stomach churn.

On my first solo trip to Pocatello, I walked cautiously from the bus station to my orthodontist's office and then hurried straight back to the station. There, I sat in an uncomfortable wooden chair for five hours and read a book until the bus made its return route. The second week, I explored all the stores on the dentist's block and spent most of my day in Woolworth's, two buildings away from the dental office. After a month or so, I ventured far enough away to find the Public Library. Before the year was over, I found myself exploring the entire city. Gradually, I ventured a little farther each visit—but never beyond the level I felt I could handle. I ended that chapter of my life with straight teeth and a huge increase in my self-confidence.

Proceeding further in my Chinese apartment, I could see that the kitchen, too, was cramped. A small-load washing machine, a plastic sink, and a small counter with a scorched-looking hot plate and a miniature microwave oven were sandwiched around a gas stove that had a big warning sign announcing that it hadn't been used for several years.

In the bedroom I found a drying rack. I remembered hanging my wet clothes in London. A nearby note told me I could hang my sheets, etc., on the communal rooftop lines on clear, dry days. The kitchen tap gave out only cold water, but there were two large thermos jugs on a shelf and a note telling me that I could obtain hot water in the boiler room at the end of the hall. That water could be used for washing dishes and washing my clothes. Perhaps inconvenient, but there was nothing here I hadn't known before.

It's easier to live with the familiar. For three decades my husband and I had resided in Provo, Utah and would have been happy to have quietly spent the rest of our lives in that community. Then plans changed. In 2000 we took early retirement from our careers teaching at BYU, sold our second car and home of thirty-two years and traveled across the country to Boston, Massachusetts. Jim and I had never contemplated making a new home there. But when your oldest child, a single woman, is told by the Spirit to adopt, and she is led to the particular child she has seen in visions, you pay attention. And because you are very aware of the issues attached to children from Eastern European orphanages, you do whatever is necessary to preserve the sanity of your generous, though naïve, daughter and your new Roma granddaughter.

That move broke the mold! We weren't going to live and die in the house where we had raised our five children, comfortably surrounded by lifelong friends. The transition was both exhilarating and terrifying. A woman in church welcomed us with this advice: "Give yourself two years and keep a road map at your side." She wasn't kidding! Navigating the poorly marked, winding, tree-hidden streets of New England was one of the most stressful experiences of my life. I got shingles—a clear indication that my body was dealing with some unwelcome changes. I took everything in stride and came to call this four-year "grandparenting mission" some of the best years of my life.

Once we had made that big move, we were no longer afraid to try new locations. Four years later found us back in Utah, but this time living in downtown Salt Lake City. We had to adjust to another ward, make more new friends and learn the location of everything we wanted to buy. But we also had the excitement of exploration—finding a wonderful bakery, a chocolate store, an eclectic garden full of sculptures, a wonderful botanical garden, etc.

Within a year we moved to London, England and adjusted to life as a missionary couple. We were assigned to the Hyde Park Chapel in London, where Jim helped in the regional Family History Library, and I taught piano and organ lessons and hosted weekly lunchtime recitals. Jim's knees deteriorated during our eighteen-month stay, and six months after our return he sought knee replacement surgery. The operation went well, so he signed up for the second knee. His physical therapist for both procedures declared him to be the "poster boy" of knee replacement surgery.

To celebrate, in March of 2008 we took a Bach Country Tour with BYU organ professor Doug Bush, a trip where I had the thrill of playing twenty-three historic organs associated with Johann Sebastian Bach. On August 11, I was scheduled to play at one p.m. on yet another historic organ—the beautiful instrument in the LDS Conference Center. Jim had planned to come along in order to take pictures of me on the bench.

But I had another obligation first. At nine a.m., we kissed goodbye and I walked up the hill to play the organ for the funeral of a man twenty years Jim's senior. Ninety minutes later, as I descended that hill, I saw an ambulance in front of our condo. It was my own husband who was lying on the gurney. Jim had called 911 in my absence, apparently at the first sign of a stroke. His blood clot soon moved to the stem of his brain, and he died within twenty-four hours.

Suddenly I was facing life alone!

It was the greatest transition I have known and brought me to this moment here now, in China, staring down my new living quarters—a widow, and a stranger in a strange land.

I unpacked until about eight p.m. and fell asleep exhausted. At 2:30 a.m. I awoke with an ominous feeling. My mind filtered through what I had unpacked. The list did not include my cards with Chinese phrases, nor (most important) the adapter plug for my computer. Based on what I had heard at our Teacher Training, I believed that I couldn't use my Apple computer in China without that adapter. That thought struck at my heart. *Oh, no!* I gasped. The nearest Apple store was in Beijing, miles and miles away. I had lost my only connection to the outside world and I was suddenly a little child—vulnerable and helpless. I felt as alone as I had in decades, even more so than at the time of Jim's death.

At that moment I had a déjà vu. In my mind's eye, I was taken back to Angouleme, France. It was February of 1964. My senior companion had just finished her two years of service and was returning to the United States. For one week, there would be an odd number of sister missionaries in the field. Ordinarily the mission president would have

brought me into Paris along with my companion, and had me stay at the Mission Home until transfer time. For reasons perhaps unknown to either of us, my mission president trusted me and circumstances enough to leave me in Angouleme for a week alone. He advised that I should work in the daytime with sisters in the branch, or sit in on teaching meetings with the elders. He arranged for me to stay with the Roux family at night if I desired. I thought that I would try the first night alone to see if it felt comfortable.

I felt confident for the first three-quarters of a mile. But as I approached the apartment, it dawned upon me that the landlord was remodeling the bottom part of the apartment house and all the other occupants had recently moved out. In fact, Sister Kearl and I, on the third floor, were the only remaining tenants. The stairs seemed longer and longer as I ascended them in the semi-dark. I found my key, entered the empty apartment, and suddenly realized that I was all alone in a foreign country, with a minimal command of the language, and with the nearest member or missionary over a mile away.

Trepidation grew to panic. Why hadn't I stayed with the Roux family? What was I thinking, coming home alone? I fell on my knees, where my quiet weeping turned into deep, racking sobs. After a few minutes I felt a presence, a divine presence, envelop me and fill my body with warmth and light and love. I knelt there in amazement and gratitude at this seminal spiritual experience. I slept soundly that night and never again, during my entire mission, did I feel fear or loneliness.

At three-thirty in the morning in China, I once again burst into tears and pled for help and comfort. Peace once again filled my body. I arose from prayer and following the prompting I had received, searched for the third time through my suitcases. I found the adapter plug and the language cards tucked into a side pocket! With deep relief, I stayed up long enough to sweep the living room floor and hang a couple of pictures, rejoicing in the knowledge that I wasn't alone. With God at my side, this would be the experience I had hoped for.

The next morning I was happy to crawl off my two-inch mattress set atop some boards, and stretch my back with a morning walk. I saw what looked like a racetrack in the distance and headed that way. It was a straight shot from the dormitory, so I knew I could find my way back. Even though I was taking in brand-new sights of Chinese people gathered in the morning air—stretching, doing tai chi and martial arts—my mind was traveling back over my life and the many times and circumstances I had ventured out, making sure—at first—that I was tethered to my home base.

This pattern of slowly increasing my radius and pushing myself outside my comfort zone continued during my eleven months in China. Somehow being in a strange place flooded my mind with memories. The strange newness brought out so many past memories of walking down unfamiliar paths. Walking onto campus my first day of class, I thought both about my freshman debut at BYU and my first experience of college teaching. My Chinese freshman students were away from home for the first time and most were homesick and insecure—just as I was feeling as a newcomer to China. My empathy facilitated an immediate and beautiful bonding.

Transitions are painful, awkward, lonely, and hard. But doable. I learned that as a young girl in braces in a big-to-me city, now re-learning in this foreign campus and country. They just need to be taken a step at a time. My year in China revealed to me that life is really a process of recycling. We live out our days repeating situational patterns. My cumulative transitions, especially the painful ones, had prepared me well for my current one. Each new layer of experience made me a stronger and more courageous person.

I packed up my suitcase and bade goodbye to my Chinese students five years ago. My adventures didn't end there. Each difficult situation, each transition from one place to another, one person to another, has trained me for the thing ahead: a mission to the Washington DC temple in 2011; the assignment in 2012 to coordinate one hundred organists in the Salt Lake Temple; my 2015 marriage to a widower; the subsequent tripling of my family.

Now my current husband and I are looking toward a mission together. I will once again be in transit. It will be fascinating to see how our past experiences merge and strengthen us for these new, shared challenges.

HORIZON

DARLENE YOUNG

A girl puts her head on a boy's shoulder; they are driving west.
—Galway Kinnell

The cool tangerine sky.
Outside Wells, Nevada, a belt blows.
They have their whole lives ahead of them.

At the garage, the mechanic listens to classical music.
5 hours to kill in the killing heat.
She will have a bout with breast cancer at 58.

They walk around town, game for adventure.
Storage units, Check-n-Loan, acupuncture.
One of their children will break their hearts.

He could get a tattoo while she gets her nails done.
A boy throwing a rubber ball against the parking-lot barrier.
Dog pens in the trailer park.

Hardware store: drawer-pulls and doorbells. Beef jerky, car air fresheners.
He tries on cowboy hats.
At 72, he will begin his slide into Alzheimer's. She will brush his teeth.

Somewhere, someone is practicing a clarinet.
The mechanic offers them tomatoes from his garden.
They pull out at dusk, her hand out the window, arcing and diving.

The stars, the sage. They could be anywhere.
Their carpet will turn powdery and dank. There will be grandbabies.
The cool of the earth, tangerine.

HOW LONG?

(CHRONIC ILLNESS)

DARLENE YOUNG

I find myself Lehi, encamped in a tent.
It's pleasant enough here, with plenty to do.
Arise, retire.
Arise, retire.
Work and pray and dance.
Retire.

I could build a house here and let go the dream
of the swaying of camels, the saltwater lapping.

But I heard a voice—and its memory has me
stretching my neck at the dry desert wind.
Still I hear only whisper of sand and tent flapping.

Arise, retire, and I used to pray
at every new dawn, "Lord is it today?"
Arise and retire. I no longer ask
but remain in my tent. You know I'll obey.

I'll make it my work to arise and retire
and cling to the ghost of the voice in the fire.
But, Lord, there's the ocean.
And what shall I do with this lack of motion?

HUNGER

BROWNIES AND BOTTLED PEACHES

JESSIE CHRISTENSEN

Food was the one positive constant in my childhood home, where money, time, love, and stability were often scarce. I first began to cook when I was about nine years old, starting with basics like scrambled eggs and ramen, then moving on to something that would change my life: brownies. Baking was a revelation. When my parents spent all day in their room yelling at each other or when money for new school clothes didn't materialize, I could soothe my anxiety with a batch of warm, fudgy brownies. There wasn't any guesswork or disappointment involved—if I followed the directions I knew that the outcome would always be delicious. Fitting in at home and at school was hard; I could never figure out the right clothes, or words, or hobbies to earn respect from my siblings or attention from my mother, but I could cook. By the time I reached eighth grade I was regularly putting dinner on the table while my mom attended night classes at community college.

As I got older, cooking became a major part of my identity. I wowed my college roommates with homemade pies and bread. As a missionary, I baked cinnamon rolls and brownies for new friends, and in exchange they taught me how to make paella, empanadas, tortilla Española and papa a la huancaína. Both before and after my mission I cooked to impress dates; I half-jokingly told my roommates that they could know how much I liked a boy by whether or not I made him dinner. Once I made a dairy-free chocolate cake for a boy, apologizing that I had run out of milk a few days shy of payday. He showed up at my door an hour later with a half-gallon of milk for me, and my roommates all swooned. I had learned in my childhood that food made people happy, and cooking was the way to make myself irresistible

Ben was the first boy who cooked dinner for me. He and I had served in the same mission; we became friends after spending a number of months in the same district and kept in touch after we both came home. When I returned to Provo in May for spring term at BYU, he showed up on my doorstep the night I moved into my house, and came back the next morning to walk me to class. Although I tried to win his love with homemade manicotti and garlic bread, Ben didn't need me to cook for him; instead of sitting back and enjoying my culinary expertise, he returned the favor by cooking spaghetti and chili for me at his apartment. It was hard for me to let go and accept his love because I didn't

believe that I could be loved just for being myself, and not for doing something impressive and useful like cooking. But Ben was persistent and I eventually fell hard for him. After we had been dating seriously for about two months, Ben picked me up one evening and told me he wanted to take me to a new Italian restaurant. Instead, we drove to Kiwanis Park, where he surprised me with homemade lasagna and an engagement ring.

During our engagement and the early years of our marriage, we often talked about our future and how we would raise our family in a more egalitarian way, free from traditional gender roles and free from the dysfunctional parenting we had both experienced. Ben and I would each get part-time jobs and take turns being at home with the kids, and each would have a chance to be equally fulfilled by work and domestic duties. Two years after we got married, I gave birth to Sophie and we discovered that our theories didn't always stand up to the test of reality. Ben started a master's degree in English a few weeks after Sophie was born, as well as a part-time job, and I stayed home to nurse the baby, take care of cleaning and laundry, and study for the GRE. Ben did stay involved in parenting and housework as much as anyone can who is a grad student and sole provider, but I took over most of the cooking. Just as I had discovered during my childhood, feeding people made them happy, and I poured my love for Ben and Sophie into every meal I put on the table.

Even after I started a master's program the next year, I still continued to do most of the cooking. We had very little money so I cooked everything I could from scratch—yogurt, baby food, bread, soups, beans, cakes, muffins, granola bars, and jam. We were foodies before it was cool, simply out of the necessity of poverty. I didn't feel deprived at all when I savored a bowl of homemade yogurt topped with homemade granola and my own raspberry jam. I loved to bring dinner to my neighbors, and Ben and I often hosted parties in our home for friends and family, whom we stuffed full of homemade food.

In many ways, Ben and I seemed like the perfect picture of young married bliss as we took turns going to graduate school and caring for Sophie, then Timothy, born nearly three years later. We were really trying to convince ourselves that we were normal and that we could have a functional, happy family, even though I'm not sure either of us believed it. When Ben savored a plate of creamy chicken pot pie topped with fluffy homemade biscuits that I proudly dished up for him, it was easier to forget about the gay porn I kept finding on the computer, the lengthy chat sessions Ben had with a friend (after telling me he was tired and didn't feel like talking), and the fact that he was only still going to church to make me happy and could barely sit through sacrament meeting.

When Timothy was four months old, we moved from Utah to Seattle for Ben to attend graduate school. Timothy had come early by emergency C-section in late May, and the rest of the summer months leading up to our September move had been difficult. Ben had worked two part-time jobs to save money for school, and I'd spent the days in a hot apartment with a cranky three-year-old and a colicky baby who would not sleep. By the time we reached Seattle I was worn thin with anxiety. One Sunday morning in early December, Timothy was napping and Sophie was busy playing, so I decided to make

homemade turkey soup while Ben was at work. For six months I had treasured the memory of a postpartum gift of homemade chicken soup filled with fat, chewy noodles nestling in rich broth, and wanted to recreate that meal to brighten our dark little apartment.

Just as I finished cutting up the noodles and arranging them to dry on the counter, I heard Timothy waking up. I spent a few minutes in the bedroom comforting him, then stepped back out to check on Sophie. "Mama, I helped!" she chirped at me from the kitchen. She had rolled all the noodles back up into a giant ball of dough. Her smile slipped as I drew in a sharp breath and reached for the rolling pin, the urge to hit something flashing through my mind. Instead, I grabbed her roughly by the arm and dragged her to the bedroom, unsure of what I was going to do next. She started to cry and wet her pants—which shocked me enough to let her go and run to the safety of our small laundry room. Ben came home a short time later to find two soggy children crying in the bedroom and one tearful wife hiding in the dark next to the washing machine. We didn't really speak about what happened; he just helped me clean everything up so we could get ready and go to church. I threw away the dough and put some store-bought egg noodles in the soup later that night.

I went through the motions at church that afternoon, stiff with shame and fear that someone would find out what a horrible person I was. My bishop noticed at some point and pulled me into his office, where I broke down crying and shared some of my fears and anxieties about Ben's withdrawal from the Church and from me (but said nothing about the noodle incident). He had spent several years already as bishop of a large ward with many young student families and had seen similar situations before. I left his office with a recommendation for a counselor; within a month Ben and I were seated in his office trying to sort out our marriage. After only a few sessions, the counselor asked if we had ever considered divorce, given Ben's homosexuality and our increasingly divergent views on religion. I stared numbly out the window at the rain, while Ben smiled and let out a big sigh of relief. Within a month he had moved into his own apartment and I was looking for jobs.

We still ate dinner together once a week in an attempt to maintain some sense of normalcy for Sophie and Timothy. When my birthday came two months into our separation, Ben cooked me steak and mashed potatoes with bacon for dinner at his apartment. He had tried new recipes from Rachael Ray, but I thought the steak was a little tough and the potatoes greasy. After years of doing all the cooking, I found it hard to appreciate his efforts. Timothy's first birthday came a few weeks after that and we had an extremely awkward dinner party together with friends. One of my reasons for inviting Ben was my desire to make chicken and vegetable kebabs, and I wasn't sure how to work our little charcoal grill. He mostly stayed out on the patio keeping an eye on the chicken and avoiding the rest of us. Eight hundred square feet was not enough to comfortably contain two separated spouses, five mutual friends, and several small children, no matter how delicious the homemade chocolate cupcakes were.

In mid-June, after a dinner of garlicky black beans and rice at my place, Ben washed the dishes and helped me get the kids in bed. He told me he missed me and that he wanted us to get back together. I missed him too, and I had been unable to find a job; when I prayed about the situation, I got a strong feeling that the decision was mine to make. Ben moved back in shortly after that, and our second year in Seattle was much better than our first. I got a job teaching evening classes at a local community college, so during the day I would prepare lesson plans and cook food for dinner. Ben would come home in time for me to leave to go teach; I would hand off the kids and the dinner menu, and while I was gone he would feed the kids and put them in bed. I signed up for organic produce delivery and began making yogurt again. Ben never came back to church, but he had come back to me, and the four of us sitting around the table together felt like home.

The next year we moved to Davis, California so I could start a PhD program. Ben worked part-time online and helped care for the kids when I was in class. We rode our bikes to the farmer's market each Saturday and loaded our bike trailer with local produce. In between reading novels and writing papers, I found time to make jam, bake bread, and perfect a recipe for homemade veggie burgers. We loved living in Davis—Ben and I both eagerly embraced the liberal political scene and local food culture, and our family life was balanced nicely with both of us having time to work and to care for the kids.

However, after a year I decided that I didn't want a PhD and that I was tired of being in school. Ben agreed with me and suggested that we move back to Utah to be closer to our families. A little less than year later, Ben had been promoted to full-time, we had bought a house, and I had given birth to Phoebe. After her birth and Ben's promotion, I settled even more fully into being a full-time homemaker. I enthusiastically cooked three meals a day for all of us, and worked on filling up the food storage room in our basement with bottled peaches and jam.

The next February, Ben was out of town for a work conference the week of Phoebe's first birthday. I had baked vanilla cupcakes and invited my sister-in-law over to celebrate with us. Since Ben had not called yet that day, I called him instead. He was distant and rushed on the phone. There was a party and it was hard for him to hear me. He needed to get back. He'd see us in a few days. After hanging up the phone, I could barely finish my cupcake as my jaw tightened with fear that something was wrong. When I picked Ben up at the airport three days later he wouldn't look me in the eye. He hadn't missed us at all while he was gone. In fact, he wanted a divorce. I was stunned—after years of struggle I thought we had finally arrived at happiness. We had a home, he had a good job, and we ate regular meals and took vacations together. It turned out that getting everything we thought we had wanted still wasn't enough to make Ben happy.

We divorced. I went back to work full time, and everything changed. Breakfast became a meager meal of cold cereal before rushing the kids out the door. Most of my efforts at feeding my children home-cooked food gradually fell by the wayside. I worried that our new diet of quick fare like grilled cheese sandwiches and orange chicken from

the freezer section meant I was depriving my children of love and affection as well as vital nutrients, but they didn't care much about the menu.

About a year after the divorce was finalized, I decided to bottle peaches. I bought a twenty-pound box of fruit on Saturday while I was running my other errands, but then realized that they needed a few more days to ripen. I thought I could process them one night after the kids were in bed, but on Monday I had to work late. Tuesday night when I started getting my canning supplies out I realized that I was out of lids for the jars. Wednesday night I stopped by a store during my thin sliver of time after work to look for lids, and they were out. By Thursday morning my kitchen was filled with the lush aroma of ripe peaches; I stuffed the box in the fridge and crossed my fingers that they would not be spoiled by the time I got my supplies together. That evening I was able to quickly visit a different store for lids while Sophie was at her piano lesson. By the time I got the kids in bed and everyone settled for the night, it was nearly nine o'clock and I was too exhausted to process peaches. Finally, on Friday night, the kids were at Ben's house and I spent a meditative two hours quickly slicing, peeling and boiling peaches until I had nine beautiful jars lined up on the counter.

When we first opened one of those jars few months later, I thought about the time and effort that had gone into canning them and nearly burst into tears. The kids obliviously slurped down the tender orange fruit while I lingered over my bowl. I savored each juicy slice, plump and sweet after marinating in syrup for several months. Peaches may not have been my children's love language, but in that moment I realized that they were mine. I knew that the next fall I would spend my precious time canning peaches, because I love them, and that love is enough.

PHOTOCOPY WARMTH
AND
FORTUNE COOKIE
MEMORIES

TERESA TL BRUCE

I was engulfed in an "it's been a year" funk after enduring the terrains of widowed firsts. The bittersweet peaks required climbing—donating his clothes to charity, attending funerals with deepened empathy, celebrating my silver wedding anniversary as a forty-five-year-old widow, and publishing writing my husband would never read. I stumbled through the valleys—holes in holiday traditions, omitted birthday celebrations, and incomplete family gatherings. The switchback pathways—between two decades as a stay-at-home mom and single parenting while switching careers—undulated as fast as the unpredictable waves grief was so frequently likened to.

An incident from four months into widowhood illustrated how profoundly I was affected. Until a friend pointed out a significant leak in the corner of the guest room, I hadn't heard the falling drops of water (or chunks of ceiling plaster) landing on the floor; I hadn't seen the trickle streaming down the wall. After the roof was repaired and the room repainted, I moved myself into the "new" bedroom, hoping the change might help me begin sleeping more than the three to four hours I'd managed on "good" nights since his death. After the switch, I entered our—my—old bedroom only rarely to vacuum (if I remembered) or to change bedding for infrequent guests.

I'd been told that once I got through the first year I would feel better. I'd hoped going through the motions of "fake it till I make it" would return me to feeling more like myself in time. But crossing the one-year threshold didn't mean I no longer grieved for my husband. Now eight days past the first anniversary of his unexpected death, it was also the sixteenth anniversary of my mom's. I still missed her after sixteen years, so why shouldn't I miss the father of my children? My mourning for her had softened over time, burnished to a deep pressure rather than a piercing stab within every thought of her, yet I foresaw no end to the anguish of raw bereavement I felt over my husband's daily absence.

My spirits hovered underfoot, tripping bereavement triggers everywhere I turned. It felt as debilitating, every bit as difficult as the thick blanketings of "widowed fog" which frequently shrouded my perceptions throughout the previous year. That day I awakened despondent, lower than at any time in the previous year. Pleading for strength to leave bed, I prayed, "Father, help me. Let me trust I won't always feel this way. Assure me I won't always be alone. Please, help me look forward."

Out of habit more than will, I got up (still dressed in yesterday's clothes I'd eventually fallen asleep wearing), took my daughter to school, and stepped back inside our empty house. My feet took me, for the first time in weeks, straight into the room I'd shared with my husband. I didn't think about it; I just entered and sat on the side of the bed. I stared, first without focusing, at the eye-level shelf and absently reached for a dusty stack of picture frames. On the top sat a photocopied collage Mom made when I was a preteen. At a beachside family reunion she'd taken snapshots of everyone, then artfully arranged them and sent copies to all. Over the years, cousins from three generations remarked on their enjoyment of the same image in each other's homes. Now, on the anniversary of Mom's death, nostalgic warmth washed over me as I studied smiling faces of extended family, several of whom had also passed on. It was almost like feeling her arm around my shoulder the way she'd reassured me when I was young, saying, "It'll be okay," as much by her gesture as with her words.

My melancholy softened as I returned the collage to its shelf. Beside it I noticed the closet door. "Huh," I said aloud, though no one else was present. It had been so long since I'd spent time in the bedroom that I'd forgotten it was there. My hand left the shelf and reached for the doorknob. I turned it, pulled it, and peered inside.

My mouth opened, but I said nothing.

The closet was bare, except for one item.

After the roof repair I'd moved my clothing with me into the former spare room. Earlier I'd packed away a few of my husband's favorite shirts (to save for our daughters) and sent the rest of his clothes to Goodwill.

Or so I'd thought.

In the closet hung a nearly new, barely used suit in a blue-gray hue that made my heart pound at the glow it brought out in his gorgeous eyes. I'd forgotten he ever owned it. I couldn't recall when last he'd worn it.

"How did I miss this?"

I stood and pulled it from the otherwise empty rack, sniffing deeply, hoping to catch a whiff of him, but he'd worn it so seldom and so long ago there was nothing of his essence left. For a moment I hugged the coat to me, letting the shoulders flop down over my arms like a tailored muff.

But only for a moment. As comforting as the action felt to my arms, my soul knew the garment was empty and I needed to let it go. "Someone else can use this," I said. I set the coat on the bed and picked up the pants, sweeping through the motions of fastening closures and checking pockets. I'd donate the suit as soon as possible.

The pants lay folded and I'd checked all but one pocket on the suit coat. I slipped my fingers deep into the breast pocket, the one he wore over his heart, and crinkled my brow at the unexpected texture. I pulled out two tight coils of paper less than half an inch tall. They reminded me of quilled paper crafts my grandmother and her sisters created way back when. Curious, I unfurled one, then the other.

My knees weakened and I sat. I wondered how long ago he'd tucked away these fortune cookie messages for me to find today, when I had pleaded for affirmation that brightness would replace bleakness in days to come.

The first strip said, "To be loved, be lovable."

The second said, "Time heals all wounds. Keep your chin up."

I lifted my eyes and spoke again, but this time not to myself. "Thank you."

The life-changing answer to my morning prayer hadn't been sung by a heavenly choir or even whispered in the quiet of my heart. It wasn't spoken at all, but delivered via a faded picture and two unassuming, curled strips of narrow paper.

THE MARRIAGE BED

SHELAH MASTNY MINER

When my sister got married three years ago, I took my sisterly duties seriously. I bought her a nice gift. I listened to my mom vent so Jilly didn't have to. I hauled my seven-months-pregnant self to the bridal shop to try on a shiny brown dress and wore it at the reception with a smile on my face. As an older, long-married, experienced sister, I gave counsel: "My best advice about how to keep the spark in your sex life can be boiled down to three words: Don't have kids."

If my advice to my sister sounds too misanthropic, maybe I should rephrase: "Don't have kids in bed with you." I'm all for the family bed, but if anyone who tells you that it doesn't take a toll on the sex life either has kids who sleep far more deeply than mine do, or else they're lying. For most of the last ten years, we've woken up in the morning with at least one additional person our bed, and it doesn't feel like a sexy, fun zone when it's invaded each night by rogue agents wearing overflowing PullUps and Dora the Explorer pajamas.

Earlier this summer, I sat at the desk in my bedroom late one afternoon, trying to write. It was hard to pinpoint what was derailing my train of thought. Was it the Super Mario Super Show playing in the background, or Isaac and Maren chasing each other around the room? Eventually I sat, not typing, and pinpointed the source of my irritation: "Bryce, stop jumping on the bed. I can't concentrate with all of that squeaking."

"I know. It's loud," ten-year-old Bryce said. "It's always hard for me to fall asleep when you and dad have sex." He giggled and looked me in the eye, then glanced at his little brother and sister, now engrossed in Mario and Luigi. I knew he was challenging me. I looked around to see if the other kids had heard, but they seemed oblivious. Seasoned by a decade of motherhood, I thought fast: "How do you know we're not in here jumping on the bed?" I played it cool, but my face burned and I couldn't talk without stuttering. He started jumping again. He wanted to talk about it, but I most certainly did not.

Bryce is ten. Not a particularly self-aware ten. I spent the last year as his Cub Scout leader, and I know he's not the kind of kid who leads the playground discussions about boobs, or even participates in them. While the other kids his age explore "going together" and holding hands, he's by himself on the swings, imagining how he'll defeat the next boss on Donkey Kong. Yet even he knew that his dad and I didn't tuck him in, lock our door, and start jumping on the bed.

As parents, Ed and I have never shied away from telling our kids how babies are made. Ed's a doctor and, if anything, we've probably erred on the side of telling them too much about the mechanics. But we've always talked about sex in generic terms: "When two people love each other, they get married. Once they're married they want to have babies. In order to make a baby a man puts his ... " Replace those abstract parents with "Mom and Dad," with us, and I start to squirm. I don't mind Bryce knowing that mommies and daddies have sex to make babies, but I do find it hard to get in the mood when I know he's lying awake across the hall, listening to us.

I never anticipated that motherhood and inhibition would arrive hand in hand. I was the paradoxical Mormon exhibitionist who streaked for the crowd at my eleventh birthday party, who got called in to talk with church leaders after mooning the boys' minivan as we caravanned to a teen youth conference, who never gave skinny dipping a second thought, even in mixed company. When Ed and I got married, after four years of dating and agonizing delayed gratification, having sex became our favorite pastime. We soon realized that homework, making dinner, going to church, reading, picking up my mom at the airport, and watching NBA finals games could all wait half an hour, or even five minutes. The honeymoon ended when Bryce arrived three years into our marriage, and suddenly we couldn't just drop everything and have sex. He wasn't the kind of baby who would be content in his bouncy chair while his parents snuck off to the bedroom. Once Bryce was finally asleep, I became aware of my flabby stomach and dripping breasts, and we were both so tired. I started making excuses, wearing flannel nightgowns and reading myself to sleep before Ed got to bed. We still had sex with predictable frequency, but it was mentally penciled in at the end of the day, after the counters were wiped and the house alarm set.

Ed and I have owned three houses. We bought our first, in Rochester, Minnesota, when Bryce was two and Annie was a newborn. In Minnesota, the kinds of houses medical interns with children and student loans can afford are split-levels and raised ranches. I didn't want to move to a house where I'd have to exile one of my babies to the basement. How could I choose which one to send to sleep with the monsters living behind the furnace? After a long morning with the realtor, rejecting everything in our price range, we found our house: dark brown exterior, brown walls, brown kitchen cabinets and countertops, a brown wood-paneled basement, brown carpet, a dangerously sloping back yard, and three miniature bedrooms all squashed together on the upper level.

When the timing worked out, when Ed was home and still awake by the time the kids fell asleep, we had sex without worrying whether or not they could hear us—even if they could, they'd forget by morning, we reasoned. Or we'd just blame the sounds on the woodpecker who lived in our bedroom wall. When Ed was gone, I sat on the bed, grading papers and watching *Grey's Anatomy*, where the doctors were always horny,

even after a thirty-six-hour shift. In February, when Ed was rotating in the outpatient clinic and was home most nights, we conceived Isaac. Isaac was a baby when residency ended, and my mom and I took him to Houston that spring to shop for another house. Ed stayed in Minnesota and prescribed Viagra for the patients on his geriatrics service.

True to the adage, everything was bigger in Texas, most especially the houses, and I quickly learned the preferred regional floor plan of the budget home: master bedroom downstairs, three bedrooms and a game room up. "I can't imagine climbing up a flight of stairs to get Isaac every time he wants to nurse," I said to my mom, "and Annie stumbles into our bed almost every night. What if she falls down the stairs when she's looking for us?"

While I knew that nearly everyone in our price range slept at night knowing that their kids were a whole flight of stairs away, I didn't stop looking until I found a house with all of the bedrooms upstairs. I fretted as I weighed my options— "The kids' rooms are close to each other, but there's this big hallway between their rooms and ours. What if they trip on their way to me?"

"Shelah, it's twenty feet. Maybe a little bit of privacy isn't such a bad thing," my mom said.

It was true that I was eager for a break from Annie using my neck as her transitional object, stroking my wattles until she fell asleep. But I feared that putting some physical distance between the kids and me would show, on a symbolic level, that I was getting tired of the sacrifices that went into being their mother.

Despite the fact that I slept less than twenty feet from my parents for most of my childhood, I can never remember hearing unusual squeaks, sighs, or (God forbid) moans coming from their bedroom. I certainly never walked in on them in the act. Evenings at my childhood home usually ended with my dad falling asleep on the loveseat in the living room while watching *The Cosby Show*. Eventually my mom would poke him, "Rick, come on up to bed." They rarely kissed or cuddled; I don't think I've ever seen him pinch her butt or grab her for a quick fondle while they did the dishes. I like to think of my parents as essentially friendly roommates who enjoy one another's company; I know they must have had sex at least three times, but I don't want to think about their sex life. It disturbs me to know that our squeaky bed and our own inability to keep it down has forced my ten-year-old to confront the reality that his parents have sex and like sex, when I can still live under a haze of innocence because my parents have been more circumspect.

Although my dad fell asleep most nights in the living room, my parents did share a bed. My best friend Liz's didn't. The first time I passed through their dark bedroom on an expedition up to the attic, I noticed that the beds were unmade. Yes, beds. I was five at the time, so I asked without hesitation, "Why don't your parents sleep in the same bed?" "They do," Liz answered. And while it was true that the beds were pushed

together and had matching sheets and blankets, they were still, in fact, two separate beds. At five, I didn't know anything about sex, didn't understand why mommies and daddies shared beds, but it felt instinctively wrong that Mr. and Mrs. Bond each had their own mattresses, sheets, and blankets. When we were about twelve, we went into their bedroom to scrounge for dimes and quarters to buy candy bars, and Liz saw me glance a little too long in the direction of the beds. She volunteered that her dad had a bad back. But by then the beds were no longer pushed together. The two youngest kids in Liz's family were adopted, and once I got old enough, I always associated the adoptions with the image of Bob and Joy Bond, sleeping chaste and celibate in their twin beds.

My parents did a relatively good job of providing us with a sexual education that was consistent with their undemonstrative manner. One day when I was nine or ten, Peter Mayle's *Where Did I Come From?* mysteriously appeared on my bookshelf. I read it and was horrified. Then I read it again and couldn't stop laughing at the illustrations of the tuxedoed sperm saying, "Who can resist a sperm like this?" and the naked, rotund mom and dad smooching in a bed with the caption, "Here is where babies are made" and the description of orgasm as similar to a tickle in your nose and a big sneeze. I wasn't sure what I was supposed to do with this information. Should I talk to my mom about the book? Inconceivable.

Instead, I went down the hall to my little brother's room, and showed it to him. He may have been too little to understand the mechanics, but he was old enough to know it was funny. We hid it on his bookshelf (where it would be less likely to be intercepted, just in case I had received it by accident), but we sat together on his bedroom floor on many winter afternoons and giggled. It was gross, and funny, and we would certainly never want to experience the gigantic, disgusting, boogery sneeze Mayle described, would we? Even if it felt really good? My brother must have decided it sounded intriguing—he went on to have five children before his eighth wedding anniversary. My pace was a little slower—Ed and I had four kids in the first nine years of our marriage.

Though I crave privacy as a parent, there are times when I also want my children to share the intimacy of my bed. When Isaac was three, he woke up one morning, feverish and unable to walk. I called the doctor, who told me to take him directly to the children's hospital downtown. Isaac spent several weeks in the hospital with osteomyelitis, a life-threatening infection in his femur, and had multiple surgeries. After he came home, we had to wake up to give him IV antibiotics in the night, so we put him in bed with us. He could have slept in a sleeping bag on the floor, but I wanted to hold him close, to let the heavens know that I wasn't ready for them to take him. After six weeks off his feet, he slowly started walking again, and his femur spontaneously crumbled in the spot where it had been drained of infection. He spent

the next two months in a cast from his chest to his toes, and he was afraid to sleep in his room, where he was anxious we might not hear him if he called out in the night.

During those months, with his body heat absorbed by the cast, his spot in our bed stayed eerily cold. Once he was freed from his prison and sent back to his bedroom, I didn't miss his fecal stink or the mountain of his cast separating Ed and me, but I missed being Isaac's protector. I lay in bed, arms and legs outstretched, clean, crisp sheets surrounding me, and resisted the urge to climb into his twin bed down the hall and curl myself around him. I stayed in bed and Ed and I reclaimed our private spaces, with all the rights and privileges.

Last summer, with Ed's medical training finished, the children in our family made, born, and weaned, we moved to Salt Lake City. One of the first things we discovered was that our master bedroom door didn't lock. Three of the four kids walked in on us having sex during the first month we lived here. I flew under the sheets when Isaac opened the door, and made Ed put him back in bed. Bryce closed the door silently and knowingly and went back to his room without a word. Annie just knocked and knocked, stopping only when I got up and answered her question. Also, it was a new house, so it had no shades or window treatments. The five large windows in our bedroom look out over the pool of our neighbor, a single guy who has pool parties at his house three or four nights a week. We spent the summer getting to know the bedroom by feel, afraid to turn on the lights. As a transplant unschooled in the ways of Utah culture, I wasn't sure if it would be more scandalous for the boys next door to see me naked or parading around in my garments. Long gone was the girl who mooned the van full of boys on our way to youth conference.

We fixed the lock and saved up for shades. After years of sleeping in the least-likely-to-be-pretty space in the house, I overhauled the bedroom. We got new dressers, new nightstands, a big fancy TV, Egyptian-cotton sheets, and a mattress without thirteen years of his-and-hers indentations. The room looked perfect, but the new bed, which sits right over the family room, squeaked. We stopped having quickies in the middle of the day when the kids were awake and hoped nobody noticed at night. When we had adult houseguests, Ed and I experimented with using the closet, but I ended up with carpet burns. We thought about trying out the back seat of the minivan, but we're thirty-five, not fifteen. It felt wrong to be sneaking around.

A visitor to this essay from another time, or even a reader from 2012 living in a different part of the world, probably wouldn't understand the way that, in my mind, married sex and privacy are inextricably bound. Last summer I visited an old dugout cabin on the Minnesota prairie, where a family of eight shared a room smaller than my current bedroom, a space that served as kitchen, living room, and bedroom for the

whole clan. Extended families in India, Malaysia, and sub-Saharan Africa share sleeping spaces, and they manage to engage in marital recreation and still look their children in the eyes over breakfast. They don't need a locked door, a space set apart. Why do I?

Linda Sillitoe's 1979 poem "Song of Creation" shows our Heavenly Parents engaged in the act of creating the world. Mormon feminists praise the imagery of Heavenly Father and Mother working in partnership with one another. Yet the closing lines read:

> *"And if you live long, my child,*
> *you'll see snow burst*
> *from thunderclouds*
> *and lightning in the snow;*
> *listen to Mother and Father laughing,*
> *listen to Mother and Father laughing*
> *behind the locked door."*

I guess if I've come to adulthood in a culture where even gods engage in creation behind locked doors, then it's also one that values privacy. There are many things that a guy and a girl unwittingly give up when they make a baby, but the lack of privacy was one of the biggest surprises. As a teenager, I could strip naked and run around the beach, then retreat to my own bedroom to read and think and sleep. Even as a newlywed, I could find private space in our small apartment. If I headed into the bedroom to read a book, Ed wouldn't follow me begging for grape juice or co-opt the bedroom TV to watch cartoons. After I've nursed, bounced, carried, cuddled, and cajoled all day long, it's often hard to want more touching, even if it's the good kind. Add a squeaky bed, a door that doesn't lock, or a curious preadolescent to the mix and it can become a recipe for married celibacy.

We've been together long enough by now that we know the freckles, wrinkles, and lumps of each other's bodies as well as we know our own. We're not having babies anymore. So if we're not having sex for novelty or procreation, why not surrender to celibacy? Why do we find ourselves at it, whispering our love to each other with the TV turned up loud and the door barricaded? He still thrills me, but in a different way he did when we were eighteen-year-olds making out or clueless twenty-two-year-old newlyweds figuring out the mechanics of making ourselves as one. Our twenty-two-year-old selves would be horrified if they knew that in little more than a decade, they'd be reduced to whispering behind the locked and barricaded bedroom door, and then only on nights when call at the hospital, science fair projects, and exciting Jazz games don't claim our attention instead. But they also might not appreciate how happy I get when I hear Ed's car pull up in the driveway on the middle of a Wednesday morning when all the kids are in school and we can slough off our roles as Mom and Dad along with our clothes.

Three years into their marriage, Jilly and her husband haven't started their family yet. I hope it's not because of my advice. I'm not quite as jaded as I was three years ago; I'm getting more sleep now than I was back then, even if I'm usually spooning Maren instead of Ed. If my sister asked for advice today, I probably wouldn't tell her "Don't have kids," but rather "Don't give up." We didn't; when Ed got home from work on the day of my little chat with Bryce, we pulled the mattress off its frame and spent the evening screwing, or rather, tightening the screws.

THEIR NAME IS VIOLET

SANDRA CLARK JERGENSEN

My grandfather's mother died before he knew her name. He was two, she was so sick so soon, scarcely able to hold him, and she was gone. Cancer confined her away from her two young sons, treatments took her away from their presence, and when she returned to them they didn't remember her at all. Hurt hurtled through her breasts, failing tissues and carrying memories of her little family: the hope that had held her up. The baby she knew didn't know her as his mother. Her children didn't get the chance to know her, or their children or theirs. Mine too.

Somehow still in the years and states of being that separate us, I know she knows me. And to my wonder and befuddlement, she knows my children too. I can't even say the same.

Her name was Violet.

Two weeks into the rush of new routine of a new baby, I'm rocking myself in the glider. Skin sore, singing with the suction of the baby girl suckling my breast, vigorously siphoning liquid life support from me, I'm vividly aware we are both alive. Overwhelmed at the shock of her copper hair, my return to my sensibility now that I'm past this mood-altering pregnancy fog and the constant reality of our new lives, I stumble into prayer. *Dear God in Heaven, Thank you for this beautiful daughter.* But the task of getting her here, the steady shocks of sciatica and nausea, the shift of my body and my self into something unfamiliar, something so uncomfortable, someone so much more taciturn and tired—so taut to the feeling I was out of flesh and ability—has been more than I can bear. I am spent. I'm sated with this baby now. Resolutely, I pray on in announcement, *I'm done. I need to be.*

I pause, daring for response.

My prayer was not an order, but offering; I had given all I knew of my body and being to this small family we created. As my daughter continued the long, slow draw of my breast, hopefully, wearily I ask, *Is this enough?* I don't know that I could commit again. *Let this be enough*, I daringly implore. I'm salty but serious, so heavy exhausted in humor and hope that I dare gamble my tired self with God. Though wishfully spoken, the intonation is charged by emotional need and sleepless delirium swirling all humor, frustration, ache, anticipation, and enervation into this confused yet concentrated call.

I was committed to having that daughter I held in my arms. I had seen her before: She came to me wrapped in a dream so many years before my arms ever knew the weight of my own children. Her orange-gold locks glinted in the sunlight, bouncing as she ran beside her older brother with tufted yellow hair. These two children that looked like mine then, were now. I was satisfied, and thankful for them and to know I was done. Weren't we now complete?

The wait to have a child and gestating one felt like years of caving: crawling through dark unending passageways, sometimes with brief reprieves, but then into another wormhole. Claustrophobia inside the tight quarters of my own stretched skin came from carrying a child that I wanted. Hormones that kept the baby thriving conversely caged me, shrinking my good humor and demeanor. Nine months ill. Clamoring on and on. I was so, so spent carrying the weight of another. Tired of unending nausea, so weary of being the worst version of myself.

I didn't realize I was depressed until I surfaced. The work of labor was so welcome. The baby left my body and I regained my own. Bringing forth a child hadn't caused me to do anything egregious—and that pink baby with carrot-colored fuzz in my arms was everything—but the burden of body getting from point A to point B became evident in the bewildering, immediate lift I felt as soon as it ended. I didn't want to and couldn't bear the climb back to the shape I'd just shed. Confidently, I announced to everyone and now God that I never wanted to be pregnant again.

Listening, but laughing, God hears. But then so gently, so quietly firm, he responds, *No, Lucy is supposed to have a sister.*

Stilled into silence by the sudden and overt answer my set jaw slackens and I incline my ear, neck, and shoulders in response. Huh? Really? I am taken aback. I have been so resolute, so firm in my position. I'm suddenly bent.

Dear God, how? I ask, trying not to laugh and cry and wondering if I could just pretend I hadn't heard the unexpected answer I so firmly felt pulsing through my brain as surely as the milk from my breast into the eager infant latched there.

Tucking my now three-year-old into her beloved edge-worn blanket for a nap, I steal out of the room for some personal time with the laundry. My phone lights up, buzzing with a text. It's my sister-in-law gently letting us all know their infertility treatments have let them down again. All the hormones, the waiting, the needles and pins of procedures and possibility; nothing took. Suddenly my eyes are hot. I'm trying not to cry. On the other end of the line, I know she is. Past, present, and future tense. As I watch her and so many hopeful friends and relations subject their bodies and hearts to experimentation of science and faith to have children, I doubt my stamina; I could not join those ranks. Yet I wonder if I should feel obligated, if I should feel like I want to have that one more?

I want to have our children but I don't want to be pregnant and I don't want to force my body to conscious, calendar-marking effort to attain that blessed state either.

So we try without trying; we wait. It's been about a year since I opened myself enough to test God's promise and my own fertility. I hoped that not saying no to another would suffice.

"There's something in the water here. It seems like everyone who wants a baby and some who didn't know they did wind up with one in their first year here," cautioned a ward member on my first visit to the ward we were moving into, while making a sweeping gesture toward several swollen bellies and swaddled infants. If only it were that simple, I bit back, pursing my lips into a forced smile.

She didn't know me at all. I didn't know her, either.

My son was six months old. Nearly two years for my daughter. I made calculations for another at this rate; I didn't expect quick returns, nor could we afford to expedite the process if I had wanted to. I didn't want to add additional anticipation to my uncertainty. Traditional infertility treatments couldn't be our answer.

One time, I was pregnant enough to heavy my head and breasts with hormones. I held my middle in existence-loathing, nauseated agony. It ended two weeks after it began. Relieved, I wondered if I should feel guilt and sadness, too? I couldn't let myself, so I didn't.

Six years from that scene in the glider I've long since sold. Wrapping presents for my only daughter in bright paper, and planning for the cake I'll make tomorrow, I can't believe my baby, still the baby, will blow out six candles this week. I expected God's promise to be made good, Lucy would become a big sister. I've been hesitant, nervous, but open enough to be open, guarded enough to protect my persistent anxiety.

We mark four years of anticipation this winter, and still I haven't seen her face. I had hoped that God would show His face through hers, a vision, a dream, or at least a speedier lag time between trying for a child and holding one in my arms. But no. No efficient child fulfillment. No dreams. No visions. No second daughter. I wonder about the possibilities of what hasn't been or what could be. Am I really holding up my end? If faith without works is not viable, does it mean my works are void? I already gave up on trying. At least in the traditional approach.

I traded body watching for fate tempting. I hoped superstition held as effective as Clomid. I applied for a master's program at a nearby university. Reservations were made for international travel many months in advance. The magenta-plum striped sweater romper, my favorite of the outfits my daughter had toddled around the house in, miniature plaid shirts my infant son had worn while I wore him in a front carrier, and all the other tiny clothes were gifted away and out of waiting reserve. My practical husband protested, but I filled out the driveway yard sale with the crib his parents gifted us, the stroller from my parents, and our five-point harness car seats. Hauling it down the stairs from the attic, my daughter announced that I would be sorry, I'd need all of it again when we had another baby.

Pausing on the middle stair holding the baby hiker backpack, I turned to look in her face. "Who told you we were going to have another?"

"I don't know. But we are," she announced with certainty.

I hadn't told her anything.

"If it happens, it happens, but God hasn't sent us any more. I'm not lodging all this in the attic in anticipation. We can always get what we need again if we need it."

She scampered off and I hauled the rest of the lot to the garage for masking tape price tags.

I sold it all and gave away the rest.

I went on the trip.

I started a graduate program, all with no pregnancy to pause or postpone my forward motion.

It was shortly after Lucy was one when I named the sister she doesn't have. The weeds and volunteer plants that shortly follow winter thaw announced her name: Violet. The plants of the same name, those hearty green things don't mind the threat of frost, or setbacks or the garden you intend or plant. Violets grow anyway.

Undaunted by their beauty, or the press of the name into some unknown reservoir inside me, I respectfully bid them all farewell as I turned over the dirt; they're not what I was readying this heap of earth for.

This day in March with the temperatures rising enough to plant in earnest and intention, I held up my packets of seeds to show those weeds who was boss and how this little garden plot was going to go: Zinnia, Giant Flowered, Mixed Color, just like the paper envelope promised. I emptied the little bed of unintended guests and tucked the feathery light, hopeful little zinnia seeds into the brown-black topsoil, dreaming of the promised huge dahlia-sized flowers in a full color range!

Sure enough the flower plants emerged in the neat rows I planted them in, but so did the volunteer violets. They always came back despite my efforts to thwart them; humbly peering in at the bottom of the bed, with their brilliant purple-blue blossom eyes, to surprise, delight and frustrate me all at the same time. The way they returned time and time again and without invitation, they struck me as a sort of gentle but persistent reminder of some unnamed thing. I chortled; it was all in the name.

It was the name.

How could it be anything but her? Apparently you can't root out your roots. Family and weeds (though not always in the same category of undesirables) are always there.

I grew fond of the dedication of violets: their prompting of hope and heartiness and my great-grandmother. It was her return in the eponymous flower to make me think of the second daughter I don't have, and suggest they share a name and association to those faithful little flowers clustered in heart-shaped leaves.

Violet Catherine Christensen Clark, a little woman with a long name and dark eyes, was always the dearest and sharpest mystery in my family tree. Passed-down stories still

flicker with the vivacity and creativity that filled her, even passed through second or third hands. She was fun and funny, acquainted with hard work, a teacher, a leader, a writer, and a lover of the stage (in the lights and behind the scenes). She adored her books, her husband, and their boys. Dark-eyed violets quietly look up at me from the garden plot. Perhaps she is thinking of me too?

My life and religion haven't lent many thoughts to reincarnation, rebirth from one person to another. But a person alive in a thing, a flower, and another person perhaps? I believe. She's there, softly, watchfully, fervently reminding me. Every flower bed of every address I've been waiting at since that day (three more of them since that first plot) brought her forward. Giving up the battle I won't win, I stop pulling out the flowers. My concessionary sigh rolls into a laugh. So it is to be: violets for Violets, both of them.

Lying on the rug in the middle of my living room, secretly late at night when my husband will not wake to interrupt my quiet, I wonder if I'm losing my marbles. I'm listening to a self-hypnosis track, *Uncommon Knowledge*, in another desperate move to position myself for grace. I'm too much of a cynic to hypnotize myself into fertility, but I can imagine myself as a "golden egg" as the soothing voice tells me to do, mostly certain I'm waving a white flag saying, "Look over here! I'm open, God! I'm ready to try something crazy! I'm doing it now."

$12.95 seemed a bargain for that realization, but still I elected to keep the purchase and the amount of time spent lying on the rug with my hands open to the sky attempting to hold that imaginary golden egg to myself.

Surprise caught me again when I realized the woman from church, cautioning fertility in the water, was only wishfully speaking. She and her husband were supplementing their family because the water didn't work for them, either. They began fostering. Three beautiful brown-eyed children came into their home, adding to their family of five. It became clear the kids couldn't go back to the home they had known. They traded their family car in for one twice the size. Maybe just drinking the water put something into their brains? Undaunted and elated, they adopted them right in. Wild.

Familiar as I was with the raw beauty of wild things and flowers, I was still awestruck at the surprising wonder that came into that family as they plodded into a new kind of wilderness and out from their old one.

I felt as though I'd been floundering, trying for years to find my way out of my own. I tried and tried and waited because God said to, and then gave me nothing.

Slowly and suddenly I sensed an energy, a cast of light in my mind's eye, a pull to foster parenting. Could this be how? I'd never planned on being a foster parent; frankly, I never wanted to be one. I wasn't the type. We weren't that sort of family. At least that's what I had always believed. Their backs are heavied, shouldering all the extra work of

extra kids. They set themselves up to love and be let down. They are a special selfless breed of altruistics with acrobatic flexibility and other-worldly acceptance of the unknown, characteristics I cannot claim. The family I knew looked as real and imperfect as mine, but still. There was something there, a tacky, itchy, pulling urge. I pray: *God, is this really what I need to do?*

Could I? Could we? I believe in making our own fate. I hold my belief in agency beside my belief in love, and I believe God does the same. He'll let me choose, and will love me no less.

All I really know is I can't shake the impression I feel, the voice I heard, and the violets that keep growing when and where I don't expect them.

My answer doesn't come. Moving too fast through my own thoughts and busyness, I couldn't catch it even if it did. We're on the move again to a new state and new state of being, away from friends, grad school, the life I had known. What was I supposed to do next? I was just trying to figure out what I was going to do right now. I needed all the time God seemed to be taking in answering.

Holed up in a crusty old sublease was a guarantee to get the kids registered for school while I continued—in vain, it seemed—the active four-month-and-counting house hunt. And after nearly six years of asking, God picks up the conversation left so raw in ragged end at a for-sale sign.

It doesn't have to look the way you thought it would.

I bend to look back at a house I had seen before but wasn't what I thought I needed. I'd seen the violets growing in the back and thought, well maybe. And now.

My chest heaves at the blunder of the unexpected blurring into the voice clarifying my mind. This was to be our new home; and here is what was next would be. The early morning sunlight poured down the street as if to further soften any remaining resistance. I put an offer on the house that afternoon. And picked up the phone to call the county foster offices to begin looking for Violet.

BOOK OF GENESIS REJECTS

CLAIRE ÅKEBRAND

That night
Adam turned to Eve:
*Let's fall
asleep under the blue
sleepless leaves.*

*Last time God poured sleep
over me, sleep
yielded you the way night
yields day and blue
sky, the sun, the sunfall.*
But then Eve
laughed: *The sun doesn't fall. It just leaves
the garden. Leaves
for what? Does the sun sleep,
too? There can't be any night
where sun sleeps,* Adam insisted. *Blue
Bells rise where sunshine falls.
Eve?*

Have you fallen already, Eve?
The fading sun warmed the fig leaves
they didn't need to cover their sleep-
ing seed. *One long dark, before God divided night
and day. No wonder He had the blues.
That's why He made a moon fall*

*always around the earth. The fall
moon falling even closer.* Eve
stirred with night-
mares. *Go back to sleep.*
But now the leaves
kept her up. *I dreamed your lips turned blue.*

Blue
to the touch like in the eve-
ning, these daisies. And the dark places the leaves
make under trees. Things leap
from this darkness. Father works in the night.
Makes stars shoot. Perhaps they fall

all on their own. The night fills me with hunger. The wind blew
unknown fruit smells toward them. Eve didn't tell Adam of all
the times she'd dreamed of falling. *Sleep, while you can. Sleep.*

THE BLACK CAT CROSSING

CLAIRE ÅKEBRAND

Good luck is like this,
resembling something
that used to belong to someone.
It drinks from our dog bowls,
sleeps in weathered furniture out back,
crashes through trash cans,
sends up a puff of magpies in the yard.

When it nudges open our kitchen doors,
it seems as startled as we are,
and disappears over the fence.

Sometimes, growing sore and heavy,
it finds a bed of gas-stained rags
in a shed, and litters
them with unnamed,
hungry lives.

ACCEPTANCE

BLUE POLISH

KEL PURCILL

He's twelve, and his toes are resting against the inside of the windscreen. He's reading a book, cackling at times, humming at others, every now and then asking some random question or telling me a morsel of his life or thoughts.

I look at his toes, hyper-flexible, knuckles curling over the shy toenails like mine do, the glass fogging slightly around his footprint. His toenails are bright blue. Or—as he regularly tells me—cyan, his favourite colour.

He's twelve, and he has painted his toenails.

He's happy. I'm happy. That shade of blue looks fantastic.

My heart takes a snapshot of the moment, cyan and milky skin, the pulsing, irrepressible life force of him warming and fogging the air.

But I hugely wrestled with the nail polish idea. If I had painted my fingernails, I would have had flecks of colour and worry between my teeth for weeks beforehand. Worry for my gorgeous boy, whom I have never worried about falling in with the wrong crowd, only that he'd never find a crowd—or a friend—of his own. My son, who doesn't just march to the beat of his own drum, but actually dances in his undies in the rain to the sound of his own impossible orchestra. My son has no disease, no label, no disorder, and no interest in being "normal." He is just totally and undeniably himself.

He's twelve, and he's painted his toenails.

He's my second child, my baby, who recently survived a year of bullying and social exclusion, every other day coming home and asking me, confusion warping his forehead, "But why do they care if I like different things? Because bow ties *are* cool! Because English really is a really weird language!" The becauses changed, the initial question didn't, until one day he mentioned offhand that the other kids knew that "I'm just who I am, and that isn't going to change." My impossible, incredible child, knows what he wants, who he really is, and waits for everybody—especially me—to catch up.

He's six months old, and won't go to sleep for anyone else but me. My mother-in-law takes it as a personal affront and focuses her attention on my oldest son, the blond, blue-eyed chalk to his baby brother's bald, blue-eyed cheese. My baby won't smile for her, and they frown at each other, equally stubborn and determined. My money's on the baby. He wins, she loses. He loses her affection because he looks like his Mum; she wins a war fought in her own head.

He's eight months old, and knows what he likes. I dress him in countless layers thick to go to sleep, because he not only always kicks his blankets off, but wakes the second I try to cover him back up. He's been professionally sleep-trained and now refuses to fall asleep any way but on his own in his crib, swapping at least two, preferably three, dummies between his hands and mouth. As his eyelids grow magnetised and pull closer, he sucks one dummy, the other two slowly tumbling between his hands, over and over again, a tactile need that tumbles on for over a decade and still endures.

Endures, sometimes hibernates, then reappears roaring and delighted to be alive. Most recently, as blue nail polish. Not immediately as polish. Honestly, the polish was my idea, and when I told him of this new plan, as the words danced from my mouth I blinked hard, wondering who had hacked my mouth and spammed my vocal cords.

"Hey Steven, I've got an idea—if you stop picking at your nails—" His nails, so beleaguered by his absentminded peeling of fragile wisps until there was hardly any real nail at all. "—if you stop picking long enough that I can actually see white at the ends, you can choose some nail polish to put on them."

He whooped in excitement and within two weeks had eight actual fingernails that were longer than the quick. He spent four minutes and eight dollars at the shiny speckled display, twelve minutes painting his nails three colours, and six minutes painting my toenails (and some surrounding skin) a luscious, flirty purple.

The whole time, I was fighting myself. *Should I be encouraging his fiddly nature—is this encouraging it? Sweet baby rhubarb, you know what a hot red mess his nails are! He's got friends now, is the polish going to create problems? Kids can be such jerks. Does he need more male role models in his life? Bugger, church is in four days, and he's passing the sacrament! What do I do, or say? Forget kids, people can be such jerks. God, a little help? You gave him to me! I so don't want him to be pushed around again ... Maybe I should take it away—*

Then all of a sudden, I'm six months and half a planet away, soaking in the American summer discussing Dalene's kids while mine are sleeping through midnight, far off over the horizon and ocean. I can hear her voice, feel the sun lick up the side of my face, smell the grass and dust of the roadside. " ... So I thought, You know what? If the worst my kids decide to do is dye their hair, or have a Mohawk, then I will happily lose that battle to win the war. Who cares what people think? It's between them and the Lord, who loves them no matter what they do to their hair."

My fight was over. My gloves came off, and my shoulders dropped. This is one part of the whole parenting gig which peels me to the jumpy, nervy layer of twitchy worry— that I know my boys better than anybody else on the planet, and that's what I have to base my decisions on. Not what I wish my boys would do, or because of what people will say or do, but what is ultimately best—in my wonky, worried opinion—for my sons.

The nail polish stays.

I chew a cranky little hole in my lip about the upcoming Sunday, all ragged edges and savage spikes. I'm standing at the kitchen bench, staring down at my own happy, painted feet when Steven sidles up to me, wrapping an arm around my waist.

"Hey Mum," he says, watching our toes wiggle, "I'm going to take my fingernail polish off Saturday night, 'cause I don't want to distract anyone with my nails when they're taking the sacrament on Sunday."

He pushes his foot against mine, comparing length, and I try to see through the glitter in my eyes.

"I'm going to put more back on after church, though. But yeah, taking it off on Saturday."

He gives me a hug, tosses a "Love you!" over his shoulder as he goes back to whatever, and I keep trying to breathe past the gratitude and disbelief that's bloomed in my throat. I take no credit for his decision, it was all his, and I'm cranky at my relief that he's not wearing nail polish to church for half a second until I huff out a breath towards my curled toes. That's my boy. Who was born determined, and has never been anything else. My boy, who will cede a ten-fingernail defeat, so focus can be pointed elsewhere.

That Sunday, some points clarify. He's wearing his bowtie, because bowties are cool, amid the other long-tied Deacons, hair styled the exact way he wants which is not how I like it. He stands watching as toddlers grab for the sacrament trays, waits as shaky, older hands pass back to him, steps three paces and repeats the process. I smile, knowing that his toenails sport three different colours, and when he catches me watching him he throws me a quick smile before rolling his lips into seriousness.

I realise half my worry was bracing myself to go into battle for him. Against those who've asked if I've considered he might be gay, suggested that he should wear a proper tie, stated that he shouldn't read so much. I'm often braced against the whole world, willing to take everyone on for the sake of my son, to fight those who freak out when someone is their own self and not the expected. Sitting on the church pew, I can feel the passionate growl of Dalene's voice against my cheek as if she's sitting right beside me "God loves our kids, Kel, for exactly who they are, not who anyone wants them to be."

I wiggle my toes as I close my eyes, singing silent praises to a God who loves the weird, the worried, the weary, and the wondrous, who then gives friends to love them and answer their prayers. My sons push into either side of me after sacrament, my own wondrous and weird gifts from God, and just like every Sunday, Steven leans in to soggily kiss my cheek and whisper "Love you, Mum." I whisper I love him back, wipe my cheek dry a little, and grin when he carefully nudges my foot with his.

He paints his toes again shortly after getting home from church. We argue about my toes needing to be redone—I say they don't need it, he insists he's much better at doing nails now, can prove it, and does. Then we sit on the lounge together, wiggling our feet, my gratitude as bright as my toenails.

MY INNER VOICE

MICHELLE LEHNARDT

"Be careful how you speak to your children. One day it will become their inner voice."
—Peggy O'Mara

This is not a story about perfect mothers raising perfect children. Rather, it features flawed mothers and grandmothers, broken relationships, and the power of God's grace to heal our hearts.

My mother was hard on me. As a child, and as I grew into an adult, she criticized and chastised, compared me to my siblings and to the smart/beautiful/talented girl down the street. I weighed too much, my clothes looked dowdy, my kitchen was messy. My mother's mother spoke the same way to her and perhaps my mother's mother's mother did the same.

Over and over I heard, "No one loves you like your mother," (especially around Mother's Day) and I felt a certain sense of shame for my unlovable soul.

Until the day she was diagnosed with liver cancer.

My husband brought the phone outside where I was working in the garden. "It's your mom." He covered the earpiece with his hand. "It sounds important."

Wiping my hands on my jeans, I took the phone and sat on the porch. "Hi, Mom."

"I have good news and bad news," she chirped. "I have the best, most treatable form of liver cancer. But I have liver cancer."

Honestly, and I'm sure this sounds heartless, the news of cancer was expected. My mother's health had been poor for a decade. She was the last of my children's four grandparents to have cancer and her eventual diagnosis felt inevitable. But her next words could not have surprised me more:

"During this past week, as I've waited for the biopsy, I've been examining my life. I've been thinking. I've been repenting." I heard her voice crack and strain. "And I'm sorry. I'm so sorry. Ever since you were a little girl I've been hard on you. I don't know why. I know I made you feel unloved."

I wanted to object. She didn't need to apologize; our relationship had been fine for the past several years. It was okay; I understood, and I have made oh so many mistakes of my own. But her words split my heart right open and filled an empty aching hole.

"Are you still there?" she asks.

By now, my throat has contracted and tears spill relentlessly from my cheeks. The only reply I can manage is a sharp intake of breath, a fragment of a cry.

"And I want you to know that I love you. I'm proud of you. I cherish you. My time left may but short, but it will be ... " Sobs steal her voice too, and as the sun sets on my porch we sit and cry together.

Finally, I find words, "I love you too, Mom." We both hang up, because it's all we can take. I'm amazed and overwhelmed and frightened too because my heart has never felt so clean and soft.

Just forty days later, I lay at her feet as she died.

People tell me I'm lucky she went quickly and didn't have to suffer, but I would have liked more time—one Thanksgiving, one Christmas, one birthday basking in her presence and the knowledge I was loved.

But as the months and years have passed, I've felt a change. I feel my mother with me, cheering me on, attending every birthday party, glorying in my children's accomplishments, complimenting my dress, and scoffing at the idea I need to lose ten pounds. Her voice in my head has changed from one of criticism to effusive praise.

Unhindered by earthly worries and stresses, my mother nurtures me in the way she always meant to.

I know her voice isn't something I've created; I recognize her lilt and tone, her spirit. My bedtime stories sparkle with her magical and silly details, suddenly my jokes are funny to (almost) everyone and my parties glow with her elegant details and warm hospitality. With her nearly constant approbation, I'm slowly gaining the self-confidence I've always lacked.

My message is simple: You aren't ruined, you haven't ruined your children. All our missteps and weaknesses can be healed by true repentance and the Atonement of Christ. I've witnessed it myself, I've witnessed it in my own children. True repentance lends to faster healing, but even if those who hurt you don't repent, your heart can be healed.

If you need a kinder voice in your head, pray to God for help. He'll send you people to buoy you, but He'll also send His Spirit to comfort you. And the voice of God remains constant, strong, omnipotent—you are glorious, you are cherished, your worth is beyond measure, you are loved.

OPEN

SANDRA CLARK JERGENSEN

The kaleidoscope of smashed glass sparkled, caught in the cracks and rough patches all along the sidewalk and street outside my house. Panes of unintended street-art stained glass: beautiful but terrifying trash. I've stepped on enough drinking glass shards on my own kitchen floor to keep my feet covered when I step outside. So the day I spied a man running barefoot down my Baltimore street I looked again out my window, then again in unbelief, once more in disbelief, and a fourth time because why would anyone in their right mind run down these glass-glittered streets without proper footwear? Up the street he ran anyway, not stepping gingerly, but with stride and purpose. Open and free. At the time I just thought anyone reckless enough to attempt this was crazy and then some. Until I met one.

Have you ever had a word pick you? Some people pick words to arc a season in their life or guide their path for a month or a year or more. I've never deliberately chosen one, but last October a word chose me. On a morning run I noticed my fists: balled up as I fought against my body's longing for repose and against the length of street stretching out in front of me. *Open your hands. Open your hands. Open your hands.* I obeyed the directions, thinking they must have heralded from some "how to run" tutorial sometime, somewhere. Awkwardly, consciously, I released my fingers from the fists. Opening my hands relaxed my entire form, releasing my neck, arms, and legs to move more fluidly. But, lacking muscle memory to keep me loose, I lapsed back into fighting form in no time.

Open. The audible word and accompanying action echoed in my mind again and again all through those inky pre-dawn miles, and so many times since, whether I am running or not.

I met Catherine in a class last semester. She's a whirlwind. The kind with more lives and life stories swirling around her that I can possibly track of. I jest to others, I thought I was intense until I met her. She spins more plates that I can follow, then says it's keeping her balanced. Knowing her, I don't doubt it. I'm gobsmacked at how full her life is, yet she lives it so open and free.

We played travelling companions this week at a literature conference. Feeling grateful to the friend that encouraged me to submit my paper, and who celebrated when

mine was accepted alongside her own, I happily agreed. I wanted to learn how she did it, so I accepted her offer to help make plans for the trip. The support didn't end there. I listened and let Catherine lead. Hoping to be more open, I willingly let her. The three-day trip was filled with firsts. We waited for the bus in lieu of renting a car and met an assortment people: wild, weird, and helpful. We stayed with a stranger she found on Airbnb. When the bus to campus didn't show, she didn't panic; instead, she suggested we put out thumbs. We hitchhiked to campus. Twice. We decided to walk the miles back to the house one evening and happened upon a sidewalk Krishna dinner. We sat on the evening-cooled curb with plates of beans, rice, curried potatoes, and farina sweetened with stewed cinnamon plums in our laps, eating slowly from our food-warmed paper plates while beautiful women and men in colorful robes filled plates for the mix of students and vagrants passing by. They didn't request anything, openly giving what they had and equally taking what came. I pushed a few crumpled bills and a jingle of coins into the donation bowl. Filled, we walked back for the night as the foreign tinging of music faded from our ears.

In the morning as we geared up for an early run. "Sandra, don't worry about your shoes," Cat called out from the bathroom just as I was rifling my suitcase for them, "you'll be fine without them." Her eager, wide grin flashed at me as she popped back into the bedroom while tucking her hair back into an elastic. "You can totally do this!" Nervously, I closed the bag and looked down, wiggling my toes in anticipation. Together we ran out the door as shoeless as we were born.

I felt odd, unready, exposing the skin I usually protected with moisture-wicking socks and supportive shoes to the gritty gray-black asphalt. I confessed my panic about glass on the street, but Catherine brushed it off, "You don't run bare-footed in front of a frat house, but most places you'll be fine. Just run light-footed and let your body lead." Remembering my goal to be more open to the world, I did it.

My feet were alive with feeling. Thrilling newness and exposure from soles of my feet connecting to the pavement ran through my body. I wasn't sure if I liked it or not. "If it's not fun, you're not doing it right yet. It gets easier!" Catherine yelled back as I paused to examine my alarmed soles. She slowed, smiled, and instructed, "Spread your toes wide, and step low to the ground." Ah. Bumps of rough pebble pavement assaulted my feet when I walked slowly and fearfully, but running while spreading my toes, opening my feet, making them light-footed and free was somehow easier. And on less rugged stretches they became pleasantly alive with sensation as we moved on to the soft yellow stripe of the road; open, freed, and even fun. The knee injury I've been nursing along for months didn't cry out once. I felt so unprotected, so exposed; but I was okay. I couldn't believe I was really doing it.

All those times I heard that beckoning to open my hands, it wasn't about relaxing but releasing. I needed to let go, to free myself to catch something new. My husband and I are

moving our family to Davis, California, far away from the home we've created in Texas. This wasn't a decision we had expected or planned for. All of us are leaving behind friends, associations, and opportunities we already regret (including an unfinished graduate program for me). It's not something any of us thought we wanted. Even though it's so hard to let go of this home, of everything we've built here, I'm trying to open my hands. I'm trying to release my closed fists and let it all go, rather than fighting my way through this challenge. I have hope that my open hands will fill with something good.

I asked Catherine, how do you open, how do you let go? Hope and belief, she said. The results affirm faith in God and good people. Good will can come when you're open to it. Being with Catherine this week was good practice; I'm feeling better already. And I learned something about myself. It may be hard to let go of my protective running shoes, it may be easier to do what's familiar (like rent a car, stay in a hotel, and pass opportunities by while picking things you can control), easier to ball up my fists and fight through hard things, but something amazing can happen when you let go and open your hands to the world. This week I met good people who renewed my faith in humanity, people I normally wouldn't have encountered. Muscles that I had never noticed before are aching from new use—but that pain is good. It reminds me that I can open my mind, body, and heart. I can retrain my muscle memory to release, to run open and free, to open to something new as I must let go of the old. I have to free myself to catch something new. I'm waiting, looking to the skies, hands open, crying out, *Okay, I'm ready.*

THE WOMAN THAT

MELONIE CANNON

The woman that I am

walks into a room like a
sheet ripping in half.

I am awake. Fierce.
I open up like curtains being flung back
to the roaring morning
light.

I bathe in God.

Who cannot feel my
striding?
strong, sturdy legs
fixed in black leather boots.

The earth knows my rhythmic walk
and welcomes my formidable feet.

Autumn leaves cackle,
twigs bend as I pass,
and my face leans forward into truth,
my skin smooth as moonstone.

Can a woman be a tree?
a pine? a fir?
I am all green needles stabbing
into the fabric of the world.

Can a woman be an entire forest?
my silence a crashing cymbal
under a blazing sky?

Does my sigh
careen down the verdant valley
through a maple leaf rolled into
nature's tiny trumpet?

My call is keen. My dense eyes roll.
I am lapis stone in earth's pocket.

The woman I am not

walks lightly.
She wears knee-high fringed moccasins
and white hippie dresses.
Her hair leans over a shoulder
in a thick braid
like the staff of Moses.

She tattoos
a fern leaf on her neck
and pierces a freckle-sized diamond
into the side of her nose.
Leather and silver bracelets circle her wrists
turquoise wreaths her ankles
and her heart beats to
the flickering of fire.

She dances to drums.

Laughter spins from
her mouth
as simple and clear
as a flute laid to lips.

The woman I am not
sees God in the reflection of a spoon,
weighs heavy thoughts
until they turn light
and her words grow gardens
nurtured by the sediment of wisdom.

Her limbs are long and lean.
Sometimes she plays finger tambourines
and walks in moss.

Fireflies follow her.

Where she is
it's always twilight,
lovemaking is slow,
stars have meaning,
snow murmurs sound,
and the pen never runs out of words.

I find her
when I speak —
that brown beauty mark,
shared on the peak of an upper lip —
a dot on the horizon –
a finite spot
marking the place

between what is and what is not.

THE BABY IS CRYING

ELIZABETH CRANFORD GARCIA

again, I turn my head to listen—
 it's the whistle through my husband's nose
 while he sleeps.

I relax and try to think of nothing,
 count backwards from 100 by 3's,
 100 ... 97 ... 94 ... 91 ... eighty-

something, it's eighty-seven,
 no—eighty-five, eighty-two ...
 seventy ... something

the baby's crying, my ears pivot
 like the deer in our yard this morning
 who must have heard through the glass

my daughter calling "Dee! Dee!"—
 but it's just the rush of the air conditioner turning on,
 whining through the vent.

But I am awake now, listening
 for the snap of a twig,
 the metal click of a rifle.

REVERSAL

BACK TO WORK

HEATHER BENNETT OMAN

Terri was forty-five. I was twenty-two. She was meticulous about taking notes; I wrote as little as possible. She was earnest and seemed kind of panicked all the time and asked a lot of questions. I was smug and a little bit of a know-it-all. I wondered why somebody her age would go back to graduate school, and although I agreed to be in her study group, I secretly thought she didn't quite have what it took to pass our comprehensive board exam, which was required for anybody who wanted to practice speech language pathology. Anybody who was forty-five and hadn't figured out by now what she wanted to do with her life was probably a flake.

Our program was small, consisting of only twenty-five students. So Terri and I spent a lot of time together, and there was something about her that always rubbed me the wrong way. She was so uptight. She worked hard, but seemed to have more trouble than the rest of us grasping or retaining the information. She never came out after class with us for a drink, or a bite to eat. She always seemed rushed like she didn't have quite enough time for everything. I congratulated myself for not being like her—man, what a stress case!

Then Terri got sick. Really, really sick. Our classmates rallied around her, and we set up a rotating schedule of people going to her home to bring her the daily notes from class. I also offered to bring her a meal, and one dark and rainy night I got in my car and drove to her house.

She lived a fair distance from the university, in a nice neighborhood about forty-five minutes from the city. When she answered the door, she looked terrible. I felt genuine compassion for her, knowing how hard it was to keep up in the classroom under the best of circumstances. She talked about some of her challenges, and mentioned that she still had to run one of her sons to a basketball game, and had to pick up another son from a friend's house, and she gratefully took my soggy casserole, saying that she was glad she wouldn't have to make dinner that night on top of everything else.

It was the first time I realized she wasn't just a student. She was also a wife and a mother. She was raising two teenage boys while also taking on a full load of graduate classes. In addition to the classwork, the program required three hundred fifty hours of outside therapy hours to graduate, which meant students spent half our days off campus, working as interns, and doing therapy under direct supervision from licensed therapists. It was a demanding workload my days as a twenty-two-year-old student were full.

Her days were full of the same things. We worked side by side. And yet somehow, she managed to also raise two teenage sons in the midst of all of it. No wonder she seemed rushed.

I no longer thought she wasn't cut out for it. I suddenly realized she was kind of a superwoman.

One day in study group, we were talking about trach tubes and vents. A trach, or tracheostomy tube, is a device that is inserted into somebody's trachea, just below the vocal cords, to help the patient breathe better. A vent can then be attached to the trach to push air into the lungs if the person is unable to breathe on his own. A trach placement also requires something called bronchial toilet, where mucus is suctioned out of the tube to keep the airway clear.

"Ew, yuck," she said. "I could never do something like that. It's too gross!! I'm too squeamish."

I considered her for a minute, and then said, "I bet you're not. You're a mother. You have two kids. I've bet you've seen some gross in your life."

She started laughing and said, "Yes, I have. My oldest once threw up from the top bunk."

"*Ewwwww!*" everybody cried, and we laughed with her.

"The worst part, though," she said, "is that he didn't put his head over the edge and puke on the carpet. He turned his head to the wall and puked on the wall, and it ran all the way down to the floor. It almost hit his brother in the bottom bunk."

We all laughed harder.

"When you're a mom, you can catch poop with your bare hands. It's like it's not even a big deal. But then you get a dog, and your life *revolves* around poop!"

We were all still laughing, and then I said, "See? A little mucous shouldn't scare you at all!"

She smiled back and said, "No, I suppose it doesn't."

Not long after that, she came to study group distracted and nervous. We asked her if she was okay, and she confessed that she had found pornography on her fourteen-year-old son's computer. She was obviously upset and worried, and asked us, "What should I do?"

We were at a loss. She was forty-five, a mother with half-grown sons. We were twentysomethings. Some of us were newlyweds, some of us were living with roommates, and one classmate had just bought a dog with her boyfriend as a sign of a serious commitment to the relationship (the warning about poop notwithstanding). We were miles and miles behind her. Again I marveled at the tremendous load she was carrying.

We took our board exams, graduated, and I moved out of the area with my new husband. I lost touch with most of my classmates, and with her probably the quickest of all.

I entered the work force full time and my husband went to school. I gave birth to my first child and cut back from full time to part time. We moved again, and I went from part time to working per diem, mostly weekends or filling in for therapists who had called in sick. When we moved yet again, I got pregnant with my second child, finally hung up my lab coat, and bought a minivan.

One day I got a call from a rehab company. They were looking for a therapist to fill a part-time or per-diem position. I got these phone calls regularly, cold calls from companies taking a shot in the dark to fill their staff. The conversations were usually the same:

"I'm sorry. I don't have a current license, and I'm not currently practicing," I would say.

"Well, if you get licensed again, please don't hesitate to call us," they would say, and we would pleasantly thank each other and hang up.

This call, however, went a little differently.

"I'm sorry. I don't have a current license, and I'm not currently practicing," I dutifully replied, folding laundry on my bed as I balanced the phone on my ear.

"Oh?" the woman on the other end asked. "Did you find another profession?"

"Um, no. I, well, I have two small children, and I am at home with them."

"Well, that's wonderful, but don't wait too long to get back. Before you know it, five or six years will have gone by and then where will you be?"

I paused in my folding, considering what she'd just said.

She noticed my pause and said, "Well, how long *has* it been since you've worked?"

"Five years," I said.

She laughed and said, "Oh, so you're already *there*! Haha! Well, have a good night!"

I managed a feeble laugh with her, thanked her, and hung up.

I wondered why she had picked five years. Was that the magic number? Is a mother useless after five years at home? Is that the cut-off for plasticity of the brain, that after five years at home I was no longer capable of learning anything?

I worried that she was right. I had, after all, watched an astonishing amount of *Blue's Clues* in those five years. I knew my shapes *and* my colors and could even sing the planet song by heart, but I wasn't sure where that would fit on a résumé.

Were résumés even still a thing? I wondered as I put the laundry away.

The day my second child went to kindergarten, I couldn't figure out a single thing to do all day. It was like I was stuck in an odd gray world where I floated along, waiting for my children to return home so the world could fall into place again. I hated it, and I hated myself for not planning for this day better, for not remembering who I am without my children.

One day, after months of the gray, I said to my husband, "I can't live like this."

He was surprised, not realizing the fundamental shift that had happened in my life when the kids went back to school. We talked about it, and he agreed to take the kids for three days while I went to a certification course to practice a specific kind of speech therapy, a certification that would hopefully allow me to eventually re-enter the work force.

The training course was in New York. I drove from our home in Virginia. I settled into my cheap hotel at midnight and called my husband to check in before I went to bed. I lay in the dark, feeling lonely in my scratchy hotel sheets, and thought, "What on earth am I doing here?"

In the morning, I followed my GPS through unfamiliar streets. I got to the conference with minutes to spare, and the rest of the students were already there. It was a small class with only about five students.

I was the only student over twenty-five. I was the only student not currently practicing therapy. I was also the only parent.

I felt unevenly matched, slow, and stupid next to the young therapists, and the information flew at me so quickly I almost couldn't breathe as I frantically tried to write down everything the instructor said. I was earnest, I felt panicked and rushed, I asked lots of questions, and took meticulous notes. And when the other students asked me if I wanted to come out with them for a drink, I thanked them kindly but declined. I was exhausted, and I desperately wanted nothing more than to go back to my hotel, process the day's events with my husband, talk to my kids before they went to bed, and decompress in front of the television before turning in early myself.

Everybody was exhausted from working hard and from the long hours of instruction. The instructor asked us to just hang on with her for a little longer as she went over billing practices. I opened my book and concentrated, trying to keep up with what she was saying. I looked over at one of the other therapists. She had stopped writing. She was staring off into space, looking bored. She wasn't even trying to pretend to be interested. I goggled at her, wondering how she could get away with zoning out like that. Wasn't she worried she would miss something? Wasn't she worried she wouldn't remember? I was frantically taking notes, how could she not need to do the same?

And then I remembered Terri. I remembered how she looked to me when I was twenty-two. Suddenly I knew how I must have looked to her when she was forty-five.

The young therapist caught me looking at her. I gave her a small smile and returned to my book.

That night, I went out to dinner with the students. We talked shop, and then they started asking me questions about my children, about how to manage the parents of their patients, and what they could say and do that would be more helpful. I asked them questions about the new therapy and we shared our experiences. We learned from each other.

I drove back home, driving through the night so I could be home when my kids woke up. I thought about Terri, and wondered what she was doing. Was she still practicing therapy, or had the balance of work and family been too much? I wanted to talk to her, to ask her how she really had managed it all. I wished I could ask her if she could give me some advice as I entered the same stage of life she had been in when we met. How could I have ever thought she was a flake? I regretted my arrogance in thinking she would never have anything to teach me.

I take small comfort in knowing that I am probably not the only one who has ever looked at somebody older and dismissed them. It is the arrogance of the young who never believe they will be old.

ONE NIGHT IN BERMUDA

JULIA BLUE La MAR

It was late when I curled up on a couch on the wide porch and looked through her Instagram photos. A warm rain accompanied the boisterous chorus of tree frogs as they sang out their nightly oratorio.

I didn't know her, had never even heard of her before, but I'd logged on and there was a request from her to follow me. My account was private, hers was not. Since she couldn't see anything on mine, I wondered why she'd sent it.

Normally I dismiss requests from people I don't know, but there was something about her that pulled me in. She and her husband appeared to have just returned from serving a mission and I was curious where they'd been. Had they served with someone I'm friends with? Why would she want to follow *me*?

While the rain poured down I kept scrolling. She was a prolific poster. For the better part of an hour I worked my way back in time, searching for clues to where and what kind of mission they'd served. Each photo was like a puzzle piece, giving a tiny glimpse into her world: big, loving family; adoring spouse; happy marriage; lots and lots of cute grandchildren. Her life appeared to be filled with quality time, fun experiences, travel, service, kindness, and love.

I wasn't quite sure why I was spending my evening searching for answers about a stranger's life, but after scrolling through a couple years' worth of photos, I decided she was the kind of person I'd like to be friends with, so I made an exception to my rule and accepted her request.

Then, quite to my surprise, a great, heaving sob erupted from my heart, and I wept.

While hot tears and warm rain poured down all around, I cried out some of the sadness in my heart. My voice ascended upward as I expressed my sorrow to God, because He is well aware that the life I'd just seen portrayed in her pictures encapsulates the kind of life I have always wanted, and tried so hard for years to create. Her photos painted a picture of a marriage in which the couple cherishes, sacrifices, and serves each other, of loving relationships with their children and extended family, of work and temporal success, and of lives of faith and devotion to God.

Somehow, looking through her photos, the reality of my own life finally started to sink in, and I said aloud, "That's not going to be me, is it Heavenly Father? I'm not going to have a fifty-plus year marriage to the love of my life, mother lots of children, and be part of an extended family rich with a long history, acceptance, and love." The miraculous blessings I'd hoped for for us weren't going to happen.

Admitting that to myself and Him was painful, but also key, because despite being divorced for over a year, till that moment I hadn't really given up that hope and moved forward. *Maybe we will end up reconciling and everything will work out after all.*

But as I sat on the porch alone in the rainstorm on a beautiful island in the mid-Atlantic looking at this woman's life, my children were with their father and his great big extended family, family which I had once been a part of, on a fun-filled tropical vacation that I was understandably not included in.

I cried because I finally realized that it was naïve of me to think that my status as part of that family would continue independent of my legal status with their son or brother, regardless of the amicable nature of our situation and our continued friendship. Most people have a rather traditional view of *family* based strictly on blood and legal ties, as well as ideas about how you should interact after a divorce. Because my family of origin was so fractured and dysfunctional, I've developed a rather broad definition of family over the course of my life. To me, family are the people I'm closest to who add joy to my life. Blood and legal ties are secondary considerations.

Letting go of trying to be a full-fledged member of that group of people who have mattered so much to me over the past twenty-eight years was a transitional step I hadn't consciously recognized I needed to make. While specific individuals will always be dear to me, I began to finally let go of trying to be accepted by those who didn't embrace me as one of their own.

For the first time on that dark, stormy night, I began to envision a future in which my ex's people, my children's people, weren't *my* people. I wasn't really one of them anymore. What was most surprising is the peace that flowed over me. It was less painful than I would have expected.

A little bit of my heart healed as I realized that even without them, I would be okay. In fact I already was. My life is rich with meaningful relationships that bring me joy, and it's a wonderful life even without fitting the mold that my new Instagram friend's life depicts. Growing up in the Church, we are taught general patterns to strive for, but we live specific lives with unique circumstances. So while my specific life hasn't ever matched up with the dreams I hoped for as a child (and really, whose has?!), it has been and continues to be a beautiful life that I am exceptionally grateful for, and the future is full of unknown possibilities.

As these insights settled over me, my tears and the rain grew gentle and eventually stopped falling. A bright moon climbed across the starry sky, bathing the garden in silvery light, and a sense of peace, love, and gratitude replaced the sadness that had hidden in heart-crevices for so long. God understands and is mindful of my hopes and dreams. He has a plan for my ultimate happiness. I don't know what the future holds, but experience has taught me again and again that things always work out after all. Storms come and go. Light ebbs and flows, and joy comes in the morning. He is the master at creating beauty from ashes.

BEN COMES HOME

MICHELLE LEHNARDT

I'll never forget the roar of jubilation when the half-dozen bedraggled missionaries rounded the corner at the Salt Lake Airport. Carefully painted banners dropped to the floor, balloons drifted up to the ceiling as families rushed past the barrier to greet their sons.

My husband reached Ben first, grabbing him in an embrace that soon included all six siblings and myself. Pulling back to inspect Ben after his two-year absence, we all declared him unchanged. As I claimed my own hug, I began to sob, releasing two years of yearning and worry in one glorious wave of joy. I didn't notice it then, but the video revealed my nineteen-year-old son—about to depart on his own mission in four weeks—was wiping away tears of his own.

At home, Ben fielded questions, arm wrestled his younger brothers, passed around Italian candies, and began unpacking his bags. When he couldn't keep his eyes open, his siblings pulled blankets and pillows into his room where they all slept on the floor in one contented pile.

The next night we were kneeling at family prayer, still basking in the euphoria of the last twenty-four hours, when Ben commented, "Wow, Hans's bed is really comfortable."

"It's a piece of memory foam over the mattress," I explained. "I can pick some up for you at Costco."

"Oh, don't bother," he replied, "I'll be headed to college and getting married soon. So I probably won't ever live at home again anyway."

If you're a woman and a mother, reading that made your heart hurt. As for me, I burst into tears which welled up often over the next few days. My boy, my oldest son, had just returned after two painful years of absence and he was never going to live at home again.

Ben's timing was poor, but his words rang of truth. A few weeks later, the family loaded up the car for the trip to Provo where we dropped my second son at the MTC and Ben at BYU. On the hour-long drive home, the only sounds in the car were sobs and sniffles, peppered with an occasional nose-blow. As we neared our freeway exit, one little voice spoke up from the back seat, "Can we stop and get some ice cream?"

A few bowls of ice cream and few more tear-filled sessions later, we began to settle into our new dynamic. Launching kids into the world affects a family much like adding a newborn—everyone scuffles a bit while finding their new role. With one older brother on a mission and one at college, my third son relished his position as the oldest of four at home. With unfailing patience and kindness he cared for his siblings, built their self-esteem, and included them in his social life.

But just six weeks later, Ben moved home for summer vacation and knocked everyone down a few notches. None of his siblings were doing enough chores, I was too permissive, Dad spent too much time at the gym. He couldn't see the happy balance we'd crafted over the last two years.

We'd missed Ben desperately when he was a missionary. Every Sunday evening we wrote letters and every Monday morning we woke at dawn to read his weekly missive. Christmas and Mother's Day revolved around his phone calls and when he hung up we all cried. But letters, photos, and biannual phone calls can't convey the changes at home; hearing that your brother grew nine inches just isn't the same as seeing your baby brother tower over you.

Everyone struggled. Ben and I were at each other's throats.

Maybe something else was going on in my head. Maybe it was hormones or age, but I've heard the post-mission adjustment hides landmines for many families. We send away boys and girls and welcome home adults. But they're adults who haven't had to pay rent for two years, or find a job, or determine their future. As much as a mission is a sacrifice, it's also a simple time and in some ways a selfish time. Missionaries have hours to dedicate to gospel study, their daily schedule is largely determined and only so many dishes can pile up in the sink. Coming home to siblings with varied needs and an entire house full of chores can be disconcerting. When a missionary does yard work, it's service, but at home, weeding and mowing are expected.

I'm not a fighter. Ben's not a fighter. Still, every interaction that summer seemed to be filled with tension. He wanted to assert his adulthood; I felt desperately insecure, afraid he didn't need me, afraid he didn't love me. As my oldest child, Ben's honest feedback helped me navigate many pitfalls of motherhood. But I'd gone two years without his constructive criticism and didn't remember how to consider his words without doubting everything about myself.

When Ben went back to school in August we both sighed with relief. With distance easing our tension, we talked on the phone several times a week. When he needed a recipe or help with an assignment, financial questions, advice on changing his major, thoughts on dating, he turned to me. Holding him by the hand as he navigated adulthood, we talked and talked on every subject. At one point Ben said, "When I get married, I won't call you all the time. You're going to miss me."

"I know," I replied. But I wasn't worried. As much as I love Ben and our long conversations, I could see marriage on his horizon. He'd grown into himself, developed his talents, readied himself for the next step.

But marriage didn't come as quickly as he'd hoped. So we talked and talked. He dated and dated.

As he applied for jobs and grants and scholarships, we discussed every one. When he debated the value versus cost of a semester in Jerusalem, I weighed all the factors with him. When fighting erupted in the Holy Land, he called me from the bomb shelter describing the events with such animation I could almost see his Italianesque hand

motions over the phone.

There were dates and breakups and one Sunday of absolute heartbreak where I drove to Provo and held him while he sobbed. He wondered, as almost everyone does at some point, if he'd ever find the right one.

So, one day when he went on a lunch date that extended into a four-hour conversation, I was thrilled. I'd taught him his first words, held his hand for his first steps, but I was never meant to hold his hand forever. I would only hold him back; she could take him forward. When he reached across the altar a few months later to take the hand of his bride, my heart nearly burst with joy.

Ben and I still talk at least twice a week and I chat with his adorable wife just as often. Time and distance might make our calls less frequent, and we'll certainly run into new hurdles in our relationship, but the love and respect infused in our relationship assures me we can work through those inevitable bumps and bruises.

Now his hopes, dreams for the future, and long conversations are with his lovely wife. Hand in hand, they are walking into the world. And no one is more surprised than myself how easy it is to let them go.

WE'D RATHER BE RUINED

MELISSA DALTON-BRADFORD

We would rather be ruined than changed,
We would rather die in our dread
Than climb the cross of the moment
And let our illusions die.
—W. H. Auden

One whiff of isopropyl alcohol, and I am hurtled back to the summer of 1974, the year I learned my first lessons about the costs of change. Though I was too young to know it then, I was destined to learn that summer and over the years to follow, just how painful, risky, and costly—yet necessary to our physical and spiritual survival—change is.

Those were hard and tactile lessons, as hard as the shoulder-to-groin body cast my mother wore for nine months, and as tactile as her waxy scars she allowed me to touch. Her "Frankenstein scars" as she called them, came from traction rods that had run through her knees, and from the four screws that had been drilled into her skull. The longer, purplish incisions that snaked down her spine and all over her torso came from surgical scalpels.

My nightly job was to swab with big wads of cotton the visible scars that were still healing, as well as the sore patches of skin around my mom's arms, hips, and at her jaw line. These were being rubbed raw by every one of her awkward movements against the pumice-stone edge of plaster.

Mom's change was no figure of speech. Her change was her *figure*, literally. She had undergone a complete restructuring of her spine to correct severe scoliosis, which series of surgeries that I'll describe here, if you have the stomach for them, saved her life and ours.

The collapsing and twisting of her spine (begun at puberty and exacerbated by four pregnancies) was far more than mere cosmetic bother. No, she couldn't wear most clothes from stores, as they didn't fit her curved back. And no, she couldn't sit in a normal church pew without shoving two hymnals under the hip that was three inches higher than the other. The real problem was that the scoliosis had advanced to where her lungs and other internal organs were severely compromised. Even her thoracic cavity was showing signs of being cramped. She didn't have full use of both lungs. There was pressure on her heart. Doctors vigorously encouraged intervention.

But this, remember, was the seventies. The surgical procedures for correcting spinal collapse were still experimental. Surgery was risky. And my parents, university instructors, were of modest means. Surgery was costly. They were also parents of four children. So risk

and cost were greatly amplified. Still, the risks and costs of *not* undergoing the change were greater than the risks and costs of not making the change at all.

So this was going to be our family's Summer of Change. My mom was going to be rebuilt. Lee Majors was *The Bionic Man* on TV at the same time, and so the idea of a Bionic Mom was appealing, super neat-o. We four children were farmed out to relatives, and my dad and mom trundled to Minneapolis in a Dodge, tugging a camper trailer across the droning of America's Midwest. In St. Paul, my mom was admitted to the hospital.

There, on July first, she was put in traction. This meant that she lay flat on her back, skewered through the knees with steel rods, to which a pulley system threaded overhead was attached. At the end of the system were tied progressively heavy sand bags. They stretched her downward, toward the foot of her bed. At the same time, she was fitted with a metal halo, literally screwed into her skull at four points, and to that halo, another pulley contraption was tethered, and sandbags stretched her to the top of the bed.

For six weeks she lay in traction. She never lifted nor turned her head. Never twisted to her side without two nurses' assistance. Never went to a toilet or looked out her window or shook out her hair. Never as much as bent her legs or reached down to scratch her shin. Immobility tested her patience, if not her sanity. The threat of blood clots was constant. But today, in recounting those long weeks, she focuses on having watched (through pulley cords and from a mirror positioned above her hospital bed) Nixon's televised resignation and his famous waving departure on a helicopter. "He looked as miserable as I felt at the time," she said, "but more stiff."

From that lateral position and after six weeks, she was hoisted directly onto a mobile operating table, wheeled into the O.R., and surgeons made a long curving incision across her ribcage. They removed a rib, ground it up, and, like master chefs, kept the ground rib to the side like a bowl of dry oatmeal. For later mixing.

Then they made another incision, this time along the crest of her pelvis. From there, they dug and scraped, harvesting more meal. That bowl they also set aside. They would need her own bone mortar for packing in around the base of her spine when they performed the final and major reconstructive surgery. It involved making a long incision down the entire length of her spinal column, laying the flesh open, then packing like sand in a sand castle her own bone meal around and into the lumbar region of her spine, then bolting two long and delicate titanium (Harrington) rods to her spine. In essence, they jacked her up like a car on lifts.

Risk accompanied every phase of this surgery. Just how serious the risk was, was brought home dramatically when, the night before mom was to undergo surgery, sirens went off in her hospital room. Her roommate, just returned from the identical surgery, had gone into cardiac arrest. Surrounded by screaming family and frantic but ultimately helpless doctors and nurses, the roommate died.

Mom was surreptitiously wheeled out of her own room.

In the hallway that night, against the accompaniment of wailing and thick terror, my parents determined that in spite of every known risk, Mom would still undergo the surgery.

"Melissa? Hi, Honey. It's Dad." My parents were calling their children. "Mom just wants to say goodnight to you and your little brother before you go to bed."

My grandmother's phone was beige-pink, I remember, and I stretched its rubbery umbilical coil across the room to where my toddler brother, Aaron, sat in a high chair. Pushed up against the receiver, his cheek flush with mine while his ear shared the knob through which voices magically sailed across miles, I let my Mom's familiar diction with its trademark melodiousness—she'd been a professional operatic soprano in spite of her spine—convince me there was nothing to fear.

"Oh, I'll kind of *look* scary, maybe, all these funny scars," she said. "But scared? I'm not scared. And you don't need to be. We'll all see each other in a couple of weeks, okay? Take good care of Aaron for us all."

I can still see my Mom when she came home. She was wearing a jersey red polka top and white pants grown suddenly too short, under which fit that bulky full body cast with its chin-high collar. In one of those golf carts, the airplane crew drove her to us waiting at the glass wall of an airport terminal. Her jaw tilted slightly to the skies, she sat primly, robotically, artificially erect. She was thinner, weaker.

Yet stronger. She was changed, and over time I saw that the change had gone to a place far deeper than her bones. Triumph filled her lungs, the oxygen of a survivor. Granted, to this very day her bionic spine sets off the occasional airport security system everywhere she travels. But *she travels*. And I'm sure that today, four decades since the Summer of Change, she would say that every shrill airport alarm, violet scar, and moment of apprehension— each a reality among the many that constitute the cost of change—was worth it.

Somewhere from my memory another image emerges. Mom is standing on a stage before hundreds. She is singing the soprano lead in *Elijah*, Mendelssohn's oratorio. Under stage lights, she is regal in her emerald gown draped from neck to floor, a gown custom made to camouflage the mortar corseting her from shoulder to hip. On that evening, she's just a few months post operation. The role my mom is singing is one of a widow, whose dead child the prophet brings back to full bloom, resuscitated. All my life I've watched my mother sing. But no other single moment has ever felt as proximate to truth, or as miraculous.

I have no idea if her surgeons subscribed to the doctrine or not, but had they witnessed her performance that night, I think they would have thrown back their heads then shaken them, joking—wondering—if she herself were not the resurrected one.

Today, I would throw back my head, too. But it wouldn't be in disbelieving wonder. Knowing what I do from life—hers and my own—with its constant choices between ruin or change, and knowing, as I do, how protracted, severe, and excruciating, yet also how revivifying, sweet, and emancipating change can be—I'd tilt my head way back and smile to the stars. Then I'd let out a sigh, nodding to myself, and tell them, "You are right. She is."

LAST NIGHT I PRAYED

MELODY NEWEY

I want this [life]
to be easy.

God said,
It is.

ENTROPY

UNCLEAN

EMILY BISHOP MILNER

Yesterday at this time, approximately two p.m., my living room and kitchen floor were pristine. As pristine as I get, I guess, by which I mean that there are stains on my carpet which will never leave, although perhaps they might if I had the carpets cleaned, but— true confession time—I have not had them cleaned in lo these eight years. There are many things I have not cleaned in eight years. Or, to dig deeper beneath the surface of the grime, more like nearly thirteen years. Nearly thirteen would be the number of years we have lived in this house. In all that time, I don't think I've dusted the blinds in my dining area more than once. Also, I have never cleaned underneath the downstairs kitchen sink. I have never thoroughly cleaned a way-scary area beneath my own kitchen sink. I have never, not even once, dusted the tops of the doors. I do not remember the last time I cleaned the spider webs and assorted bugs off the windows of my front door. Every year in October I say they are authentic for Halloween.

But back to yesterday: The floor and its stickiness were threatening to fix me in place every time I tried to walk on them, and it was driving me crazy, so I mopped. My feverish toddler followed me around, slipping on the wet floor and whimpering, because he wanted me to pick him up. But I was determined, absolutely fixed and resolute, that I would Get That Floor Mopped today.

And I did. I tried mopping and holding him at the same time, but it didn't work. I sent my preschooler to entertain him, but a toddler with a fever only wants his mother, not the Duplo blocks my preschooler passed him. So, in spite of the toddler, I soldiered through, and yesterday it was indeed clean.

Today, though, it's got mysterious orange pulp caked on, saltine crumbs spread everywhere, assorted aforementioned Duplo blocks, and random lids and cooking utensils from my ever-busy toddler. And it looks like I did nothing, nothing at all yesterday. My main accomplishment of the day, wiped out in an hour. And if it could be wiped out so easily, is it worth cleaning in the first place? What is the minimum I ought to do? What else do I have to do to stay sane?

Because that's what this feels like: a battle for my sanity. Nothing clean can stay. It always, always gets dirty again. There's more, and more, and more. I read organizing blogs and they tell me to get rid of stuff. I try to, but there is always more stuff, till I'm drowning in it, swimming in it, picking it up and putting it away over and over and over.

I cannot possibly be good enough. I can't clean out every cupboard and dust every surface and keep the fridge free of mold and grime. It feels like so much I want to crawl

away and live on the internet and hope that it will all disappear. Or hope that I disappear instead. I want to be absent from my own life, because when I open my eyes I see failure in every crumb.

Perhaps I inherited a portion of my struggles with cleaning from my grandma. She did not throw things away till they had thoroughly outlived their usefulness, and sometimes not even then.

I inherited other things too, which I claim more readily: she memorized poetry while doing her laundry, listened to KBYU opera every Saturday, and did yoga. She learned downward facing dog from library books and record players. I remember watching her raise her legs into a headstand when she must have been in her late seventies. And she could beat my father and my aunt at Scrabble up until her stroke, the stroke that left her mind sharp but her words garbled.

After my grandma's stroke, we had a family party to go through her house. In her bathroom were several shampoo bottles, almost empty. Her medicine cabinet held several bottles of rubbing alcohol, each half-empty, each dating from a different decade. In one bedroom I found a boxful of shoelaces, unused, just sitting there. In case she wanted them for something.

I wish I had made an inventory of everything we found there: ancient wheat, toxic canned peaches, various slivers of bar soap with dirt grimed in the cracks. My father made multiple trips to the dump, and several thrift-store donations. But I looked at everything and felt a sense of rueful recognition. Sitting on my own counters were three nearly-empty bottles of lotion, saved by their elusive possibility of usefulness.

> *Changes, no matter what their nature, interrupt our lives and often require a response because these changes and transitions leave us with homes, belongings, and schedules that no longer work for us. Something is out of alignment ... Now you need to reorganize your belongings and schedule to reflect those changes ...* *

In the last four years I've had two babies, who are now two and four. My older children have been through transitions as well. I always dread the chaos surrounding a new baby, and now this chaos has a name: It's the inevitable result of any transition.

But what I've experienced is a chaos backlog, never fully purging all the debris from past transitions. I have lost a level of order with each child's birth that I've never regained. I used to have one laundry day, and I'd do all the laundry that day. Washed, folded, put away. That ended after baby number two. I used to make all our bread. (Yes, really. Dough in the bread machine, bake in the oven.) That ended after baby number three. I used to clean my bathroom every Saturday. Pregnancy and baby number four ended that. And I

used to sleep a lot more. And mop every week. All the habits that I started out with gradually fell away, and my homemaking is left to survival-level maintenance: What will we eat for dinner? Is anyone wearing the same underwear too many days in a row? Did everyone bathe this week at least once?

You can see the repercussions of all our family's changes everywhere. The carpet stains, from the artistic efforts of the toddler. The added toys, from added children. And the residual dust and cobwebs—those are mine. I own them. They belong to me, and to the depression that has followed me the last few years.

I started on Lexapro, an antidepressant, just over six weeks ago. That would be after I wrote the first part of this essay. I decided it was time to go to my doctor when, one day as I cleaned, I began pondering all the different medicine we keep in our house. In a locked fire safe there's all manner of pain meds for my father-in-law's illness, and perhaps it would be better for everyone if I left this messy house, that I could never ever keep clean, and Matt found someone new to take care of it. Surely just about anyone else could do a better job than me.

The sane part of me (you may have thought earlier that I meant sanity in a metaphorical sense, but no, I do mean it literally) saw this line of thought clearly enough to make an appointment for my doctor.

The first day on Lexapro felt amazing. I mopped the floor that day, too. I stood back and looked at the clean tile and when it dried I walked barefoot on its clean smooth surface, and I felt happy instead of despondent. Because I could clean something and then see that one clean spot and pat myself on the back. And believe it.

Clutter sends my thoughts spiraling down to a dark place. But at least on Lexapro, when I look at a clean spot, the tension inside me relaxes. Without Lexapro, looking at a clean space only reminded me of all the many spaces that still needed my presence. Now I can see clean and believe in the space of that clean moment.

The children will return and splash purple smoothie all over the floor, scatter bits of Play-Doh, dump out all the crayons. They will make things messy again. And this is perhaps because they are bodies in transition, in motion, growing and learning and changing, and the accompanying mess they bring is a part of their growth.

I am learning to embrace this idea, to tell myself that my family's mess right now is part of our growth.

Often when I go to yoga I think of my grandma. My aunts tell me that as teenagers in the seventies they were mortified by their mother and her downward facing dog. No one else's mother did yoga. But now they are grateful for it and so am I, today especially, because I'm going to Yoga Nidra. It's the yoga of sleep.

Ramdas is teaching it. He has a beard and wears loose Indian-style clothing. He wants

us to chant. I'm more of a power yoga kind of gal and everything feels new. Especially the chanting. *Om* is about as far as I go.

But I'm here, present. It's a start.

Close your eyes, he says. Think of one thing in your life that if you could change would make it better. It can be anything. You want to lose weight. You want to quit an addiction. What would make your life better?

My mind goes to my house, to the mess I left there so that I could be here tonight.

Now, he says, find a mantra. Find words that say what you want to be. I am free. I am healthy.

I think about this. What is my mantra? *I am a perfect housekeeper. I am organized. I am, I am. Not.*

Nothing fits, nothing seems to fill that place. I settle on "I am organized" and try to repeat that.

Then we lie down on our mats and empty our minds, and these words float into my brain: *I am clean. I am clean.*

They feel like a gift from my grandma, those words. *I am clean.* They feel like the words she would tell me right now about who she is as a spirit, waiting to greet me someday. They feel like the words she wants me to tell myself, the words that will ground me in a deeper reality than crumbs and stains.

In all this joyful mess, in all this lively chaos, I am clean.

I tell myself this. Often. I keep taking my Lexapro. And sometimes, I also mop.

* West, Susan Faye. *Organize for a Fresh Start: Embrace Your Next Chapter in Life.* Betterway Home Books, 2011, Cincinnati, Ohio.

Reviving
A Doused Testimony

EMILY CLYDE CURTIS

In June of 2014, my testimony felt like a campfire ... not a blazing bonfire, but no longer the small flame of a tapered candlestick from my younger days. It thrived and was fed by meaningful interactions with the Divine through my sisters and brothers both inside and outside of the Church, fulfilling scripture study, and personal prayer. I had lived the role of the faithful Mormon feminist for most of my life. It was an oxymoronic title in which I took some pride.

By the end of June 2014, I felt like someone had thrown a five-gallon bucket of water on my campfire, and for months afterwards I couldn't find even smoldering embers of my testimony that might be coaxed into something more.

For years I had been saying, "LDS Church, your behavior indicates that women are less important than men. You don't want people to think you really believe that. Let's fix this! Show them what you really think."

I saw progress, more slowly than I would have liked, but I celebrated each small triumph that happened on the local level, a new mother holding her baby in the circle during the naming blessing, and the larger ones, like a woman praying for the first time in General Conference.

I was sure that if we kindly pointed out the sexism within the Church and gently worked with our leaders, they would see the problems and correct them. They weren't sexist ... just more androcentric than was appropriate for the Twenty-first Century.

In June 2014, two prominent progressive Mormons faced disciplinary councils, John Dehlin, founder of Mormon Stories, and Kate Kelly, a founder of Ordain Women. I knew both individuals and their work. I saw a lot of myself in both of them. But when John was allowed to remain in the Church and Kate was excommunicated, I was devastated.

I felt like the Church was sending a clear message: Men are worth working with in the disciplinary process for apostasy. Women are not.

I understand that Kate's and John's stories are not identical or even comparable, but the Church's response to both of their actions does contrast the difference gender makes in church discipline. By continuing to negotiate and compromise with John who had first been accused of heresy long before Kate and her work, I couldn't help but feel like I had

won the argument I was having with the Church for all these years. My church really doesn't care as much about women as they do about men.

I have never been so sad upon realizing I had won an argument. And my sorrow transformed to anger.

With my testimony now a pile of soggy wood, I didn't know if I wanted to be Mormon, and I didn't know if I wanted to raise my children as Mormons.

Everything felt like it had been turned upside down. I felt deceived, like I hadn't really seen this church I thought I knew and had trusted for my entire life. How could I have read everything so wrong? For the first time, I doubted the ability of the LDS Church to be an integral part of my relationship with God.

I knew I needed time to figure out whether I would stay and in my prayers, I only received one answer as to how to figure out whether I would remain a part of this church.

I felt inspired to continue to attend my ward every week.

My prayers changed from asking for blessings and change to asking to understand God's plan for me and my church, for my children and my community.

And nothing happened for months. I didn't get answers to my prayers, I didn't feel much of the Spirit. I watched many of my friends leave the Church during this time, and I wondered if that was also my path.

I saw the courage it took to leave the Church and for the first time, I could see what that path of leaving might look like for me.

But I wasn't ready to make the decision in either direction, so I went every week. Numbly, blindly, usually not making it in time for the sacrament. I didn't make a single comment in Sunday school or Relief Society during this time. I felt guilty for the first six weeks. I stopped introducing myself to others, I didn't volunteer to do anything. I sat by myself whenever I could. I sat each Sunday with a prayer in my heart that I wouldn't hear anything that would feed my anger or throw more water on my campfire ashes, showing me that it really was gone. My only goal was to make it to some part of church each Sunday because I felt like if I missed even one, I might never get back my courage to return.

After that initial guilt, I realized that I was doing important work. The only person I could minister to at this time was myself, and I was worth it.

In October, I was asked to substitute a Primary class. The lesson was on Elijah. Elijah and I have a history. His stories make me ambivalent. A prophet of God killing four hundred people just for believing differently? And his attitude toward Jezebel makes me think he was an exemplary misogynist even for his time.

When I taught those Sunbeams though, I focused on a part of the story when Elijah was going through his greatest persecution: He's being chased, he's tired and hungry. He's wondering what the heck he got himself into.

An angel feeds him, the wilderness shelters him, and he regains his strength over a long period of time.

After all that, comes this section:

⁹ *And he (Elijah) came thither unto a cave, and lodged there; and, behold, the word of the Lord came to him, and he said unto him, What doest thou here, Elijah?*

¹⁰ *And he said, I have been very jealous for the Lord God of hosts: for the children of Israel have forsaken thy covenant, thrown down thine altars, and slain thy prophets with the sword; and I, even I only, am left; and they seek my life, to take it away.*

¹¹ *And he said, Go forth, and stand upon the mount before the Lord. And, behold, the Lord passed by, and a great and strong wind rent the mountains, and brake in pieces the rocks before the Lord; but the Lord was not in the wind: and after the wind an earthquake; but the Lord was not in the earthquake:*

¹² *And after the earthquake a fire; but the Lord was not in the fire: and after the fire a still small voice. (1 Kings 19:9 – 12).*

I finally was ready to hear the answer to my prayers that had felt so elusive for all those months. The direction I was to receive from God was not in the earthquake of excommunication or the fire of friends' and family opinions on the matter. The answer to my question, "Should I stay in this church?" was one that would be revealed by the still small voice. My spiritual growth was dependent on my access to personal revelation and for a time, it was to be independent of the Church.

It wasn't what I hoped for, but it felt like more direction than I had received in months. So I continued trudging down the wearying path—going to church every Sunday, praying when I was up for it, and adding something else. I avoided the excommunication debate.

In my professional life, I cover a large territory and spend long drives through the deserts of the Southwest and the forests of the Rocky Mountains. During one of my long solo car trips in December, I felt a spark. As I was driving, I was sifting through the remains of my campfire. I did that often while driving, digging through the ashes of my testimony, raking through them with my fingers, hoping to find some warmth, and never finding any. But, on this trip, as I was turning over the events that led up to my situation, it felt different. I felt some warmth in those ashes; there were embers buried deep.

Was my testimony okay? Was everything going to work out the way I hoped?

No. But, I felt a desire and an ability to fuel the fire.

In January, I gave my first comment in Gospel Doctrine. I was only able to give that comment because the teacher was a good friend, and I knew she'd back me up with whatever I said. She had been walking a path parallel to my own. My voice shook, and I have no idea what I said, but I was exhausted for the rest of the day. Exhausted and hopeful because the embers grew hotter a little that day.

In May, I was asked to substitute in Relief Society. I had a perfectly fine lesson prepared on following the prophet, but I found myself telling the Relief Society the story

I've just written here. It wasn't a story I planned to tell and certainly not one I wanted to tell. I am typically a private person, but I couldn't stop myself. Every ugly piece of how lonely I felt, how I hadn't had an answer to prayer for so long, and how I didn't know where I would end up was laid before my Relief Society.

If I had to do it over again, I wouldn't, though I have no idea how I would have stopped myself. That day I understood the analogies in the Old Testament of being unable to stop the fire coming out of one's mouth. I have since felt naked in the presence of a few in that class, but I've also never received as many phone calls, notes, and words of gratitude for telling my story.

I don't know where this transition will lead me. I have never felt more removed from The Church of Jesus Christ of Latter-day Saints. When I interpret Paul's passage in 1 Corinthians 12 as the LDS Church being the Body of Christ, I no longer feel like I am part of it. I feel like the excommunications are akin to the eye saying, "Hand, I have no need of thee."

In other ways, I have never felt more Mormon because it was my Mormon foundation that helped me to stay: my knowledge of personal revelation and how to access the Spirit, the work I am doing to try to remain humble, the charity I try to extend to those whom I feel don't accept me, and the fact that the Atonement will one day make all this right.

And yet, it is also my Mormon teachings that keep me from being fully back. I want to be humble and obedient and all those good things we hear in church and at General Conference. I want to say, "I can stop fighting. This is God's work, not mine."

But fighting for equality of marginalized members of the Church is not just God's work. Personal revelation has shown me that God uses us to right these wrongs ... to end systemic racism and sexism in the Church, to ensure that our doctrine reflects the love God and all of us have for our sisters and brothers in the Gospel regardless of gender or sexual orientation. And the value of integrity that my Young Women leaders did such a good job of instilling in me will not allow me to be comfortable and complacent because this is not just God's work, this is my work too.

EARS TO HEAR

KYLIE NIELSON TURLEY

PART I:

" ... and hearing they hear not,
Neither do they understand ... "
—Matt 13:13

I used to yell without a problem. All I needed was the slight provocation of a two-year-old throwing my phone in the toilet or a stray cat spraying in the garage, and I would open my mouth, fill my lungs, and screech. My throat muscles must have been strong because I had no trouble yelling, "Come eat dinner!" at six p.m., nor did I struggle to howl, "Shut the door!" as air-conditioned air flooded out into the 101-degree heat. If my little one toddled toward the road, I bellowed, "Back on the sidewalk!" and I could yell, "Practice the piano!" with the best of the tiger moms. And so I did—dozens of times per day—all without straining a single vocal cord.

Then came yet another day that required yelling: I stood at the top of my stairs, frozen, as precious moments ticked away before I could force my brain to comprehend the horrific scene below me: My four-year-old daughter decided to change her little brother's diaper. It was so sweet, so thoughtful—and, I remind you, she was only four. My son, who apparently had eaten something that caused diarrhea, decided to run away, half-diapered and fully humored as he giggled and laughed his way under and over furniture weaving in and out of various rooms. My daughter chased at high speed, calling him to stop, waving the clean diaper in her soft hands.

My mind whispered rhythmically, "She was trying to help. She was trying to help. She was trying to help," but the hysteria dammed up, then burst out of my mouth. I shrieked, "What were you thinking? What were you thinking?" then paused to suck in more air and holler at the top of my lungs, "Stop! Stop! Stop it! Stop it!" I did not swear out loud. I think. I am really almost positive—though I do confess that a few choice nouns might have been bouncing around in my head, all stunningly appropriate words to describe the stinky, smeared diarrhea on my walls and carpet and furniture. Yes! The walls! Streaked with diarrhea-brown brush strokes! Considering the circumstances, do I really deserve censure?

So I yelled. Easy and natural, the screeching came up and out as smoothly as raspberry sorbet slides down. Still, easy or not, the un-screaming part of me registered the

shock in my daughter's smooth face and panic staring up from her bright eyes as she lurched to a stop at the foot of the stairs, clean diaper clenched in her little fat fist. I stopped screaming, but anger seethed in my voice as I repeated, "What were you thinking?" Looking back, I know that some tiny bit of calm brain knew I was grinding my daughter's sensitive spirit into the ground like a bug under my foot. But I continued, slamming my rag into the bucket of hot water for the fortieth time, wringing it out like a chicken's neck, and slapping it on the wall, muttering, "What a mess. What a horrible, horrible mess." My daughter worked silently beside me, her four-your-old determination to fix things eventually outlasting my fury.

I am embarrassed. To this day, I cringe in shame. She was only a child trying to help, and I scared her. I saw that same fear on my son's face and I shriveled inside the day my other son cringed and shrunk back from my words as if they were a stick raised to whack him. That day I wasn't even going to yell; he just thought I was—and he flinched away, shrinking from his own mother.

Obviously I had to change, so I did. Not overnight. Heavens, no. It took years of individual days. Sometimes I would make it until 9:30, 9:45, 10:00 (in the morning), and some days I would barely make it until 7:36 a.m. before screaming and pulling out my hair because of the latest spilled milk/obstinate child/mortgage stress crisis. But I did change. After a decade of trying, I was not much of a yell-er at all. Months could pass without me raising my voice.

Then my dad died. Whatever was left of my loudness died, too. I could not endure anything noisy for months. I do not know why. It was just my reaction, my sadness. I felt compelled to walk from the kitchen to the living room so that I could ask my children to come to dinner face-to-face; I could not stand to raise my voice, even just to call them to read scriptures. If my family watched a movie or listened to strident music, I retired to another room—near, just an open doorway away, but far enough to muffle the noise. Everything was so loud. This new, soft stance was better. The quieter, more peaceful me, this me who spoke calmly and listened, this was the real me.

PART II:

> "And in them is fulfilled the prophecy of Esaias,
> which saith, By hearing ye shall hear, and shall not understand;"
> —Matt 13:14

Parkinson's disease has wreaked havoc with my quiet. In my understanding, low dopamine plays games with my central nervous system, which then causes muscles to lose strength. As the disease progresses, Parkinson's patients have troubles with their neck and throat muscles. They may lose their ability to project their voices, to enunciate

their words and, eventually, to swallow. Low dopamine levels in the brain also contribute to a neuro-processing error: my brain thinks I am speaking in a regular voice when I am actually whispering. A year ago, my neurologist became worried that I was speaking softer. Speech therapy could delay the time when my words become garbled and unintelligible, my speech inaudible. To delay the disability, I needed to learn to yell.

With my speech therapist, I yelled. Four or five days per week, I yelled. Then I went home, and I practiced—singing as loudly as I could, sliding my voice up until it screeched and down until it growled, and hollering "functional phrases" at least ten times per day: "Come to dinner!" and "Please pass the salt!" and "It is time to read scriptures!" I yelled into the refrigerator, in the garage, and in the car. I yelled, "I love you!" to my husband, and, "Have you done your practicing?" at my kids. I yelled, "Hello! How are you?" when I picked up the phone, and "Your essays are due on the thirtieth" to my students. I yelled at everyone all the time. And I still do. I must maintain my vocal strength, so I yell.

But I loathe how it feels. Giving in to that horrid habit? I taste the bitterness of self-betrayal, the acrid flavor of guilt and incrimination. I hope people around me are hearing appropriately modulated words when I am speaking, and the amplitude app on my phone says they are, but my brain says they are not. My ears and my brain think I am yelling. Is there a difference between a mid-range whisper and a screech at the top of my lungs? I may be speaking so softly that people strain to catch my words, and I may be bellowing my secrets out to the entire room. I do not know. My ears do not hear.

PART III:

> "But blessed are your eyes, for they see:
> and your ears, for they hear."
> —Matt 13:16

Scripture references to "eyes to see" and "ears to hear" often run in parallel, and we are constantly asked if we can hear. I thought I could hear when my ears worked, but I may have been wrong. Hearing ears made the world tangible, and it was easy to believe I was making correct decisions based on definite tones and concrete sounds. But I was misperceiving the data and creating a fictionalized fantasy world. My eyes saw the brown-smeared walls, yet did not see my daughter's compassionate nature. My ears heard my own voice yelling, "Stop it! Stop it!" but did not understand I was shouting at myself. Technology indicates that I cannot judge how loudly others hear my words or if they hear them at all, so how will I learn to judge my voice, my volume, my words, my thoughts?

What is the price of that knowledge? How I behaved with my daughter still shames my neck a blotchy red, a shade that plagues me incessantly now; I flame that color every time I see people lean forward to hear me better and every time my voice booms out in a

whispering place. Embarrassment is my companion, and it teaches me how little I heard when I could hear. Even with heat burning my face, I wonder if the knowledge is only skin deep. The words on the thin pages of my scriptures have asked me for years if I could truly hear, but I did not hear, nor did I even know I could not. The crinkly sound of those pages simply breezed past my ears.

If I just learn to scream again, will I learn to shout loud enough that I can hear? Can I yell away my fears, my weaknesses, my angers, and my flaws? There are days I am desperate, and I try. "Father in Heaven," I say, "what I am supposed to learn?" The words themselves seem humble, but the volume rings with nervy stubbornness and makes me wince. The loudness proclaims, *I don't want this. I don't want Thy way.* I do want to be better, to change, but does real learning require Parkinson's disease? Must change sink into the chemistry of my brain, alter my nerves' most basic functions, make my muscles ache?

This disease will rob me of my voice and my ability to communicate what I want to say, but I hold out hope for a gift in the broken remains. Perhaps when I am deaf I will hear the truths I have not wanted to hear before: I am a woman who screamed without trying; a mother who scared her own children; a daughter who learned silence when her father died; a wife who still shouts "I love you." I am a yeller who is losing her voice, a questioner who is most often thinking of God. I am a lover of words, but I do not think my words matter—because I am not who I thought I was, nor am I becoming who I want to be. I am slowly being undone—disabled, in fact—not by a lack of dopamine, but by the smallest of things: memories and stained walls, fears and scared young faces; a child's helpfulness, the sound of stillness, and perpetual humiliations. I hear these simple things. They sound in my bones.

A PLACE TO WAIT

BECCA OGDEN

Wenn Du noch eine Mutter hast, so sollst du sie in Liebe pflegen,
daß sie dereinst ihr müdes Haupt in Frieden kann zur Ruhe legen.

If thou a blessed mother hast, bestow on her devotions tender,
That she may lay her aching head to rest, when she is bowed with age and sorrow.

—*"Wenn Du noch eine Mutter hast"*
German folk song

7:04 AM: Arrive at hospital.

Grandma was thinner than I've ever seen her. A tattoo of bruises ran up and down her arms from failed IVs and collapsed veins. Her hair, scraggly black and streaked with gray, was spread behind her in a matted crown. She slept soundly, but she had a look that was worn and unrested.

I walked in alone.

I crept past Grandma's bed and collapsed into a plastic-covered chair near the window. The cushions were stiff and crackly, but I was five months pregnant and already tired.

I pulled out my notebook. It was early morning in El Paso, Texas. The sun swept across the ugly, cracked landscape like a yellowed web. I scribbled notes and tried not to think of the day ahead.

7:27 AM: Nurse arrives. Administers Pepcid, Vancomycin, metronidazole, alprazolam. Checks vitals.

The nurse was tall and Jamaican.

"My name is Elsie, honey," she said. "If you need something, you call me, yeah?" She wrote her extension on the whiteboard.

"Thanks," I said.

Grandma opened her eyes. She had a blank, unfocused look.

"You gonna eat for me today, Missus Jensen?" said Elsie.

"What you say?" said Grandma. German was her first language, so accents sometimes threw her.

"I said, you gonna eat for me today?" said Elsie. She wheeled the untouched breakfast tray to Grandma's bedside.

"I'm not hungry," said Grandma.

"You have a vis-i-tor," said Elsie. "Can you tell me, who is this pret-ty lady?"

Grandma didn't know I was there. I rose from my chair and touched her shoulder. She blinked, her watery eyes wide.

"Hi, Grandma," I said. "It's Becca. Ray's daughter?"

Her jaw hung slightly open. Her lips were dry and cracked. Her teeth, or what was left of them, were rotted and brown, unbrushed for what must have been weeks. She blinked again and her eyes remained blank.

"I don't know you," she said, and looked away.

7:38 AM: One bite of toast. 4 oz water. Spit the rest into her napkin.

Grandma wasn't eating. We didn't know this. We didn't know anything. That was why I'd come to El Paso, to clear things up and write things down.

Grandma had two adult daughters—my aunts—living in the city. Both were surprisingly inept at keeping their family informed and their mother alive.

Monika, the oldest, was kind but unreliable. We needed her to meet with doctors, to ask questions, and make decisions. But when Grandma checked in, Monika grew endlessly busy. She visited, but only sporadically.

Then there was Jennifer, the youngest. She and her two daughters lived in a motel on the edge of town. Like Monika, she was supposed to link Grandma to the rest of the family. Instead she avoided the hospital and ran out the money sent to her by Dad and his other sisters.

Dad had two other sisters—Melody and Marian. Melody was in Germany with her husband, an army officer stationed in Frankfurt. She wouldn't be stateside for another year.

As for Marian, no one knew where she lived or how to reach her. Dad sent out a few emails and left a few phone messages, but these were never returned, never answered.

9:25 AM: Three bites of yogurt. 2 oz water.

10:41 AM: Sleep.

12:15 PM: Lunch. Ham sandwich and vegetables.

"Tasteless!" Grandma spit into her napkin again.

"Just take three bites," I said.

"I hate it!" She stuck out her tongue and shuddered.

Grandma still didn't recognize me. All morning I reminded her who I was, where she was, and what we were doing.

"It's lunchtime," I said. "You need to eat."

"You eat it. I can't take another bite!" She pursed her lips until they turned white.

I put down the fork. My baby kicked and bounded against my ribs. I hadn't eaten since breakfast. I was still waiting for the doctor.

"He's on his rounds now," Elsie said when I found her in the hall. "Should be there ver-y soon, honey."

I waited three more hours. Grandma slept and fussed over her lunch and slept some more. Another nurse administered an oxygen treatment. She placed a mask over Grandma's face and held it for five minutes. Grandma yelled and fought and then slept again.

4:46 PM: No doctor yet.

I didn't know Dad's family well.

When I asked about them, my mom used to say, "You know your dad had a rough childhood."

Back then, I didn't know what a rough childhood looked like. I never had my father kick in our TV. I never had sisters with abusive boyfriends and husbands and ex-husbands. I was never beaten up, never bullied for being white in a town that was eighty-two percent Hispanic. I never had my bedroom ransacked, never had my possessions pawned by those same abusive boyfriends and husbands and ex-husbands.

Dad worked hard to raise us far away from the dysfunction. We didn't visit his family. I only heard from my grandparents on random birthdays. On one or two Christmases we got half-wrapped packages full of trinkets and hand-me-down toys in the mail. But for most holidays, we didn't get even a phone call.

5:48 PM: No doctor.

Jennifer was supposed to meet me at the hospital. I texted, asking about Grandma's doctor, about medications and eating habits. She replied with an "I don't know" once or twice, but there was mostly radio silence.

When nurses or their assistants came in, they seemed surprised to see me.

"You her daughter?" said one. "I heard she had a daughter, but I never seen her."

"Her granddaughter," I replied.

She glanced at my belly.

"Boy or girl?" she said.

"A boy," I said.

She nodded and emptied the trash.

6:23 PM: Dinner. Four bites of whole wheat roll. 3 oz water.

Dysfunction is part of our legacy.

When Grandma lived in Germany, her mother fell terminally ill. Her father sought a replacement while she was still alive. Then, at the funeral, he and the new wife told Grandma she couldn't come home. She was fourteen.

"Too many mouths to feed," Grandma explained. It was a harrowing story, but one she'd told often while she was still lucid.

Grandma and I had grown close in recent years. Her husband (my grandfather) died while I was in college. Something in his death prompted me to reach out to her. I got her phone number from Dad and sat on it for months.

Finally, one night after a study session in the library, I worked up the courage to call. I was walking home. It was snowy and slick and I took my time, holding the phone in my mittened hands as I read and reread her number.

I hadn't heard her voice in years. But her German accent was unmistakable.

"Hallo?" she said.

"Hi, Grandma. It's Becca. Ray's daughter?"

The conversation was awkward at first. She didn't know which granddaughter I was or anything about me. But Grandma was good at filling silence, and soon she launched into a story.

She told me about a winter when the Danube froze over. It's a huge river, wide and deep, but it was so cold that it froze, at least enough so that Grandma could walk out onto the ice.

Now that I retell it, I realize there's plenty I don't know. I don't know how old she was or who was with her. I don't know why they were near the Danube, which is a good twenty miles from their small German village.

I wanted to ask her these questions, and every question that followed. My dad had sent me to El Paso to care for Grandma. I came for that too, but I also came because of all the things I never asked.

7:24 PM: Grandma's awake.

"What do you remember about Germany?" I turned to a fresh page in my notebook

"Nothing," she said.

"Do you remember what your house looked like?"

She frowned, as though she knew she ought to.

"It was a regular house, I suppose," she said.

"Did you have a fireplace?" I asked.

"No," she said. "We had a wood stove."

I wrote this down.

"Did you share a bedroom?" I asked.

"Ja," she said. "With Friedl. She wet the bed and they thought it was me!"

I wrote this down, too.

"What about your other siblings?" I asked. "What were their names?"

"Meine Geschwister," she said. "There was Friedl, Johann, Heinrich, Hans, Rosa, Emil, Ludwig, and little Hellie."

She interrupted herself. "Little Hellie died," she said. "He shot himself in the leg. But he deserved what he got! He wasn't careful!" She chuckled hoarsely. It was the first I'd heard her laugh since I arrived.

She paused. "And then there was Adolf."

I'd never heard of Adolf. He was the youngest, born in 1937, the same year Hitler announced his plans to conquer Europe.

I wrote it all down, and more besides. I felt like a stranger. How had I not known about Adolf? Or little Hellie, who died from an infected leg?

"What about friends?" I said. "Did you have friends?"

"Ja," she said.

"What were their names?" I said, turning a page.

But the blank look crept back into her eyes.

"I don't recall," she said. And then, "I'm so tired. I want to rest."

"Do you want some water? Some soup?"

"No," she said.

I put down my notebook and turned out the light.

8:27 PM: Nurse arrives. Administers Pepcid, Seroquel. Checks vitals.

The doctor never turned up. I waited for over twelve hours and I didn't even have his name. I asked Elsie whether I could expect to see some doctor—any doctor—tomorrow.

"I'll find out," she said. The two of us crushed Grandma's pills into her applesauce.

"I can't eat another bite," said Grandma.

"Just one," I said. She opened. I slipped the applesauce onto her tongue and watched her swallow.

"Terrible," she said. "Just terrible."

9:47 PM: Grandma sleeping.

That night, back in my hotel room, I stepped into the shower and cried. I cried and shook and let water run over my belly as my baby kicked.

Before bed I called Dad.

"How was it?" he said.

"Not so bad," I said.

"I'm glad you're there," he said.

"Me too," I said.

Tuesday October 14th

9:00 AM: Help arrives.

Her name was Arely.

"Like Cind-a-relly," she explained. She was Melody's daughter in-law and she'd come to help.

This was Arely's way, as I learned. She was willing and kind, and her quiet confidence anchored me time and again in the coming week.

Grandma was awake. She didn't recognize either of us, but we talked and laughed.

"Are you going to eat for us today, Grandma?" said Arely.

Grandma sucked on her teeth.

"Maybe I try a little something," she conceded.

9:37 AM: ½ cup of oatmeal, 2 oz juice, 2 sips of Boost!

After breakfast we called Melody. It was evening in Germany, so Melody was home making dinner.

"Gutentag, Mutter!" she crackled over speakerphone. They chatted. Then Melody offered to sing her mother a song.

"If you like," said Grandma.

So she sang, and Grandma joined in. It was German, and the first line was sweet and light:

"Weißt du, wieviel Sternlein stehen, An dem blauen Himmelszelt?"

Grandma's voice was unsteady at times, but she knew the song top to bottom. When they finished, she said, "You know what that means? It means, Do you know how many stars are in the sky? Do you know how many clouds hang in the heavens? God knows them all, and not one is forgotten."

Friday October 17th
10:45 AM: Nurse arrives. Checks vitals. Leaves.

By the fourth day it was obvious no one in the hospital expected Grandma to live.

Before we arrived they kept her heavily medicated so she would keep quiet. They didn't turn her or change her. She didn't eat, she had bed sores and a terrible rash.

After four days we asked them to stop all medications so Grandma would be alert enough to start physical therapy. Her back had healed. There was no reason to continue the drugs.

The nurses scolded us and called us selfish.

"You want her to be comfortable, don't you?" they said.

We wanted her to come home.

1:00 PM: Physical therapy: Grandma sits, then stands.

Two physical therapists, Arely, and I stood around Grandma's bed. The therapists pulled Grandma up to sit. She crowed and howled. We wheeled a walker toward her. Grandma shouted as the therapist instructed each of us on how we would support her.

Then we lifted her up. She pushed against my pregnant belly and yelled. Finally we got her to grip the walker and stand.

"You all hate me! You hate my guts!" she yelled.

"Mrs. Jensen, can you take a step for us?" said one therapist.

"I hate it!"

"Just one step," said the second.

"No! Put me down!"

So we did. We eased her off the walker and back to the bed.

As they left, one of the therapists pulled me aside. "This may seem like a victory," she said. "But if you want her to go home, she's going to have to be way more cooperative."

And she left.

Back in the room, Grandma cursed and fussed and shouted.

"Grandma, please," I said.

"You all hate my guts! What did I do to deserve this?"

She went on and on.

Arely and I sat on opposite ends of the room and said nothing. We were both of us broken and still.

9:22 PM: Grandma sleeping.

That night I talked to Dad. He wanted to know if he should come to El Paso. His schedule meant he could only stay barely two days.

"What do you think?" he said.

My throat swelled. "I think you should come."

"Okay then," he said.

Saturday October 19th, 8:35 AM: Dad arrives.

Grandma recognized Dad immediately. He gave her a hug and a kiss, then he sat down in the chair and held her hand.

"Who is this old man?" she laughed, pointing at his hair.

"I'm older now, yes," my dad said, smiling.

It had only been a year since he'd seen her, but he was older. I noticed it, too. His hair had grown silver, the sunspots darker on his cheeks. When he was young, he carried me on his shoulders. He swung me by the arms. He held me on his chest as we looked up at the stars.

But now he was older.

Grandma ate breakfast without much fuss. Then they talked while Arely and I listened. Eventually Dad told Grandma that I was writing a book.

"What's it about?" she said.

"You," I said. "And your life in Germany."

"If you think it's interesting, write it down," she said, and she laughed again.

After a while, Grandma grew tired and fell asleep.

Then Dad stood and closed the door to her room. Next he drew the curtains and dimmed the lights. Things we hadn't done in all the time we'd been there.

The next time she woke up, Grandma said, "Time goes by so fast. I'm just glad I met you, Ray."

It was a strange thing, we thought, for a mother to say. But her English was not as good as it was, and it was all she would say, again and again.

We got her to eat a little lunch, then she fell asleep again. As she slept, Dad spoke.

"When I was little, I figured, as long as my mom was alive, I was okay," he said. "I knew, no matter how bad things were, no matter what everyone else thought, there was still someone in this world who really, truly loved me."

Grandma stirred again. She opened her eyes and saw Dad sitting there.

"I'm thankful," she said. "So thankful to have met you."

He smiled and kissed her again on the cheek.

Sunday October 19th: Dad flies back home.

Tuesday October 21st: Grandma leaves the hospital.

I had to go home.

My four-year-old son had been without me for over a week. We'd run out of babysitters. My husband was lonely and stressed. I was tired. My body was tired. My baby was growing and I was not being mindful of it. I couldn't stay. I consulted my conscience again and again, but each time I knew: It was time to leave.

The day I went home, Grandma was transferred back to TriSun, the care center where she'd lived months ago.

It happened in a rush. That morning we learned she was cleared for release and a bed had opened. By afternoon we were wheeling her through the front doors. I signed a flurry of papers and soon she was checked in.

TriSun was loud—loud and bright. Fluorescent lights blinked from the ceiling, nurses bustled, and a thousand phones rang somewhere.

We wheeled past the front desk, down one of the halls to Grandma's room.

The hall was lined with abandoned people. They were stooped and wrinkled, their heads bent, their hands in their laps. Most sat in wheelchairs.

"What's going on?" I asked.

"The rooms are pretty crowded," the nurse explained. "They like to spread out."

I nearly tripped on two slippered feet. They belonged to a thin man in a folding chair.

"Sorry," I said.

He didn't even look up.

I trailed behind as the nurse wheeled Grandma into her room. The room came with a roommate, though Grandma was so agitated she didn't notice.

"I want to go home!" she yelled. "Take me away!"

The roommate gave us a look.

"She's not always like this, is she?" she said, and she turned up the TV.

My plane was leaving in just over an hour.

It was time.

I took Grandma's hand. She was still upset, but she calmed at my touch.

"I have to leave," I said. "I know you don't remember who I am, but I love you."

Grandma puckered and scowled.

Then she said, "Love you too."

I kissed her on the forehead and left.

That night as I laid down to sleep in my own bed, I cried. I cried and felt my baby kick and spin. I thought of the center, of the flickering lights and the abandoned people up and down the hallway.

It was nowhere, I thought. It was nowhere to die.

Now: Visiting Grandma.

We found Marian in Utah.

She heard about Grandma and flew down to El Paso. After a few hellish weeks, she forced Grandma on a plane and brought her to Utah.

Now Grandma lives forty minutes from our house. We visit every few weeks.

Marian's careful attention has changed my grandma. She talks, she eats, she sings her German songs and walks with a walker.

She's met my sons. When we visit she asks, "How old is this little prince?" again and again.

She still doesn't remember me. That's the hardest part. Before she was in the hospital, we'd end our conversations the same way each time:

"We do all right together, the two of us?" she'd say.

"Yes," I'd say. "We do all right."

She still can't feed herself, or change her own clothes, or do most things she used to. There's no optimistic turnaround, no best case scenario. She won't return to El Paso. She'll never see her home, her dogs, her old life again. This is the last place she'll live, the last place she'll breathe and move and be.

This is a place to wait.

But there are people here to close her door, to dim her lights and draw her curtains. There are people to sing her songs and tell her stories. There are people to hold her hand, to kiss her cheek and watch her sleep.

These are places worth their space.

Sometimes I sit with Grandma and listen to her sing. I bring my notebook. It's all I can do, gathering the final whispers of a life hard spent.

As I write, she finds an old German poem lodged in her brain.

It's called, "Wenn Du noch eine Mutter hast." She recites and then translates in her familiar, warbling voice.

She says, "If thou a blessed mother hast, bestow on her devotions tender. So she can lay her head to rest, when she is bowed with age and sorrow."

When she's done, it's time to leave. I lean in and kiss her on the forehead.

She says, "Ich liebe dich auf," and sees me with bright, lively eyes.

11PM

ELIZABETH CRANFORD GARCIA

We've just settled into bed
 and I am eager for a few hours
 without nausea,

the days long
 perched on the couch with a bowl
 trying not to think of food,

or what mess our daughter has made
 in the other room.
 Outside our window,

a barred owl hoots to his mate,
 his raucous call almost a bark,
 piercing and drawn out

and I wonder what has brought them here—
 my neighbor's cat? (I wouldn't miss
 his scat in the flowers)

or a tree good for brooding,
 where she will settle for weeks
 on spit and feathers,

her eggs warm beneath her
 as she listens, alert,
 to the rattle of katydids,

the neighbor's dog,
 his stereo left on all night,
 thumping like a heartbeat.

EXCHANGE

KATE, RIVER GUIDE

KATIE NELSON STIRLING

"Katie, you have to apply!" Annalee gushed. "It's the best job. You sleep under the stars all summer. You get buff and tan. You work with amazing people. Moab is so fun. I'll call Bryan and put in a good word for you!"

I was totally convinced. I was going to be a white water rafting guide. It didn't matter that my only experience with rafting was a one-day float trip on flat water at age ten. I had always looked up to Annalee. Driven as a concert pianist, while still fun, carefree, and outdoorsy, she was the kind of person I wanted to be. Here was my chance to try to be someone new, not that I hadn't attempted such a feat before.

When I entered elementary school, I let everyone know that I would no longer be known as Katie. I was to be called Katherine. It was much more sophisticated and serious to my five-year-old mind. While the scholastic ambition remained, the name didn't stick. I was soon writing Katie—the name I'd been called my entire life—on all my assignments.

I was always highly self-conscious of who Katie was, how I wanted her to be seen. I wanted to be popular and liked, but being the "smartest" in class led to a group of boys replacing Katie with "Pet" for all of fifth and sixth grade. I thought wearing the right clothes would change me so I insisted on one pair of Girbaud jeans instead of a bunch of new school clothes. It didn't work. Thankfully "Pet" faded away when I got to middle school and I was just Katie again—smart girl, pianist, ballet dancer.

My older sisters were dancers and cheerleaders in high school. They were popular too, so I decided to be Katie, cheerleader my sophomore year. But I also wanted to be Katie, outdoors chick. I wanted to look like the girls in the REI catalogue, so I wore hiking shoes, fleece jackets, and hemp necklaces. In the locker room, the head cheerleader once looked me up and down and said, "You always look like you're ready to go hiking." I don't think she meant it as a compliment, but it confirmed that I had achieved the desired effect.

Now here was my chance to truly become an outdoors chick and not just dress like it anymore. Here was a chance to do something fun and carefree, and Annalee was going to recommend me! I made it through the interviews acting the part: wearing my outdoorsy clothes and singing with my guitar for the managers like we were around a campfire instead of in a taupe office. They never asked if I knew anything about rafting. (Phew!) I was hired! Soon an email arrived asking to confirm how I wanted my name spelled on my company shirt. Katie? Like I'd written on my application?

Hmm. I paused before responding. The opportunity to be whoever I wanted to be with people I had never met was too tempting. I responded to the email: Kate. Kate was

more laid back than Katie. Kate sounded cool and quick and grown up. I would be Kate, River Guide.

After finals I loaded up my Honda Civic with everything I thought I might need, but really having no idea. Lifejacket, a bunch of quick-dry shorts, tankini tops, and sunscreen—that should work, right? I said goodbye to my parents in Salt Lake and headed south on I-15. After passing Provo, I suddenly realized that I had no idea how to get to Moab. It was in the general southern direction ... I thought. So I called my dad.

"Hi, Dad. Um, how do you get to Moab?"

"Ha ha ha ha ha ha ha! Where are you?"

Three hours and only mild embarrassment later (I mean, look how carefree I was! I didn't even know where I was going), I pulled up to two trailers and a warehouse. A double-wide would be home for the summer when I was not on the river. I picked a bunk in the girls' trailer and awoke the next morning to the first day of the three best summers of my life.

Training began on Cataract Canyon with the managers and returning guides rowing the rapids. The water and air were both cold in late April so no one took more than a splash bath for four days. On the last day, a rainstorm blew in with fierce upstream winds. We strapped the four boats together and took turns pulling hard on the outside oars. Those not rowing huddled together under a tarp and laughed hysterically about our combined stench. We cleaned up from the Cat trip and headed the next day for Desolation Canyon, a milder four-day stretch on the Green River. Lessons in rowing and reading the river began. I learned to use the right ferry angle to pull away from danger, to look for the V leading into the rapid and the tell-tale signs of a domer. In camp we learned to cook the trip meals, set up and take down the camp toilet, also known as the groover.

After Desolation, we headed to Westwater Canyon—a one-day stretch of the Colorado with ten technical rapids. We would run this stretch twice a day for three days, giving each of the new guides three chances on the oars. There was one rapid, Skull Rapid, our manager filmed from the canyon ledge so we could see ourselves doing it. To do it right, you had to cut across the top ledge wave, completely avoiding the crunching of Skull Hole to safely pull away from the Rock of Shock and the swirling Room of Doom.

I was selected to be one of the first new guides to row. I didn't make the pull. We dropped into Skull Hole sideways and time slowed down. The boat lifted up on my left and I watched as it dumped all four of us into the water. I was sucked into icy darkness and pulled in all directions. The rescue boat waiting below the rapid picked us all up with throw ropes. We flipped the boat over, I faked a brave face and lied, "I want to get back on the oars."

When I had to run it again the next day, I didn't think anyone would want to be on my boat. But Justin, Brody, and my trainer Ammon hopped on without hesitation. "You'll be fine, Kate." Ammon said. "I'll tell you when to pull." My hands shook as I willed the tears back into my eyes on this boat with three boys who had all succeeded where I had failed.

"Pull Kate!"

PULL, PULL, PULL, PULL! Eddy-out.

"Wahoo!!!!"

I got to make the pull through Skull Rapid once more before I ever had to take passengers through it. Though I did have hairy runs on a few other rapids during my three years, I made it through Skull every time.

River guides can't put on pretenses. You are together twenty-four hours a day for four to five days at a time. You see one another groggy in the early morning, exhausted late at night, and dehydrated and grumpy in the hot afternoon. You set up camp together, cook together, entertain passengers together, clean up the groover together, and laugh and play while doing all of it.

Without the trappings of "real" life, I became the most comfortable me I'd ever known. My clothes were dirty, my hair was filled with sand, no one knew if I was the smart girl or the cheerleader, and it didn't matter. I didn't have to try to be anyone. No one cared. I was just Kate. I was happy and free and surrounded by others who were as stripped down to their true selves as I was. Our friendships flowed as easily as the river and we were deeper friends because we were ourselves as we worked and played together.

One hot night after the passengers went to bed on the last day of a Cataract Canyon trip, Justin, Max, and I swam across Lake Powell to the other side of the canyon. Justin had been there for me on Skull Rapid and we'd been close friends ever since. Max had been working there since my second year; we were friends, but on the cusp of something more.

The water was cool on our sun-dried skin. The moon was small and provided just enough light on the rippling water where we played "Here, Kate, hold this!"

From the canyon ledges, Max and Justin picked up the heaviest rocks they could and handed them to me. I'd sink under the weight as far as I could, drop the rock, and pop out of the water from the buoyancy of my lifejacket. We soaked in the joy of being young and carefree and happy. After running two back-to-back Cataract trips together, Max and I kissed. I could say we were dating, but we didn't "date." We played, we baked in the southern Utah sun, we laughed, and we fell in love on the river.

At the end of my three summers as Kate, river guide, I said yes to another new name; this time a new last name. Max proposed to Kate, Katie, Katherine; after my time on the river I wasn't so concerned about what my name was or the message it sent. I was happy just being me, happy we were together. Max's family met me as Kate, and so they, along with all my river friends, still do. My family and everyone I grew up with calls me Katie. The difference means less than I once thought it did. It's all the same person now and there are more important things to think about—like planning next summer's river trip with our four sons and our river friends.

LESSONS FROM THE VALLEY OF THE SHADOW

LINDA HOFFMAN KIMBALL

In late March 2007 my husband Chris got a CT scan. He had been unwell with digestive problems for months. He had lost weight and had night sweats. He saw a GI specialist who suspected diverticulitis (a serious disease of the colon) and ordered the scan.

It was quickly apparent from the scan that Chris's problem was not diverticulitis. His abdominal cavity was filled with the telltale mucinous tumors signature of a rare (one in a million) cancer called Pseudomyxoma Peritonei (or PMP for short). The disease is slow growing, beginning with a burst tumor that then spurts mucin into the empty places in the abdomen. Over time the mucin crowds, distorts, and eventually crushes the vital abdominal organs. Inevitably comes disruption of functions and eventually death. Chris had probably been accumulating the PMP for ten years.

The night between the scan and Chris's first appointment with an oncologist was excruciating. An ill-advised internet search offered dire timelines and little comfort. I grieved as though he were already dead. We wept holding each other in our arms. I prayed loudly and emphatically for help, rescue, cure. I wanted to be on record with God about my wishes, all the while repeating what Christ prayed: "Thy will be done."

Learning to relinquish control over the outcome was constant. We and our eventual medical team would invest all of our combined intellect and energies toward Chris's healing, but the rest? That was in God's hands. Every day brought a honing of my humility, a spiritual workout towards acceptance.

We found a top surgeon, Dr. Paul Sugarbaker, who had success with this complex cancer and we traveled to Washington, DC from our Midwest home. When Dr. Sugarbaker agreed to take Chris as a patient, he had reviewed Chris's scans and knew the grim facts. He described Chris's case as "beyond category" and "ultimate."

We learned that the treatment for Chris's condition was a blend of barbarism and (literally) cutting-edge technology. The standard of treatment involved a massive surgery to remove the cancerous tumors followed by the application of heated chemotherapy directly into the patient's opened body.

We spent the two weeks before the surgery "getting our lives in order." Our nest was at least temporarily empty with our daughter settled in New England and our two sons on missions in Europe. We called our daughter. We called our son in Germany. We called our son in Holland. I was Relief Society president at the time and knew that my counselors were more than up to the task of overseeing things in my absence. In a blessing given to me by our bishop before we left for Chris's first surgery, I was advised to "write about this."

Throughout the process organizing these practical details I became aware of a shimmering grandeur of grace in all of these relationships, and in all the "ordinary" moments. How generous of J. to house sit for us. How reassuring to have S. take care of our mail and bills. How caring our friends were in tending other local responsibilities and an array of lackluster chores. How comforting to know that the world around us would continue to keep up its normal rhythms when internally seismic fractures threatened my sense of order. How connected I felt to our children—those incredible miracles—who shared the pain, anxiety, and holiness of this journey with us.

I began to see every ordinary act as a gift; every random driver at a stop sign, a fellow child of God on their own mortal journey; every ripple of sunlight through the newly budding trees a visual hallelujah. Everything became a simple sacrament of the present moment.

On May 15, 2007, Chris's operation began. The complexity of this surgery is on par with what is required to separate conjoined twins. The nickname for it is MOAS—Mother of All Surgeries. It involves removal of the tumor and irretrievably damaged organs (what might otherwise be considered a dozen or more major procedures) and then—crucially— putting things back together, absent some important pieces, in a way that life can go on.

Chris's surgery lasted fifteen and a half hours. He lay on the surgical table with his arms outstretched in cruciform. The doctor sliced him from the base of his ribcage to his pubic bone, keeping his abdomen wide open with clamps. For one of those hours Dr. Sugarbaker held Chris's stomach in his hands—carefully, patiently—peeling the sticky cancer off its surface and thus preserving it intact. He spent another hour doing the same to Chris's cancer-encrusted liver. During the surgery Dr. Sugarbaker performed a total of eighteen "ectomies," "otomies," or installations.

For ninety minutes following the surgery—but before he was sewn back up—Chris's injured and seared innards marinated in a toxic elixir of heated chemotherapy drugs poured into his open abdomen, sluiced around by hand for an hour and then drained out. This treatment (hopefully) killed any remaining bits of cancer the surgeon wasn't able to see and excise.

Chris survived the surgery. When he was finally assigned a room in the hospital, I thanked Dr. Sugarbaker profusely for saving Chris's life. He replied quickly with "We're not out of the woods yet."

I'm sure on some level I knew this. What struck me was that I was now facing advanced courses in the lessons of letting go. This was not one hurdle I had to jump. It was a lifestyle I needed to develop.

Luckily, blessedly, I had a host of helpers with this. I felt surrounded by love. Our families were our greatest comfort. Another way love was made manifest was through the online journal we kept on CaringBridge, a website that provides a forum for medical updates to friends and family. I feel certain that at least part of the Bishop's inspiration to tell me to "write about this" was to take advantage of this opportunity. CaringBridge provided a practical, and in some ways miraculous, forum. I wrote often and candidly.

First a few, then dozens, then hundreds of friends and family members from all eras of our lives wrote back supportive, thoughtful, funny, hopeful, encouraging messages to us. Even though many of the contributors didn't know each other, online they developed a group feel. People all over the world were praying for us and cheering Chris on. There were times when I felt almost physically lifted from despair because of the impact of those who knew how to "comfort those (i.e., us!) who [stood] in need of comfort."

The next weeks in the hospital were a cavalcade of tubes, stitches, infusions, drainage, strange alarms and beeps in the middle of the night, constant monitoring, frequent shots, fingertip pricks, pain killers, blood thinners, cautious walks down hospital corridors, and compression socks to ward off blood clots. There were frightening setbacks—a sudden and severe assault of double pneumonia from aspirating vomit, and serious problems with dehydration as we tried to get Chris in condition to leave the hospital.

Once we made it back to Illinois, we were stunned to see every tree in our yard adorned with yellow ribbons! We felt buoyed by their festive presence that night when I drove Chris to the local emergency room for another immediate IV infusion of saline. The first Sunday after our return I responded to the doorbell and found the entire Relief Society on my front lawn singing songs to welcome us home. No heavenly choir could have comforted and strengthened me more.

For the next six months Chris managed twelve grueling rounds of chemotherapy infusions and required IV fluids every night. A home nurse came to check on him every week. We learned new skills. Chris was soon nimble at setting up his IV on his own. Both of us eventually became adept at switching his ostomy appliance. With his unreliable hydration and adjusting to a wonky new digestive tract, he was down to his junior high school weight.

During these most precarious months I was constantly suffused with a profound sense of God's presence and love. It was strange—like breathing intoxicating air. I felt like I was saturated in a sense of the Divine and embraced by God's radiant, accepting, joyful love.

In February 2008 we headed back to Dr. Sugarbaker in DC for Chris's scheduled "second look" surgery. This meant slicing him open again along his torso's long incision to check for any remaining or new evidence of cancer (there wasn't any); to remove scar tissue from the vaporization and chemical burns (there was a lot); and to reverse his ostomy.

It has been years since Chris's "Mother of All Surgeries." He continues to be cancer-free. At his last appointment, his oncologist told Chris he didn't need an oncologist anymore. Chris will continue to have annual blood work done, but he's now trying to

persuade himself that when he does die, it won't be from PMP. His stamina is not what it once was. (I try to remind him that no one fifty or older has the stamina they once had.) He has an unenviable digestive tract making the entire digestion process uncomfortable and unpredictable.

Chris has always claimed that his task during the worst days of his medical crisis was very basic: to keep breathing, to sleep, and to heal. He learned how to surrender constantly, learning to take one day at a time. I noticed that when he was most ill he would thank me for every little kindness. I like to tease him that I could tell he was getting better when he started getting a bit bossy again.

While Chris was moving from one breath to the next, I worked overtime on the implications of this face-off with mortality. Much of what I experienced eased my transition into our new normal. I retain the witness and vivid memories of how deep, constant, thorough, abiding, and eternal that Divine Love is. I felt and feel His love for me profoundly and at a level unimagined before this wrestle with Chris's cancer. I feel God's love deeply and broadly for all of God's creations. It is amazing how all other matters get shuffled in importance when love is the predominant focus.

I remember now, as I did then, what a fabulous gift life is—full of wonder, generosity, and joy. I sense that dying is not the worst thing that can happen to a person; that we are all going to die; and that what matters most is how willing we are to accept God's will and in how loving we are to one another. In some indefinable way it feels like the task of mortality is to "become love" through Christ. By this kind of love, I don't mean becoming sappy, sentimental, or self-sacrificing without boundaries. I mean something muscular, potent and spiritually grounded enough, as Elder Bednar put it,* to "have the faith not to be healed."

This assurance does not, however, make me exempt from feeling worry, grief, loss, or even fear. When Chris had a prostate problem a couple of years ago, I felt as though I had stripped a bandage off a still-raw psychic wound. Until we knew that it was benign and dealt with, I fell immediately back in "preparing for loss" mode. I didn't feel like I had somehow lost the accumulated wisdom of those first years of Chris's cancer and recovery. Instead I felt aware that I would need to stretch again to both my own and heavenly reservoirs of insight and strength.

I have learned about patience and gratitude. Chris could easily never have survived the surgery or been left with extreme limitations and a poor quality of life. I feel a constant sense of stewardship and an impulse to both shout "Hallelujah!" and to quietly bow my head.

My perspectives have shifted. This is not solely from Chris's near miss. It is also the result of my own accumulation of years. It forces me to choose more carefully the ways I spend my time and emotional energies. As invincible as we like to think we are, we are all one diagnosis, one virus, one missed red light, one slip and fall away from our own mortality.

The task is to live the time we have abundantly. I love a Latin phrase I learned from another PMP patient: *Dum vivimus vivamus!* (While we are alive, let us *LIVE!*) This is

the kind of eternal Life Christ calls us to. Abundance, as it turns out, isn't limited to our "three score years and ten." It's not about time limits at all. It's about love, relationships, patience, learning, and gratitude.

And more love.

* Bednar, David A. "That We Might 'Not ... Shrink' (D&C 19:18)." CES Devotional for Young Adults. Lds.org. The Church of Jesus Christ of Latter-day Saints / Intellectual Reserve, Inc., 3 Mar. 2013. Web. 23 Jan. 2017.

I TELL MY CHILDREN

MELODY NEWEY

If you want to know me, look in here.
There will be no other record after I'm gone.
These slim cardboard volumes, I leave instead of ashes;

these and the songs I sang to you at bedtime,
melodies I hummed while stirring vegetable soup
late at night with the first autumn cold snap.

You will not find me bound in tidy brown leather,
gold leaf lettering the cover, nor embellished
with stickers on acid-free paper. I will be faded
to almost nothing where I wrote in pencil.

When you read, you may hear my alto or perhaps
remember the way my freckled hands turned pages.
You may discover a blossom pressed where it fell

unnoticed from the wisteria one summer.
Remember how it grew in braids up the ancient Cedar
by the corner of the house, how in early morning

while you slept, I sat beneath walnut trees,
wrote about robins digging worms in rain-soaked soil,
the crescent moon at daybreak?

You will find me recalling a certain sunset,
Lauren's golden hair, Sara tasting ocean sand,
the smell of Luke when he was seven.

If you look, you will find me here—
quiet in the hammock, the apple I was eating
fallen to the ground unfinished.

STEPPING OUT ON THE WORD

HEATHER R. KIMBALL

On a cold November day four years ago, I stood at the top of a small aluminum ladder and looked down into a big blue plastic tub of water. My friend, a mathematics grad student at a nearby Kazakh university, stood chest-deep in the water, his white tie and shirt halfway soaked as he reached up to take my hands. I locked eyes with him, trying simultaneously to clear my mind, think deep profound thoughts, and forget the dozen people watching me. Rashid smiled, squeezed my hand, and in a voice just loud enough for me to hear, said, "It's perfect." Relief and peace washed over me as I lifted my foot and stepped into the water.

It goes without saying that this step is a step of faith. I can think of few times when I felt more acutely the fact that I did not and do not "have a perfect knowledge of things" (Alma 32:21). The night before my baptism, I literally trembled as I thought and prayed on the gigantic step I was about to take. I read Moroni's urging to "come unto the Lord with all your heart, and work out your own salvation with fear and trembling before him" (Mormon 9:27) and thought to myself, "Well, I guess fear and trembling are just part of the package." Maybe fear, and doubt, and worry, and even trembling are part of the experience of making important covenants. God certainly wants us to take them seriously. But I don't believe anyone steps into the waters of baptism focused exclusively on their trembling. Even with my heart thumping and hands shaking, my feet walked resolutely past my fears and doubts toward the golden glimmers of hope I saw in the water.

Fearful tremblings and divine assurances had dotted my path before. When I received my long-awaited invitation to serve as a Peace Corps Volunteer in Kazakhstan, I burst into silent tears in my living room. I had recently rekindled a flame with my college boyfriend, but had a sinking suspicion that two years and eleven time zones would prove too long and too far for our blossoming relationship. My internal feminist wouldn't allow me to tell anyone (or even acknowledge to myself) that my primary concern was about a boy, so I talked with others about fears of leaving family and worries about losing grandparents while I was gone, but when I eventually knelt in prayer about my decision, it was the fear of breaking up, losing him, that I brought before God.

Tears dropped one by one onto baby blue sheets. I sat huddled at the foot of the bed. Go to Kazakhstan and risk heartbreak, or stay and preserve my hopes for a long-term

relationship. I didn't expect a divine answer; I had never received one before. Weighed down at each choice, I prayed, and felt a warm and gentle hand beneath my chin, lifting my face up. My eyes moved from the scales weighing my current concerns to focus on a distant vision of my future self. Wordlessly, I felt the message: This step is just one step, my child. Trust me. I know where you're going. My tears stopped. Calm and courage coursed through my veins as I sat back, confident that I would go to Kazakhstan not knowing what would become of my relationship, not knowing anything except that this was right; that if I would take this right step, and each right step that followed, God would make sure I ended up where I needed to go.

My time in Kazakhstan held much more than I could anticipate: loving host families, eager schoolchildren, a new poetic language, and boiled horse meat. And time. Solitude. To read and reflect on faith. I connected with one of the two LDS branches in the country. Sister missionaries taught me while I was in training near that branch, then over Skype when I moved to my permanent assignment eighteen hours away. They asked if I was ready for baptism. I wanted to, but I wrestled with scriptures and doctrines that didn't fit neatly into my liberal feminist worldview. I struggled to feel at peace with every piece of the whole Mormon doctrinal/cultural package.

As I perseverated on my fear and trembling, a loving friend had the wisdom to share a partner verse to read alongside Mormon 9. We read in Doctrine and Covenants 52:17:

> *And again, he [or she] that trembleth under my power shall be made strong, and shall bring forth fruits of praise and wisdom, according to the revelations and truths which I have given you.*

I wanted to be strong. I wanted God to take my tremblings and make them my strengths. I wanted to confidently proclaim those words I'd heard so often from the pulpit: I know. But I didn't know. Not really. Not everything. I'd been "investigating" for over a year and still felt like I might not pass the final test. I wouldn't be bringing forth fruits of praise and wisdom any time soon.

I did know some things. I knew that through prayer I had found the kernel of personal truth and guidance that had brought me to Kazakhstan. I knew that I had felt God's love. And I knew that I wanted to feel it again; every little anxious fiber in me was thirsting for him to "pour out his Spirit more abundantly upon [me]" (Mosiah 18:10). This hopeful thirst led me to baptismal waters, and there I discovered that even someone as trembling and doubtful as I could be courageous and take a step of faith. To step courageously toward those things I hoped for but had not seen. I could have the faith to step into a covenant with Christ.

I still tremble. I grapple with the magnitude of decisions I'm making, the millions of missteps I might take, the billions of questions I don't have answers to. I tremble like a reed. But I don't have to know everything perfectly; it's okay to quiver and shake, to tremble. Exercising a particle of faith, listening to the Spirit is enough.

On the morning of my baptism, the water faucet that filled the baptismal font had stopped working. Fast-thinking missionaries pulled a garden hose through the window, across the Relief Society room, and into the blue plastic font. Water that, in the early Kazakh winter could be generously described as chilly, filled the font. I sat in a back room, changing into white, talking nervously with my mother, and confronting my trembling heart as loving members and missionaries heated kettle after kettle of water so that my baptismal waters would be warm. It was time. When Rashid stepped into the water before me and said, "It's perfect," he might have been talking about the temperature. But I felt that he—or the Spirit that filled him—was saying to me, "Heather, this water, this covenant, this promise, is perfect. You may not be perfect, and you may not know all things perfectly, but take hope, and keep faith, because this step will be perfect. With this step, you may be perfected in me." And so I stepped in.

TENNIS HAIKU

MELISSA YOUNG

The kids decided
to exchange a real dinner
for some hastily

made sandwiches and
a trip to the park to play
tennis. I brought a

book to read (written
entirely in haiku),
thinking they would play

while I read. But the
book ended up courtside while
we took turns smacking

our delight back and
forth, managing in thirty
minutes to lose all

three balls. When I picked
up my book on the way out,
there was a cluster

of ants underneath,
and the idea of insects
joining us to munch

verse completed the
wild perfection of a day
where crows sang with doves

and bees hummed madly
amid reckless blooms, and the
breeze laughingly cooled

our skin where the sun
had warmed it, and we returned
home squinting from the

new angle of light,
the smell of summer's coming
clinging to our hair

like a blessing and
a promise of more lost balls
sailing out of reach.

GRAPPLING

HOW TO KILL
A COCKTAIL PARTY

TRESA BROWN EDMUNDS

Whenever I'm at a gathering with moms there is always a moment. We're sitting around with wine glasses and Coke cans, nibbling on cheese and things covered in chocolate, and I find a moment where I have to ask myself, "Do I participate in this conversation and drag down the room? Or do I pretend I don't exist?" I sit there with my mouth full and what I hope to be a warm smile on my face while I nod at the stories of sassy-mouthed children, the troubles with getting into the "good" school, funny stories of potty training or picky eating or driving all over town to practices.

I have those stories too, only no matter how I tell them people react to them as tragedies. My son doesn't go to practices, so I drive him all over town to get to physical therapists and neurosurgeons and county specialists. There was really only one school option for him—a class that focuses on the "orthopedically impaired," but I did have to fight to get him appropriate educational access. My son might never leave diapers, which means, no matter how ridiculous the poop story, it will always carry a subtext of fear. And he is certainly sassy, but the stories involve so much context—the television shows he quotes, the body language he uses, how he uses his disability to manipulate people around him—that they don't make great cocktail party anecdotes.

I want to draw connections between our experiences. I want to feel not so desperately alone. I want to do my part as a disability advocate to insist that people with disabilities are always a part of the conversation. But without fail, every time I do, I watch as the eyes widen, the smiles turn to grimaces, stammered out "Oh, really? Good for you!" takes the place of actual conversation, and another potential friendship wanders away to see if there are any more cream puffs.

Speaking about your disabled child in a room full of acquaintances triggers every conversational minefield. All social niceties of not bringing up religion or politics or personal information get completely ignored as people frantically search for something to fill the empty air.

"God never gives us more than we can handle."

"Isn't it a shame our politicians don't make 'this' more of a priority?"

"People with disabilities are such special spirits. God sent them to teach us."

"Obamacare must be terrifying for you."

"I know just how you feel: I have a cousin in a wheelchair."

"How did it happen? Was it something you did while you were pregnant?"

"It's so hard. I have gout in my left foot and what I've had to go through to get that treated ... "

They throw out all manners and common sense because their brains are busy trying to hide the terror. They fear saying the wrong thing—which they will—but the dread goes deeper than that. It's that primitive terror that tragedy is catching, that the world is uncontrollable, and that misfortune awaits around every corner. Their illusion of safety is shattered because you are a living, breathing example of the boogeyman under their bed. They arrived, unsuspecting, thinking they're going out for a much-needed breather in their own struggles with parenthood, and just when their guard was down here you come: proof that no amount of five-point harnesses and good schools can shield a child from the hardships in life.

I took all my prenatal vitamins and drank orange juice like it was mother's milk. I read all the books and said all the prayers and monitored my weight and exercised enough but not too much. I made my own organic baby food. And my son has cerebral palsy.

I came by my hypervigilance honestly. It took us eight years of surgeries and medication and fasting and prayers and invasive procedures to treat our infertility and add our son to our family. During all those years of doctor's appointments and longing I'd have those same conversations with parent friends, only I was an outsider still because I wasn't a mom. But there was no terror in that, just condescension. My conversational partners would wave off any differences with a "someday" or "but you know what it's like to love kids" or "all women are mothers." It was unsatisfying and alienating, but not conversation-killing in the same way that talking about Atticus is. I didn't provoke any deepest fears when I was just a childless infertile. Back then I longed for the day I would be able to fully participate. I dreamed of cracking up a roomful of friends with hilarious misadventures and feeling like I was part of a tribe. I never imagined I could be any more left out, any more misunderstood or invisible. I was wrong. The price of belonging in this circle of women balancing plates of hors d'oeuvres on their palms is to betray my child and pretend he's just like most other mothers' children.

Before motherhood I had nameless potential. I could be lumped in as a token, a reminder of more carefree days, included as part of the village raising children. After becoming a mom to an adorable and brilliant little boy—who uses a wheelchair and doesn't talk like other kids and doesn't play their kind of games—I'm fears realized. People see us and they have to remember that chaos exists, that accidents happen, that bad luck is not offset by wealth or righteousness: a burden to live with. It's much easier to pretend it's not there.

We were lucky in that we discovered Atti's disability early—too early. He was born at twenty-eight weeks and spent three months connected to tubes and wires that provided

him what my body couldn't. Born that early and that fragile, he was given frequent brain scans to check for damage, and in Atti's case, some showed up.

One night we came to the hospital for our regular visit and we noticed a tension in the nurses. "Has the doctor talked to you yet?" said with forced brightness, "I know the doctor wanted to make sure she spoke with you." She brought us into the private room where short timers got to sleep over and sat us down on the hospital cot. She showed us a picture of the tiniest little skull and the unmistakable dark spot in his brain. I know she spent a lot of time telling us what that meant, but her words are lost in my memory. All I remember is the image of that brain scan and the sensation of my dreams crashing so violently it was tangible.

The way Cerebral Palsy works is that you won't know there's a problem until there's a problem. Each kid develops so differently, the results of injuries so myriad, there's no looking at a baby and saying, "They won't walk, and they probably will only speak in rote phrases." Maybe they will be a quadriplegic, maybe they'll just end up with one leg shorter than the other. You don't know what these kids will do or not until they do it. Or not.

This has been a cauldron of worry and fear, lying awake at night wondering if he'll ever live independently, if he'll ever walk, if he'll even be able to communicate. Hearing family members speculate if he'll ever marry or even understand what they're talking about. And sorrow as one by one all the things that were once so important to me became impossible. For three months I laid in bed watching Tyra Banks yell at wannabe models while I was strapped to a breast pump. I felt so strongly about breastfeeding and was so committed to success that I pumped for twenty minutes of every hour, all day and night, only to watch as my milk supply decreased every day I was away from my baby. By the time he was finally healthy enough to try to nurse, it was more work for him than the calories I could provide.

Once I accepted the fact that Atti had special needs, once I accepted that his growth was never going to match up with a neat little pediatrician's chart, I realized that the regular mommy judgments don't apply to me because we have a big asterisk on us over here.

How could I carry guilt for not breastfeeding when it was because Atti was in the hospital? How could I beat myself up about not using cloth diapers when it was because they didn't work with multiple caregivers? How could I feel bad for not holding him more, letting him watch television, exposing him to plastic, blah blah blah, when it was all because he had special needs?

What I've learned is that every child has their own set of needs. And the grief and guilt and shame we feel as parents always comes in when those needs, coupled with our needs, don't meet our expectations. From the early days of apologizing for bringing a processed playgroup snack, to fights over what career path our children choose, it is always the friction of expectations rubbing up against reality that causes the pain.

What I wish I could tell those moms, in the moments of the record scratch, in those milliseconds of realization that my child is different, as the fear soars in to crowd out anything else I might say, is that I know things now. When they feel guilt or shame in the middle of the mommy wars, I wish I could give them my answers. Answers that were learned in the hardest ways: watching your child wake up from surgery, confused and in pain; watching your child singled out as different or ignored; having to let go of every dream you had for yourself to relish in what is real. When other moms are overcome with fear about the future of their child, I wish I could show them that your fears coming true aren't the end of the world. And someday, when their child is a teenager and they're fighting over their expectations and the freedom their children long for, I wish they'd find me.

Here's what I know: The trick to joyful parenting is to take a rag, stuff it in a liquor bottle, light it on fire, and toss it into an open window of the building that holds all your expectations.

"Letting go" isn't enough. Destroy it. Dance in the embers. Send out invitations and celebrate the anniversary of the day you stopped worrying. List that as one of your best qualities. Measure that every day instead of your weight. Gnash it with your teeth and rend it with your fingernails and stomp it into the dust. This is something you will do every day. Every minute of every day. You will have to retrain your thoughts and the people in your life to stop grasping for the usual and celebrate what is.

What I didn't see trailing along behind all that worry was a secret benefit. Knowing how many obstacles were in Atti's way also meant that every accomplishment is cherished and celebrated. Week after week I would put him on a quilt for tummy time, as I sat on the couch and cried and sat on my hands. Week after week, month after month, I forced myself to not pick up my baby as he struggled. Until one day, as I watched, biting my lip afraid to breathe in case I spooked him, he pulled himself like an army commando to get to his favorite toy. That was all it took to make my sacrifices worth it as I hoisted him up like Simba the Lion King and danced around the room. The day he legibly wrote his name was filled with such joy that I refuse to believe his wedding day would be any better. Even when he smarts off, by closing his eyes and refusing to look in my direction, pretending he doesn't understand me, or playing up his disability to make his babysitter put his toys away for him, I can't help but marvel at his creativity.

Expectations bury joy. They suck the sweetness out of discovery. Every accomplishment is burdened with the knowledge that someone did it better or first. Competition reigns instead of wonder. Instead of rejoicing in a child developing language, we panic about how many words their peers can say. Instead of communing with other parents, we worry that they're judging us—and maybe they are because they have unfair expectations of the parents they associate with. We hold ourselves up to a standard that has never existed in fiction or history and hate ourselves for not meeting that expectation.

Imagine what your parenting might look like if you allowed yourself the freedom to discover. If you celebrated your own milestones unburdened by what it looked like to

anyone other than your child. If you brought the same wonder and victory to your own growth that you do to the marvels of a child's development. Because parents develop in just the same way. A parent is born on a child's birthday, confused and crying, learning about the new world they've been thrust into, only they think they know all the milestones and heartaches and good choices that await them. But that's an illusion. Because whether your child gets married, goes to college, finds a fulfilling career, practices the religion they were raised with, or even lives to adulthood, is all to be determined. You don't know what they'll do until they do it. Or don't.

But in the meantime, there are so many victories to be celebrated. And cocktail parties to dominate with the power of your secret wisdom.

TRUTHS REVEALED FROM A NAKED ADONIS

LESLIE M. W. GRAFF

The docent pointed me to join the group of twelve-year-olds loosely assembled around the fountain in the center of the Great Hall of the Saint Louis Art Museum. We stared silently at the floor and nervously fiddled with our sketchbook spirals and pencils, consumed with an adolescent cocktail of awkwardness and self-consciousness. United by the common themes of "my parents me signed up for this class," and "I like art," we waited for our teacher, then followed her like reluctant ducklings into the Ancient Art gallery when she finally arrived.

Marble sculptures of unabashed Adonises and voluptuous Aphrodites stood on pedestals, with spotlights illuminating the planes of their muscles. The next thing I knew, I was seated on the floor with my compatriots, pencils and sketchbooks in hand, and we were staring up the chiseled marble sculpture of a nude Greek, tasked with the assignment to draw him. I laid my eyes on this stone body and thought, "I don't even have these parts. This certainly does not look like the "boy" diagrams I've seen in health class. How am I supposed to draw this?" I stalled, fumbling with my pencils, unwrapped my pristine gum eraser, and opened to the first blank page in the sketchbook.

I was used to painting flowers from the plastic wells of an inexpensive watercolor set, or doing still-life drawings of fruit in elementary school art class. So it should be no surprise that my first lines were faint and tentative, the kind that were easily erased. I hunched across my sketchpad, trying to obscure my drawing from the rest of the class and the casual Saturday patrons who wandered past. I struggled to replicate the curves and troughs of the rippled torso. This might have been the longest three hours of my life.

When my teacher announced we had five minutes to finish up, I immediately started shutting down. I had done my time, and it was time to put it away. The torture of witnessing my own imperfection and owning my anatomical ignorance was over.

Only it didn't get better: it got worse.

The next step in my artistic indoctrination was critique.

"Bring your sketchbooks and line them up here against the bench," she motioned to a spot at the feet of the statue. "Critique is where we share our work, and we get to talk about what is working in your piece and possible areas of improvement." I knew that was teacherspeak for the worst things about your drawing.

This was no "I'll show you mine if you show me yours" agreement. This was a forced reveal. I didn't want anyone to see my drawing.

I propped my open sketchbook by the bench and hurried back to place on the floor as discreetly as possible, hoping to create distance between myself and ownership of that drawing.

Our row of pictures cowered at the feet of the statue's ageless perfection. These were poor offerings to the art gods. There were sloppy, dark ones, sadly disproportionate ones, tiny ones ill-suited to the paper size, and others timid, anemic, and tentative like my own. There in the echoing mausoleum of a gallery, in the company of the unclad Adonises and Aphrodites, I was to be laid bare to the scrutiny of my peers under the gentle, but still "constructive," commentary of my instructor.

The teacher started at one end, praising the "bold strokes," "nice lights and shadows," and offering her gentle yet honest suggestions to "work a little bigger, really fill the space" and "work on adding the highlights." I could feel her getting closer and closer to my piece. My face was hot and flushed. "Nice use of space," she offered me. "Don't be afraid to really get in there with the darks."

I looked at the dark pieces she was praising. They looked so dirty and ugly to me. I didn't really know whether I even thought her suggestion was worth taking.

The faint outline of a naked body on my paper seemed to expose my personal nakedness, my fear of mistakes, my belief that perfection was attainable and everything should be happy and good.

I was the girl with the straight-A report card, the girl who never got in trouble. I believed you could live life without any darks. Wasn't that the goal? I loved this safe world of gold stars and praise.

My teacher's critique was of the twelve-year-old me as much as it was of my art. My sketch was an embodiment of me, my life in light grays. My nakedness yet unexposed, my avoidance and inexperience with the darker things in life.

Class ended and we shuffled back to the fountain. As we walked back to the car, my mom asked me how class had been. "Good," I lied. I talked vaguely about going to the gallery and drawing from sculptures and knew she was going to ask to see mine. I lifted the cover of my sketchbook only allowing a quick flash. Then I steered the conversation to anything else, not wanting to revisit that naked torso, my feeble drawing, and worst of all the humiliation of critique.

I didn't think I could do this for the next eight weeks, but my parents paid a lot of money for the class, so I was stuck.

The weeks came and went, as did many bad drawings, and many suggestions for improvement in critique. As I was forced into the vulnerability of showing my work, I found deeper honesty within myself. I had to admit I wasn't perfect at this or a lot of other things.

Would that balance of light and dark make my drawing better? Without those bold, deep shadows, my drawings were forgettable, powerless images.

I even began to make darker marks, realizing they were necessary to give form to what I drew. Somewhere in the charcoal dust and pencil shavings, the nervous kneading of

gray erasers, I began to realize that darks were necessary in my life too.

Those critiques didn't hurt so much either once I realized they were there to help me learn things, to see with someone else's eyes the things I missed. I never would have believed that first embarrassing drawing class would be what taught me to step out of the garden, learning that innocence and seeming perfection and goodness wasn't the goal.

Growth was the goal, and it would be messy and dark while I learned to work with what I had.

I was taught to see the glass half full, so much so that I wouldn't let myself appreciate the half empty. There were parts of the human experience I hadn't come to understand yet. I thought opposition meant that one side (the good side, the light side) should always win. But really, it's that we all have to experience a lot of opposites.

Each drawing, book after book of sketching, was an evolution for me, not just as an artist, but in my understanding of life.

Dark isn't something to fear, but to put in perspective.

Shadow illuminates light.

The effort of attempt is good for something.

Critique is not about criticism.

Improvement takes effort and work.

Somehow this place of endless pages of blank paper, erasers, and painting over and over again has taught me to not be afraid. Learning as an artist meant turning the sketchbook page again and again. There was always another attempt, a way to change; endings were negotiable.

As a professional artist, my studio is filled with pieces. Big, bold ones, confident ones, half done starts, and good ideas that got lost in muddled execution are all out in the open.

There are also stacks and piles of sketchbooks filled with the figure drawings I do on Thursday afternoons at the Worcester Art Museum. I still grapple with grasping the complexity of form, and what it means to be human, in shades of black and white and gray. I don't go fill an assignment, I go to work on something I haven't mastered yet; I go to practice, to try and fail, and to face my imperfections more peaceably. I go to see things through other people's eyes. In the dark marks and contrast I still sense echoes of my middle-school dread, but I also embrace the defining depth they offer.

The oppositional necessity I had been missing. My innocent experience, while beautiful, was flat. Experience revealing deeper shadows: sin, sorrow, injustice. Things repugnant and foreign in my childhood world were now focusing in my consciousness and reality. I missed the tension of humanity, the form that comes from a light place next to dark, only in acknowledgment, not avoidance.

It took years of seeing it all: injustice, illiteracy, death, poverty, disease. I had travelled the world. Doing humanitarian work, I worked with hospitalized children, taught in low-income schools, got dirty, faced my own imperfections, lived through bitter disappointments. I felt like naked Eve stepping out of the perfect garden. Paradoxically, knowing that experience, hardship, and even failure was the only way.

UNCALLED FOR

ANNA SAM LEHNARDT

"God loves us equally, but he loves missionaries just a little extra," the sealer winked as he congratulated the bride and groom, who had both recently returned from missions.

Across the room, my mom's eyebrows shot up and the light caught her eye as she laughed. My husband of just four months threw his arms around me, and out of the corner of my eye, my mother-in-law and aunt winced. I had the distinct feeling that we'd all been relegated to some sort of awkward club for high school misfits while the rest of the cool kids got to go to the party.

Ben's hug lasted, protecting me from what we'd just heard. And in it, there was shock—shock that anyone could think that God loves girls who serve missions more than girls who don't, even more shock that anyone would say so out loud.

I explained to him after the ceremony that this was not the first time someone had told me God loved me less because I didn't serve a mission. I was used to hearing it, from friends who served, from boys I'd dated, from parent after parent, and even some bishops. I had learned to have confidence in and gratitude for God's plan for me, but it still hurt my feelings when I was treated like a second-class disciple because that plan hadn't involved eighteen months in a calf-length skirt and a nametag. But surrounded by three of the women I admire most, all of whom also hadn't felt the call to serve as full-time missionaries, the suggestion no longer seemed hurtful or judgmental; it was simply hilarious.

Especially hilarious, because if I had believed it, nothing could have been more damaging to my self-esteem. Ever since I was eleven, I had planned to serve a mission. I'd grown up surrounded by three brothers—the knights to rescue me when we played castle and the lost boys at my side when we'd swashbuckled our way through Neverland. They were my best friends, my heroes, and I knew, for as long as I could remember, that each of them would one day go on a real rescue mission. Each would spend two years of his life thousands of miles away from me, sharing the joy of the gospel with people who spoke different languages and lived different lives. And I knew, as surely as I've ever known anything, that I would not stand back and leave such a noble sacrifice to them alone.

So when I knelt at nineteen for a confirmation of my decision to put my papers in in two years' time, I didn't understand the emptiness that washed over me. I must have prayed wrong, I reasoned. Or perhaps I had simply tried too early. I would try again in a year or two, when the mission would truly be on the horizon.

In the meantime, I wrote my brother serving in Houston. I baked him a terrible batch of lemon bars (no lemon zest) that I never sent. I made up for the bad lemon bars with

scads of cookies. In my novels of letters, sometimes ten pages or more, he got more information about my high school life than any of my friends, or my journal. I thought of myself as the homefront, too young to go out now, but running support 24/7.

Dex came home to balloons, welcome banners, chalk art all the way up the driveway, death-grip-tight hugs, and enough star-shaped Rice Krispie treats to feed a small whale. All the time, I checked in when I prayed on the question of my own mission. Radio silence.

I began to feel like a three-year-old nagging at a parent from the backseat. Many of my prayers were answered, but to the question of a mission, I received nothing but silence. Stupor upon stupor continued, until the spring before I turned twenty-one, when I got direct instruction to start working on the paperwork—for a study abroad to northern Germany.

I went. Maybe the language immersion would prepare me to serve a German-speaking mission, I reasoned. I already spoke French fluently, but hey—maybe the Lord needed me in Germany or Austria instead. I'd partially given up the idea of a mission after years of prayer, but I still wondered if this program might be my preparation.

And then I met my Wendy. She was a student in the international studies section of the study abroad, a few years older than me and much taller. As we became friends walking the flat fjord of Kiel and ordering streuseled rhubarb tarts at bakeries, strangers would ask if we were sisters. Neither of us, funnily enough, had any sisters at all. I was immensely grateful for Wendy; for the first time in my life, I was the only Mormon I knew, and I was desperately lonely. Each Sunday, I took the hour-long bus ride to the ward by myself. Every day, I rode back alone. Rampant loneliness and some spiritual nudging forced me to the front of the chapel to bear my testimony just three days into the program. I was jet-lagged, sobbing, and stuttering through long German words, but I was grateful for the Spirit—the one friend that had come with me to this tiny city on the sea.

But Wendy was my second, and by the fourth week, I was dying to bring her to church with me (and also to have someone to sit with on the bus). I casually told her which bus I'd be on, then suddenly, the next day—there she was, hopping on the 52 at 8:44 a.m., wearing a skirt and coming to church for the first time in ten years. Six months later, she hadn't missed a week of church, came to Institute with me twice a week, had been through the temple, and had received a call to serve in Latvia.

So this was our adventure—there was no nametag and no tracting, but Wendy came home. And though I learned a great deal in Germany, I often think that I might have been sent there solely to find Wendy. My unplanned missionary effort taught me that God does indeed love every soul and count every sparrow, and sometimes he will send us halfway across the world to find them.

I never got a mission call. Not when President Monson announced that young women could now serve at nineteen, nor in the wake of mission applications many of my friends gleefully rushed to fill out. Not after I prayed, and double-checked, and triple-checked, and probably risked Martin Harris-esque desperation. I wrote my friends, I

watched them come home, and then I stood up to needling and speculation—why didn't I serve? Was I unworthy? Was I scared? Most likely I was selfish. The more I dated, the more aware I was of my status—cute, good, but not great. Not valiant. When I started dating my husband, my mother-in-law was bombarded with similar comments: "She seems lovely. But she didn't serve a mission." "If only she'd served a mission, she'd be just about perfect for him."

How little we know of each other's missions on this earth. How few people knew Christ's mission; He shared its full extent with only a few before he went to Gethsemane.

When I met Ben, I was serving as the first LDS editor-in-chief in memory of the University of Utah's notoriously liberal *Daily Utah Chronicle*. Thirty years earlier, my dad had written Op-Eds to *The Chrony*, defending the Church to repeated libelous articles published in the paper. Into the late hours of the night while we were waiting to go to press, I'd bend over the proofing pages and explain to page designers that no, Mormons do not hate gays, bishops do not stalk inactive members when they move, and of course—that full-time missions are not required.

Why didn't I go on a mission? I don't believe God turned me down because I wasn't good enough for His field. Now I know: I didn't serve a full-time mission because God knows me, and loves me, and He had another plan and other needs for me. His plan was complicated: It involved dragging a crew of hungover sophomores through Oslo and reminding them that life is beautiful without vodka or beer, teaching a dear friend with same-sex attraction that he was still very worth the love of a friend, assigning and laying out the school newspaper's coverage of General Conference, training to be a loving wife and mother from angelic women surrounding me, and more glorious twists and turns than I could ever count.

So that day when the sealer speculated about how God divides His love amongst His children, I smiled, knowing the deeper truth: First, that God loves us equally, entirely, and more intricately than our mortal minds can process. His love comes regardless of who we are or how we live our lives. It doesn't matter what we look like, or think like. But secondly—if we are after His kingdom, and seeking His will, we shouldn't measure our lives by whether or not we served a mission, but by whether or not we served His mission. This is not something on a checklist—we cannot complete it in eighteen months or two years, or even on repeat service as a couple. It's an ongoing task, from morning to morning, now through our whole life, and if we're up to it, it will be far grander than anything we ever would have planned for ourselves.

FIELD WALKING

ANGELA HALLSTROM

Jennifer is a mother of three—Sadie in high school, Carson in middle school, Jordan in elementary—which means weekdays start at six a.m. and quickly unspool, devolving into a mad scramble of showers and hair dryers and cold lunches and lost homework and family prayer and kisses goodbye, the front door slamming its exclamation with each departure until eight, when her husband, Dean, loads Jordan into the car to take him to school on his way to work.

By 8:05, the house is perfectly still. Most mornings, Jennifer turns on the *Today Show* while she does her chores, the hosts' friendly chatter filling up the quiet as she unloads the dishwasher and sweeps the kitchen floor. Then she takes off her pajama top and puts on her sports bra and does her *Thirty Minute Yoga Blast* DVD. Then she takes a shower. Then she puts in a load of laundry. Then she does her makeup and her hair. Then she decides what else she needs to do, and how, and when.

Most mornings.

Not this morning, or the last few weeks of mornings. A few months have passed since the miscarriage, and for the first time in her adult life, she feels the charge of rebellion in her veins. She's dealt with anxiety and sadness over the years. She even experienced a full-blown bout of postpartum depression after Jordan was born. But never before has she felt this urgent impatience, more powerful than frustration but not quite tipped over into rage. And she's doing all sorts of surprising things. One morning last week she stayed in her pajamas all day long and ate s'mores for lunch, toasting the marshmallows over the bright red coils of the stove burner. A few days after that, instead of going to the grocery store, she drove forty minutes south to the Mall of America, where she bought two new bras from Victoria's Secret—neither of them white—and a book by a self-proclaimed psychic about energy healing. She sat in the food court overlooking the Nickelodeon Universe indoor theme park, hysterical adolescent screams approaching and receding as the roller coaster rattled by (why were these kids not in school?), and read the strange little book cover to cover. She pulled in the driveway just minutes before the kids were due home, but none of them asked her what she'd done all day or where she went. When Dean arrived home from work and asked, "How was your day?" she answered, "Fine," then paused and said, "Different." He responded with a distracted kiss on the top of her head. She left the new bras in the shopping bag, the tags still on.

This morning, as soon as the front door clicks behind Dean's back, she winds her dark hair into a messy ponytail and heads for the car. Last night's dinner dishes remain in the

sink and she hasn't done laundry in almost a week, but she doesn't care, and this apathy both astonishes and thrills her. Today, she thinks, will be a movie day. She'll head to the library and stock up on a few films she's been meaning to see but hasn't made time for.

She drives there with the windows down and the music up high, the radio tuned to a station her daughter Sadie likes, and she sings along with Lady Gaga—no you can't read my poker face—impressed with herself that she knows both the singer and the words. She's aware, too, that if any of her children were in the car with her, they'd beg her to stop singing.

Inside the library, Jennifer stands in front of the rack of DVDs, disappointed. Most of these movies are old, and many are of absolutely no interest to her. She considers *Shakespeare in Love*, a blushing young Gwyneth Paltrow on the cover, but Gwyneth seems suddenly unbearable to her, so stridently blonde and healthy and apple-cheeked, as if she'd tucked the key to happiness inside her ruffled blouse, right next to her perky twenty-five-year-old bosom. No, she doesn't want Gwyneth, and she doesn't want Julia Roberts or Reese Witherspoon or even Kate Winslet, bonneted and demure on the cover of *Sense and Sensibility*. Jennifer also moves quickly past any movies for or about children or teens. She wants to watch a grown-up film—a movie made by grown-ups, for grown-ups.

And then she sees a title that makes her stop and consider. *Brokeback Mountain*. She remembers the movie receiving a good deal of acclaim years ago, but back then she never would have considered seeing it. Not only does the movie deal with homosexual relationships, but it's rated R, and Jennifer hasn't seen an R-rated movie since the early 1990s. She pulls the DVD case from the rack and recognizes one of the leads, Heath Ledger—the poor young actor who died a few years ago. She'd seen him as the Joker in that *Batman* movie Dean dragged her to ("PG-13 for cartoon violence," he'd said when she objected) and his performance had literally haunted her dreams: his menacing, blood-red smile; the wildness in his eyes. On the cover of this DVD, he looks like an entirely different person—so lovely and so sad. She realizes her heart is pounding at the thought of taking this movie home. Should she? Can she? Then she feels her apprehension turning inside her, twisting into indignation and, finally, cool decisiveness. She is a grown woman. Grown. Who's to stop her?

She watches the movie in her bedroom, tucked up under her covers, the blinds closed tight, and her heart races with anguish and empathy as each character on the screen tries so hard to love and be loved, and then fails. The pathos is almost unbearable when Heath Ledger is on screen. He's so vibrant in all his doomed beauty, his wild blonde curls and the sweaty shimmer of his skin radiating life. So young, so unaware that his real-life death sits crouching just around the corner, waiting to steal away his earthly promise. God needed him. Surely someone said those terrible words to his grieving mother; someone will say them, someday, to his orphaned daughter. The thought of it makes her want to weep. Who are we to feign understanding of God's mysterious needs? she thinks. Why must we bend our tragedies to fit His unknowable will?

It must not have been the Lord's time. Those were the words her own mother said when Jennifer called to tell her about the miscarriage. Jennifer didn't answer her or acknowledge the platitude in any way. She simply gripped the phone and breathed, and as the silence between them continued, her refusal to speak gathered weight and power, became an act so aggressive and courageous that she still can't quite believe that she, Jennifer, was the woman withholding even a murmur of assent.

After the movie, she curls onto her side, her knees pulled up against her chest. When she finds herself sliding into sleep, she doesn't fight it. She sleeps deeply, never dreaming, until she hears Carson, home from middle school and pounding on the locked front door. She hurries downstairs, apologizes for locking him out, and then busies herself cleaning up the house and preparing dinner as usual—grilled cheese sandwiches and chicken noodle soup, one of the few dinner combinations that each member of the family will eat without objection.

But she doesn't sit down to the meal with the rest of the family. Instead she grabs the keys and the movie that needs returning, holding the DVD case with the scandalous title facing out, and when Dean asks where she's going, she answers simply, "Errands." When she arrives home she walks right past Dean and Jordan at the kitchen table, sweeps by without a word as her husband quizzes her son on his times tables (it's the sevens—the unbearable, unknowable sevens, a quiz he keeps failing, the cause of incalculable tears). From her bedroom, Jennifer can't help but hear Jordan's voice escalating, stressed and panicked, punctuated occasionally by Dean's rumbling baritone, but she chooses to stay in her room, reading. At one point, Carson lingers outside her open door, unaccustomed to seeing his mother lying down unless she has a migraine or is ready for bed. But she doesn't look up from her book. She doesn't go downstairs and join any of them until it's time for family prayer.

Then all night long she sleeps fitfully, Dean's rhythmic snoring and the stifling weight of the bed covers bringing her up out of her dreams. By five-thirty a.m. she's given up the struggle and lies there, fully awake and sweating in the muggy morning air of a late-May heat wave.

She speaks one sentence aloud. To the ceiling. To God. "What do You want from me?" She doesn't bother whispering. Dean doesn't rouse.

This is all the praying she can muster, a single line flung up into blades of the fan spinning lazily above her head. She digs her fingernails into the palms of her hands, narrows her eyes, and waits. The house is so still she can hear the metallic whir of the refrigerator in the kitchen. She remains quiet, tensing in the silence, daring God to answer. Listening. Breathing.

Nothing.

Then Sadie's alarm begins its rhythmic bleating, and Jennifer hears her daughter fumbling with the clock. Then she feels the ground shake as Jordan, always anxious to be the first one up, leaps from his top bunk. Then she hears her name, "Mom!" as Carson yells down the hall, "Where in the crap is my baseball shirt?"

All her life, since she was a little girl, she's tried to do what she thought God asked of her: marrying in the temple, having children young and staying home to guide them, serving faithfully in her callings. She'd been trained to listen for the promptings of the Spirit, and she thought she knew how to hear them. But for years now—four years, maybe five, definitely since Jordan started first grade, and more emphatically once her children began transitioning to their teens and her failures as a mother were reflected in them more starkly—for all that time, as the emptiness inside her yawned wider, she's been unable to decipher God's will for her life.

At first she thought it was a phase, a normal spiritual fluctuation, and she tried to wait patiently for the day when God would open His mouth. She studied her options. Should she go back to college and finish her degree? Start working part-time, see if she could get a job at Jordan's school? Or perhaps God wanted her to keep her free days free, blessed as she was with a husband who could support her—it could be that a big calling in the Relief Society or Young Women's or early morning seminary was in the works. But the years passed, and the only calling change was from Sunbeam teacher to CTR 7; no part-time jobs opened up at Jordan's school; she looked into the University of Minnesota and found that she'd have to retake way too much math.

So she increased her temple attendance. She woke up early to read her scriptures before the rest of the family claimed her day. She got on her knees and told God the truth: how paralyzed she felt by her own aimlessness; how she feared she would soon be overwhelmed by her creeping sense of failure. She pled with Him until the silence whistled in her ears.

And then, after all that pleading, she thought she finally found her answer. Have another baby. It was hard to be sure whether the prompting came from God. There was no overwhelming spiritual feeling; no prophetic dream. The idea took hold slowly, beginning first as an example of something she could do, then slowly evolving into something (perhaps?) she should do, until finally becoming something she felt she must, at least, attempt. Dean had been surprised that she wanted another baby. She'd been so adamant that they were done at three. And they were getting old, it was true. But once the idea implanted itself, she couldn't let it go. After a year of trying she finally conceived, and immediately she felt jolted out of her terrible inertia, as if she'd been living for years on a broken carnival ride that had been miraculously repaired and was finally moving forward. So this is what God had in store, she'd thought, and the relief had been intoxicating.

The bed springs creak as Dean rolls over, finally awake. He moves closer to her, then puts his arm around her waist, his warm hand finding her stomach's bare skin.

"You okay, hon?" he asks.

She can't turn around. She can't look at his face. "I'm fine," she says, her shoulders rigid and unyielding.

"You seem ... I don't know," he says, his breath pulsing against the back of her neck.

"I'm fine," she says again.

The day is breaking across the Midwestern horizon. Yet another day. Suddenly an idea comes to her, clear as the sunlight bleeding in through her window: Today, she will go field walking. She throws off her covers, releasing herself from Dean's loose embrace, and rises.

By nine-thirty a.m., she's ready to go: the floor swept, the dishwasher chugging, the comforter on her king-sized bed pulled tight, its pale blue accent pillows arrayed in an artful pile. Jennifer herself is wearing comfortable jeans and a good pair of tennis shoes, and she's prepared a small backpack containing a water bottle, some granola bars, her journal, her phone, her credit card, a Cedarville City trail map, and two hundred dollars in cash.

Jennifer realizes that "field walking" isn't the perfect term to describe her plans for the day. The descriptor doesn't work in the literal sense, since the trails she'll be walking don't cut through fields, but through suburban neighborhoods and nature preserves. And she's not exactly going field walking in the figurative sense, either—the sense that she and her best friend from a decade ago, Amanda DeWitt, adopted during the daily phone calls they indulged in as punchy, sleep-deprived young mothers. After all, Jennifer isn't bringing a gun. She doesn't even own a gun. And she has no plans to kill herself, although a part of her understands why suicide might appeal to some as a seductively rational solution. No, if she picked up the phone today and dialed Amanda's number to confess her plans, her best friend from ten years ago would sigh in that ironic, drawn-out way of hers and say, *No gun, no suicide, no field? It's not field walking.*

Then Jennifer would agree. Technically, she would tell Amanda, it's true she's not going field walking. But she plans to embody the spirit of the thing. She intends to open her door and wander away for a while, from her home, her family, her life, her self. And whether she'll decide to come back? That remains an open question.

Well, when you put it that way, she can imagine Amanda answering. *I get it. I see.*

As young mothers, Jennifer and Amanda often joked about killing themselves. Jennifer remembers this time fondly. Amanda—smart, tough, wry, everything Jennifer wished she could be but wasn't quite—Amanda was the first to dare joke about such a thing, and Jennifer was more than willing to laugh along.

The two of them talked on the phone nearly every day. Jennifer waited for the ring amid the smear of jelly sandwiches and the yammer of Elmo or Blue, and when the call finally came, she would take the phone to the master bathroom, close the door behind her, and join Amanda in the cathartic pleasure of complaining.

"I'm going field walking," Amanda would say, her three-year-old daughter howling in the background.

"Oh no," Jennifer would answer, the sound of barely suppressed laughter in her throat. "What today?"

"Pooping on the stairs. Preschool drop-off tantrum. Bounced check."

"Definitely a field walking day. Heading straight out the back door?"

"Yep. Right out the door. No looking back. Locked and loaded, baby!"

Then Amanda would laugh and Jennifer would join her, their voices tired and musical and young.

Occasionally, their shared black sense of humor made Jennifer feel a bit guilty, especially since the phrase "field walking" referred to an actual woman who'd killed herself: a mother of eight kids ranging in age from infant to teenager living in the Salt Lake City suburb just south of their own. Jennifer and Amanda didn't know her, of course; Jennifer liked to think they'd never joke about such a thing if she'd been an actual acquaintance. The truth was, not many people in the community had known the woman well, but they'd all been shaken by the incident. It's not every day that a mother of eight escapes out the back door and shoots herself in the head. According to news reports and neighborhood gossip, the morning wasn't out of the ordinary: the kids were fighting over the cereal, the oldest had missed her bus, and in the midst of all the squabbling, the woman stood up and left. She didn't say a word to anybody. She simply headed for the field behind her house, barefooted and in her bathrobe. She'd hidden the gun in her bathrobe pocket.

Even today, fifteen years later, Jennifer remembers the irony of the dead woman's name: Joy. She also remembers the woman's age, thirty-nine, because it seemed so terribly old to Jennifer at the time, too old to still be having kids. The whole scenario reinforced Jennifer's decision to have a smaller family—at least by Mormon standards—and to be done having babies early so she could enjoy the rest of her life. Jennifer was twenty-six when the shooting happened and already the mother of two. Three years later, she had one more. A year after that, she began her longstanding relationship with her IUD.

Jennifer and Amanda were in fierce agreement regarding matters of family planning and family size. Have 'em young. Have three, four tops—although four might be pushing it. Amanda herself had three girls, and whenever somebody would ask her when or if she planned to have number four— "Try for a boy?"—Amanda would narrow her eyes and deliver her answer with calculated coolness: *That's between me and the Lord, don't you think?* It was a horrible, wonderful thing to witness, the unfortunate questioner babbling her apology and Amanda icily dismissing it with a wave of her hand. Only Jennifer was allowed to ask Amanda such personal questions; only Jennifer was privy to Amanda's secrets and motives and deepest, most complicated feelings.

For reasons Jennifer never understood and that still remain unclear, for five whole years, she was Amanda DeWitt's anointed best friend. Then a Ph.D. student and divorced single mother named Chelsea moved into the ward, and in a matter of months, Jennifer's phone stopped ringing. Later that year, Dean accepted an offer to head up his company's Midwestern sales division in Minnesota. Amanda and Chelsea co-hosted a goodbye party for Jennifer and her family, during which Chelsea kept Amanda and all the neighborhood men raptly entertained with witty stories and slightly ribald pop culture observations, while Jennifer somehow found herself in the kitchen, helping the

children decorate sugar cookies.

Amanda and Jennifer called each other on their birthdays for a few years after the move, but the conversations grew briefer and more stilted until they finally ended altogether. Now, they stay in touch via Christmas card. Last December, Jennifer opened the envelope to find a family photo of Amanda, her husband Will, and their three beautiful girls all decked out in holiday finery. And then, a surprise: a gloriously bald baby boy grinning up from Amanda's lap.

Jennifer had learned of her own pregnancy just days before receiving the card, and she'd been tempted to call Amanda, to revel in the serendipity of it all, to pepper her with questions about pregnancy and childbirth in the face of what doctors called "advanced maternal age." It would be like old times. The thought of listening to Amanda on the other end of the telephone line—her sharp laugh, the joy thrumming through her rich, throaty alto as she exclaimed at the news, a sound Jennifer had once truly loved and hadn't heard in years—it tempted her so much that she picked up the receiver, despite the decision she'd made with Dean not to breathe a word of her condition until she'd reached twelve weeks. But then she hesitated. She looked at the phone in her hand, and her heart clenched, apprehensive. *No*, the thought came. *Don't.*

Looking back, she counts this one event as the single tender mercy of the entire pregnancy and its aftermath. The one time that the Spirit actually protected her from harm.

Jennifer steps onto her porch and locks the front door behind her. The morning sun hangs low in the sky; the air is warm and filled with frantic birdsong. Her neighborhood, lined with imposing two-story homes and neat green lawns, is devoid of human noise: garages and windows closed tight, no little children riding tricycles on the sidewalks or playing ball on the driveways.

She slings her backpack over one shoulder and strides across the silent street toward her subdivision's nature preserve. Once inside the canopy of trees, she inhales the ripe, heavy air and feels her body relax. She loves these trails, even if she doesn't use them much anymore. Cedarville is famous for its extensive citywide trail system—in fact, one reason Jennifer chose to buy a home here was because she liked to imagine herself running on these paths, a fleet figure moving underneath the trees, alongside the lakes— but she hasn't run on them for years. Not since the summer she tore the meniscus in her knee training for a half marathon that a woman in the ward had talked her into attempting.

She heads south, knowing she has hours of walking ahead of her if she keeps following the connected trails, and that, if she keeps following them, she'll end up on the outskirts of Cedarville, its southeastern corner. There, the suburban sprawl abruptly ends, becoming farmland. Long, straight country roads. Fields.

Perhaps, she thinks, if she walks long and far enough, she'll end up field walking after

all.

Moments after plunging into the nature preserve she feels her cell phone buzz against her hip. A text. She knows if she's getting a text it's from one of her kids, since Dean doesn't text with her, and neither do any of the handful of middle-aged women friends who have her cell phone number. What she should do is ignore the text. But. If she ignores it, then whichever child is sending it will worry because Mom always answers texts; then that child will call home and the phone will ring, unanswered; then that child will call Dean who will call both the cell phone and the home phone and become increasingly more alarmed until he decides to come home for lunch and start looking for her. Then the jig, as they say, will be up.

She pulls the phone out of her pocket.

> **SADIE:** Hey ma so sry but i left my math book home & it has my hmwork in it & i need it by 4th per so i don't get docked. Thnk u thnk u thnk u!

Sadie is a high school sophomore and forgets her homework (or her cell phone, or her permission slip, or her cheerleading shoes) at least once every couple of weeks. Jennifer has tried grounding, allowance-docking, raging, long talks about the psychological reasons behind her disorganization, the silent treatment, and cell phone confiscation as means of treating the problem, all to no avail. Dean has told her over and over again that the real problem is Jennifer always rescuing her. She punishes Sadie, yes. But only after delivering the forgotten item to school.

> No

Jennifer types, and presses send. She sits on a fallen log, the phone cupped in her hand, waiting for the hammer of her daughter's wrath to descend.

> **SADIE:** Wat do u mean no? Where r u? Y cant u come?

> I CAN come,

Jennifer types.

> I simply choose not to.

The response is immediate.

> **SADIE:** But ma this is an emrgncy. If im late i get docked & thn my grade will be a C+ prblby and then i get on probation for cheer this summer. U know this!!!!!!!!!!!!!!

Yep. Consequences suck.

SADIE: It will take u like 10 mins!!!!!!! Srsly mom this is not a good time for u to tch me some lesson or smthing!

Sorry, hon. I'm not coming. No amount of begging will change my mind.

Jennifer's heart beats fast and she realizes she's smiling. Smiling! What kind of sadism is this, when a mother enjoys her child's suffering? Well-deserved or not?

SADIE: Ugghhh! I dont believe this! U picked the wrong day 2 go crzy mom! UGGHGHGHG!

Is there ever a good day to go crazy? Jennifer thinks, then sends one final text:

Love you, hon. Have a good day.

She waits for a few minutes but her phone has fallen silent. Other than the shirring of the trees overhead, the whole world is still. Jennifer stands, brushes off her backside, arranges her pack over both shoulders, and starts to jog.

She jogs for twenty minutes straight, the longest she's run without stopping in years. Her knee feels fine. She's passed a few people on the trail—an older couple out for a walk, an intense young man all decked out in racing gear—and each person has inspected her with curiosity. She realizes she must be a confusing sight: a woman in street clothes with a backpack over her shoulders, running. The older gentleman even looked concerned, as if Jennifer were running away from someone or something and needed rescue, but she made eye contact as she passed and smiled reassuringly. He smiled back and raised his hand in a faltering wave.

Once her breath turns ragged she slows her pace, walking briskly out of her neighborhood preserve and through an older residential area. As she walks alongside the busy thoroughfare bisecting Cedarville, her hair flies loose from her ponytail and whips in the wind as cars barrel by. She walks past a playground, near a mother sitting on a bench reading a magazine while her toddler, a redheaded girl in pink tennis shoes, piles rocks at the bottom of the slide. She walks across the cracked asphalt of a gas station parking lot. She walks the eastern length of Carver Lake. She walks past a municipal tennis court where two gray-haired women play, their legs wide and white in their tennis shorts, their practiced swings both elegant and strong. She walks into a dense patch of forest ringing a medium-sized pond. She can hear the frogs, their cries like a screen door creaking.

She has walked now for over three hours without stopping, and she's finally hungry and tired. She's on a little-used trail, an offshoot of the main trail encircling Carver Lake.

A number of beautiful homes back up against this path, the nicely kept grass of their long green back lawns sloping down toward the jumble of wilderness just beyond the walking trail. Jennifer sits on the slightly damp grass of a particularly well-tended yard, not caring whether her jeans get wet. After she takes a long swig of water, she opens a granola bar and eats it slowly, considering. It's almost one o'clock. She is a three-hour walk away from home, and Carson, her middle schooler, gets off the bus at three-fifteen. He knows the garage code and can let himself in, but thus far in Carson's middle school career he hasn't had to do it. Jennifer always makes sure she's there. But there is no way, now, she can make it back in time.

No way. She's walked too far.

She pulls the trail map out of her backpack and studies it. An hour's worth of brisk walking will lead her to the southwestern outskirts of her town, emptied into the stark brightness of farmland. Once she reaches the end of the map, she knows there are no bus stops. No municipal trails. No canopies of sheltering trees. Just long straight roads, furrowed fields, and the occasional car whizzing along the two-lane highway.

She wants to keep walking. She wants to keep walking until she disappears.

She imagines what it would feel like to reach the end of the trail and step off the pavement into the mounded furrows of newly planted crops. She would pick a path through the wispy sprouting corn until the road behind her fell away, until the farmhouses receded to smears of color against the horizon, until only the buzz and hum of silence filled her ears. Then she would lay herself down against the loamy brown earth until the sun burned itself to darkness, and when the night air covered her body, she would close her eyes and rest. All alone. Her whereabouts a mystery.

But she can't do such a thing. Can she? An image of her family crowds into her mind: Dean and Sadie and Carson and Jordan, each of them standing still and expressionless as chess pieces on a board. They are light and hollow, carved out of balsa wood or pine, and she sees her own hairless arm sweeping across the flat plane of her imagination, sending them all tumbling. It's so easy. One swipe and they topple, helpless.

Her family. The family she made.

She remembers a voice from her young adulthood, a non-Mormon college professor at Utah State, telling her class full of mostly Mormon students that they should wait until they were older to marry and have children, not only for their own sake, but for their children's sake as well. She remembers the professor's words exactly: Children deserve to be raised by grown people. Oh, how this woman offended her! She remembers putting a hand over her abdomen—Sadie was growing inside her—and seething. But as she thinks back on all her failures as a mother, all those mistakes born of naïveté and blindness, she can't help but wonder who her children would be if they'd been raised by someone more mature. Sadie would be kinder, Carson would have learned how to manage his anger, Jordan would have received the early intervention or medication or (what? can she even think it?) the undivided, focused attention that she knew he needed as a preschooler, but that she was too exhausted—too selfish—to provide.

But she can't change any of that. No matter how long or how far she walks, she can't escape these truths: She is her children's mother. She is her husband's wife. The past unwinds behind her like a paved trail, each stone set into the ground with her own two hands.

Jennifer pulls out her phone. It's almost one. Dean will be at lunch with a customer, she's quite sure. He's a good salesman because he knows how to keep his people happy, which means that every day from eleven-thirty to two he's usually out of the office, sharing an afternoon steak with some middle-aged plant manager. Jennifer can call his office phone and leave a message so at least he won't panic. She can do that much.

The phone rings once. Twice. She composes the message in her mind: *Hello, Dean. I'm fine. Please don't worry about me, but I'll be gone for a little while, maybe until tomorrow. I promise I'm healthy and safe and I have every intention ...*

"Hello?"

Dean's voice sends a jolt of adrenalin straight to Jennifer's heart. He's at his desk? Her mind races, scrambling her memorized explanation into an incoherent jumble.

"Jen? That you?" He has caller ID. There's no turning back now.

"Yes. Yes, it's me. I didn't think you'd be at your desk."

"Oh, I get it! You only call me when you think I won't be here? Ha! How's that for wifely devotion?" He laughs at his own joke, his powerful voice booming in her ear. Jennifer closes her eyes and inhales slowly. It's difficult having a happy husband. She's never admitted this to anyone—she has a hard time even admitting it to herself, it sounds so ungrateful—but it's true. He's never understood her, really. Her sadness. Her fear.

"Listen, Dean," she begins. She has no choice, now, but to tell him. "I just want you to know I've been out today, doing some things. Some thinking. It's been good to be out."

"Good, good. I'm glad. You needed to get out. Hey, did you call that new woman in the ward who wanted to go to lunch? Annie? Or was it Amy. You know—the youngish one with all the hair ... "

She can feel her resolve crumbling beneath the weight of his optimism. She interrupts him. "Dean." Her voice isn't loud, but it's sharp.

"Oh, hey, sorry. Go ahead," he says.

She steels herself. "Here's the thing. I need some ... space. Some time alone, I think. Not a lot of time alone; not weeks or even days or anything like that. But just, you know. Time."

There is silence on his end of the line. She imagines him holding the phone to his ear, his face blanched with confusion and concern. Finally he answers her. "Is this about the baby?"

Is this about the baby? She wants to laugh, or cry, or both. That he even has to ask! Is this about the baby? Dean was the one she roused awake in the middle of the night, her abdomen clenched like a fist, the bed they shared crimson with blood. He was the one who knelt beside her on the cold bathroom floor while she sat on the toilet, moaning and sobbing, overcome with pain and fear. He was the one who yelled at their son Jordan

when he appeared, ghost-like and stricken, at the door of their room: *Get out! Get out!* He was the one who wrapped his arms around her broken body and let her sob until she was ready to clean herself up and go to the hospital.

He had been there. And then it was like he hadn't. *Let's think positive*, he told her. *We can have another.* Just days after the miscarriage he told her this, all confidence and peace. *We can have another.* As if it hadn't been her idea in the first place to have this baby, not his. As if it hadn't taken them more than a year to conceive. As if she wasn't forty years old. As if this wasn't a sign from God that His answer was no, she'd been wrong all along, and He wasn't going to let her try again.

"Of course it's about the baby," she answers, her patience straining. "It's about the baby, and it's about you, and me, and life, and God, and loneliness and futility and rage." She spits out the last syllable. She can't help herself.

"Rage?" He speaks the word as if it's a stranger to his mouth, as if it belonged to a foreign language he'd learned in his youth but had since forgotten.

The sound of rushing blood fills Jennifer's ears. "Dean, please just understand. I need a little more time, is all. Away."

"Away," he says, not a question this time, but a statement, tight with understanding. He swallows. "You need some time away," he repeats again.

Then a sadness wells up inside her, a sorrow too corrupted by guilt to be sympathy. "I know how this sounds, but you have to trust me," she says. "I'm not leaving, leaving. I just need some time."

She hears the sharp crack of his office door closing. "So let me get this straight," he says, louder now, and she's somehow relieved by the sound of his anger rising. "You went on a walk, but now you don't want to come home and you thought, what? You could leave me a message and nobody would worry? You realize you sound like a crazy person, right? Do you have the car? Do you have money? Are you lost?"

She answers him slowly. "I don't have the car. I told you, I've been walking. I have money. I have food. I have my phone if there's an emergency."

"But, Jennifer, where are you going? What does this mean?"

She doesn't answer him.

"What is it you want?"

Again, she is silent. She wishes she could answer him, but she simply doesn't know what to say. *What is it you want, Jennifer?* Not a question, but a stone—so huge and impossibly heavy that she's lost hope of ever turning it around, a portion of its surface forever curving just outside her range of vision.

"We can have another baby," he says, a note of pleading in his voice. "It's not too late."

"Isn't it?" She wants to know. Hasn't it suddenly become too late for almost everything? Can't he see how narrow, how straight, their road has become? *We can have another baby*, he says, and he says it without thinking, without paying attention to the words as they leave his mouth. Can. Such a slight little word—just one staccato syllable—

and so deceptive. As if the act of claiming a choice is simple enough to be contained in one tiny burst of sound.

"I've told you, Jen, I'll support you in this. Whatever it takes. Testing. In vitro, if you need it. I know we don't have much time, but it's still possible. If having a baby is what you want, we can make it happen."

Her hands are shaking and she needs to take a few deep breaths, but the desperation in her chest won't let her inhale. She misses the child she carried, the child she lost, its absence a hollow ache inside her ribcage. She'd envisioned an entire life with her (she'd imagined this baby a girl), a life more beautiful and purposeful than the one she currently led, one where she parented with patience and vision and could call herself wise. This baby, this girl that she lost—she could have been her delight and her redemption.

Who was she to ask such a thing of a child? Who is she?

She's exhausted, so tired she can barely speak. "I can't talk about this right now, Dean. I've got to go."

"Wait! Just wait. Let me come get you. We'll talk, I promise. I'll take you wherever you want. We can go … "

"Dean!" She is not deaf to her husband's pain. She feels like a criminal, like an assassin. Truly cruel. "I'm hanging up now. I am fine. I will be fine. I'll be in touch with you tomorrow. But I'm hanging up now."

"Jennifer, wait! I need … "

She presses "end." She holds down the power button and listens as the phone chimes three times, signaling its goodbye. She lies back against the grass and closes her eyes.

When she opens her eyes again, the angle of the sun tells her that it's early evening. Five o'clock, perhaps? She would take out her cell phone and look, but she doesn't want to turn it on again. She knows there will be a message and she'd be tempted to check it. Her body is stiff from sleeping flat on the hard ground. Her bones are not young.

She rises up on her elbows and listens. She hears the sighing wind, the birdsong, the creak of the frogs, but there's another sound, too, higher and more insistent, riding just above the rest. A thin, urgent wailing. The noise registers deep inside her brain: a newborn's cry.

The sound comes from behind her. She turns and looks up at the house set back from the trail and realizes immediately that she's being watched. She can make out the form of a woman holding a baby, standing inside the screened-in back porch, inspecting her. Although the length of the manicured backyard separates them and the woman stands behind the gauzy mesh, Jennifer senses the moment their eyes meet, the subliminal click of seeing and being seen. The baby in the woman's arms continues to scream. Jennifer stays frozen on her elbows, caught. How long has this woman been watching as she sleeps on her lawn? How will Jennifer explain herself?

Finally, the woman opens the screen door and steps onto the deck's top step. From this distance, Jennifer can tell she's close to her own age. Her dark hair hangs like heavy curtains against her shoulders and her long gray T-shirt shows a telltale circular stain

against one breast. The baby is swaddled tight in a blue receiving blanket, and his cries pierce the evening stillness, tense and rhythmic.

"Do you need help?" the woman calls.

Jennifer raises one hand and shakes her head, embarrassed. She begins to stand.

"I've been watching you for a while now," the woman says loudly, the sentence carrying past Jennifer and across the water. "I was beginning to get a little worried."

Finally, Jennifer is able to speak. "I'm so sorry!" she says. "I was on a jog. I mean, a walk. I sat down to rest a little and before I knew it ... " She lets the sentence trail away. She raises a hand and sweeps a few blades of grass from her matted hair.

The woman takes the three steps down onto the cement landing of the deck. She squints at Jennifer. "You sure you're okay? You look a little—I don't know. Shaken?"

Jennifer tries to laugh dismissively, but it sounds stiff and forced. "No, no. I'm okay. I don't do stuff like this usually." She increases her volume over the wailing infant. "Sleep on people's lawns!"

The woman moves across grass toward her. She's not smiling but her bearing is friendly, even as her eyes run up and down Jennifer's body. "Yeah. You don't look like the type," she says confidently, standing a few feet away now. "Although I don't think I've interacted with another human being in, oh, seventy-two hours, so my judgment could be a little rusty."

Jennifer lets some of the tension out of her shoulders, relieved that the woman is kind. "The baby doesn't count as a human being?" Jennifer asks with what she hopes is a playful tone. The red-faced bundle bucks against his mother's tight grasp.

"Ha! Sometimes I wonder." The woman smiles ruefully. "I probably should have said adult human being. Hell, I haven't even interacted with a verbal human being. I think I would take a conversation with a three-year-old at this point."

"How old is he?" Jennifer asks. "Three or four weeks?"

"You guessed it. Three and a half."

"Three and a half weeks old. I remember three and a half weeks old. Does it help to remind yourself that the crying usually tapers off around six weeks?"

The woman sighs. "That's what the books say. They also call breastfeeding a 'beautiful bonding experience' instead of 'hellish physical torture,' so I'm a little skeptical."

"I hear you," Jennifer says. "I bottle-fed mine. Couldn't do breastfeeding, although heaven knows I tried. But you know what? It didn't kill them." Jennifer knows her nonchalance is misleading. She still remembers her defeat as she filled those bottles of formula, an Ace bandage wrapped around her breasts like a guilt-grip on her heart. Three times she couldn't get her baby to latch on right, three times her nipples cracked and bled, three times she gave up, conquered. She couldn't bring herself to feed her babies in the mothers' room at church, feeling somehow unworthy to be around the breastfeeding moms and their easy, natural mothering. And she still blames herself, just a little, for her children's average test scores. The correlation is scientifically proven. She's read articles.

"It's great that you're breastfeeding; don't get me wrong. But don't let them make you feel too guilty about formula. Being a mom is hard enough without all the guilt."

The woman closes her eyes a beat longer than a blink. When she opens them, Jennifer is surprised to see tears welling up, then spilling out and down her cheeks. "You're right," she says softly, shifting her gaze away from Jennifer's face, embarrassed. "This really is hard enough. It's harder than hard enough." The boy in her arms has maneuvered his upper body free from the swaddling and one hand flails above his angry red face.

Without thinking, Jennifer opens her arms. "Would you let me take him for a minute?"

The woman's eyes find Jennifer's and fill with relief. "Would you? He won't let me put him down. I don't know what I'm doing wrong but he won't let me put him down." Her voice breaks. "My mother left two weeks ago, and then on Sunday my husband went out of town, and I told them I could handle it, I told everybody I could handle it, but I can't handle it. He won't let me put him down!" She's sobbing now, unashamed, her nose running and her tears staining the baby's blue blanket.

Jennifer takes the baby gingerly, then turns him so he's facing outward, his body running lengthwise along her arm, her hand gripped between his legs. She swings him slowly, side to side. All three of her babies were colicky, and all three liked this hold best. He keeps crying, but the pitch seems a little less frantic.

"Thank you," the woman says, and wipes her face with both hands. She takes a deep, shuddering breath. "What you must think of me!"

"And you're saying this to the lady who's been sleeping on your lawn?"

"You have a point," the woman says, and smiles. "I know this sounds arrogant, but I never considered that this might be too hard for me. I'm a lawyer, you know? I deal with crying babies all day long." She shakes her head. "But truly, what was I thinking?"

Jennifer smiles sympathetically.

"I'm asking you in all seriousness. What was I thinking? You said you did this three times. Three times! I can't imagine that. What were you thinking?"

Jennifer looks at this woman, this stranger, with her long unwashed hair and her tired, middle-aged eyes, and she feels a surge of love and sisterhood well up inside her, a visceral expansion so powerful that for a moment she can't bring herself to speak. "I don't know," she says quietly. "I don't know what I was thinking. I simply did it back then. It was what I was meant to do, so I did it."

"But would you change it? If you could go back, I mean. Would you change any of it?"

Jennifer knows the answer that almost any mother would give: no. Automatic, deep, instinctual. She, Jennifer, wouldn't alter the fact of choosing motherhood when she did because her children are the fruit of that decision. Her living, breathing children, with their warm skin and flashing eyes and fragile wrists. Hers. But she can't simply answer this woman with a "no." The question is too complicated.

"I wouldn't trade my children for anything. I wouldn't change having them," Jennifer says. "But there are things I regret. I think you can regret things even if you'd never change them."

The woman nods, understanding her. The baby has relaxed against Jennifer's arm and his crying has mercifully ceased.

"Look at you," the woman says. "A pro."

"I don't know about that. No. Not a pro."

"You have three kids. Don't they give you some kind of upgraded status for that? A mothering medallion or something? Baby whispering certification?"

Jennifer laughs, loose and honest, the kind of laugh she remembers sharing with Amanda and can't recall sharing with any woman since. "Nope, no certifications here. Anyway, I was young when I had them. Too young, probably. I made a lot of mistakes. I was actually hoping for a do-over."

The woman tilts her head to one side, curious.

"I was going to have one more. Actually, no. I did have one more, just a few months ago. It was a miscarriage at eleven weeks. But there was a baby." Jennifer takes a deep breath, preparing herself to say it. "And that baby died."

"Oh!" The woman's single round syllable stabs the air, full of surprise and sympathy. "Oh, no!"

She reaches out and gathers Jennifer in an embrace. Jennifer wraps her free arm around the woman's waist and keeps her other arm grasped tight to the baby, his warm body fit snugly between them. She buries her face in the woman's dark hair and she cries.

The two women spend hours that evening on the back lawn, talking and passing the baby between them. The woman's name is Candace, and she is forty-one years old, twice-married, Episcopalian, more Libertarian than Republican, and her high jump record at Eden Prairie High School still stands. Jennifer tells Candace everything: about field walking and Amanda DeWitt and Utah and Mormonism and her worries for her children and her husband's infuriating cheer. She tells her about the two new bras. The fascinating book by the energy healer. The last phone call between Dean and herself.

"You can stay here tonight, you know," Candace says. "I mean it. Is that weird? But you can stay with me, if you want."

Jennifer looks up at the rows of windows lining the back of Candace's house. She imagines entering Candace's mysterious guest bedroom and slipping between the cool sheets of a relative stranger. She's surprised to realize she wouldn't be afraid. She could do it. But not tonight.

"Thanks," Jennifer says. "Truly. But I think I need to be alone. For one night at least, I need to be alone."

Candace nods. "But where will you go? You realize you can't do the thing where you lie down in the middle of a corn field, right?" She smiles.

Jennifer laughs again, soft and knowing. "I know. But the Days Inn is just a few miles away. It's not too late yet. And I can walk. I want to walk." Her legs feel strong, and the

night air is perfectly cool. She'll be at the hotel before it gets too dark, and then, for the first time in her life, she will check into a room under her own name and stay there, alone. The desire to do this thing—pull out her credit card, claim her anonymous shelter—wells up inside her with the force of inarguable necessity. One night, she thinks. She can give herself one night. A stake planted in the ground so she can tether herself.

"So after tomorrow, then," Candace says. "What do you want to do?"

For the first time in years the question doesn't sound like an accusation. "I have no idea," Jennifer says, and then she begins to laugh again. "Isn't that awesome?"

Candace's brown eyes are luminous and wise. It's so easy to meet her gaze. "You'll figure it out," she says, and the timbre of her voice—so serious and kind, so unambiguously certain—sounds the way Jennifer had always imagined God's might, if she'd ever heard Him speak aloud.

Jennifer embraces Candace, tight. She smells like mother sweat and milk. "You have my number. You call me."

"I'll call you," Candace says firmly, and Jennifer believes her.

Jennifer leans down to kiss the baby. "What is his name?" she asks, suddenly aware she's never learned it.

"Henry," Candace says. "After my father."

"Henry," Jennifer says, brushing her lips against the top of his warm head. "Beautiful Henry. I'll see you again." Then she pulls on her backpack and starts along the trail, heading west, retracing her steps toward the hotel and into the setting sun. She doesn't need her map. Even in the gathering darkness, she remembers the way she came.

A DIFFERENT LEAVING

TERRESA WELLBORN

A decade in, four children deep, two mortgages bled,
my husband asks, *What do you want?*
Another master's degree, a poetry class to teach,
friends, life cancer-free, a Newbery, new teeth.

To leave
without leaping,
a different leaving,
one that does not require packing,
passport, pill. It sleeps under suburban
porches, clings to bathtub rings, celery hearts,
nesting cups. It crouches in the thread count of
Egyptian cotton sheets and yawns a mouth like a tiger.

It wails, a heaving of days, bottled, fetid, folding in on
itself, this leaving, like a colt's soft neck,
a drunken flower, a want that is ripe and
falling. It springs into books without keys,
karate chops chair legs, unwinds vines,
rips open the violet's throat and hangs,
an unhinged door to salvation,
a pillar of salt,
a liquid dark drink,
a leaving complete.

YÁ'ÁT'ÉÉH

TERRESA WELLBORN

—For my father

I was five the summer
I biked around our backyard pool
then sideways fell, the water beneath me,
my hair a thicket you lurched to save.

Later you called us in Navajo,
Yá'át'ééh,
as if standing among your limbs
every bird would vault to you.
And yet you kicked the dog, cranked the
History Channel, starched to church
alone. We mastered the mad dash, the
smoldering iron while you
mastered deafness, divinity.

I have a habit of making
people into Gods.

The night the midwives caught my twins
you arrived alone, Septembered,
held them in your arms, gave them your
blessing, *All is well.* You posed for the
camera, while I edged
out of the frame, gutted:
where was my mother?

There was no second sight, no birth in the caul,
no good luck omen, only membranes
saved, flattened to dry on my dresser like
trees uprooted, insurance that none of us
would ever drown.

Name: Lorna M. Hall
Email: lornahall@cox.net
Order Date: 2/26/2018 5:30:34 PM
Ship Method: Standard

Order #: 00441156A1
PO #: PO-18016627-IBC
Seller Order: 112-5082823-2061866

Qty	ISBN/UPC	Title	Price
1		Seasons of Change: Stories of Transition from the Writers of Sygullah (Paperback or Softback)	$19.35

	Subtotal:	$19.35
	Shipping:	$0.00
	Tax:	$0.00
	Total:	**$19.35**

Questions:

00441156A1

S	1

TO REORDER YOUR UPS DIRECT THERMAL LABELS:

1. Access our supply ordering web site at **UPS.COM**® or contact UPS at 800-877-8652.

2. Please refer to label #02774006 when ordering.

02774006 RRDR

GRAFTING

BECAUSE OF BOB

SHERILYN OLSEN

Mom's gasp drew me out of bed and into the tiny hallway of our San Francisco apartment. My pudgy four-year-old self quietly intruded on an intimate scene already in progress, as my parents stood across from each other in their bedroom, Mom gazing down at a small, velvety box resting in Dad's palm. Covering her mouth, she looked up at him with tears in her eyes. As he opened the box and placed the turquoise and silver ring on her finger, she blinked out the tears, and they streamed down her cheeks.

"What's wrong, Mommy?"

I broke the spell and Mom stooped low, meeting me in the eye, reassuring, "Oh, honey! I'm not sad. These are happy tears!" Officially confused, I returned to my room and my childhood all at once.

I had just turned six the next time I saw my mom cry because of my dad. She even crouched down again to my eye level, but Dad wasn't home this time (his absences becoming more typical), and from Mom's puffy, mascara-smeared eyes (and with my additional two years of experience), I ascertained that these were not "happy tears." She explained that she, my younger brother, Chris, and I would leave the next day and drive "across the desert" to live with Grandma and Grandpa in Ogden, Utah.

And then she dropped, "Dad is gay."

I grew up more in that next split second than in all the previous six years combined.

"That means he wants to be with other men and not married to a woman—to me," she explained, like it was today and not 1978. My mother knew the best way to satisfy her exceedingly curious, oldest child. I knew what she meant instantly, even though I'd never before entertained the possibility. I could define gay before I could define divorce.

We left the next day, and I don't remember saying goodbye to my dad. I do remember sweating in the backseat of our robin-egg-blue Datsun, squashed between my towheaded brother and a classy set of Book of Mormon children's encyclopedias. My mother packed all she could into that miniature car, and she sang to us through miles of midsummer desert, her voice lilting between my naps and the sound of the wind whooshing through the half-rolled windows. She convinced my brother and me that we were on an adventure, and I felt exhilarated by her positivity. It's only now that I know she was really mad. Mad and brave.

From my grandparents' house to an apartment, we began our new lives together. Getting used to everything in a new city seemed to me like a bigger adjustment than not having my dad around. Two times over the summer, he promised to visit. He came once.

Just as things settled into routine, Mom started dating. It took only a few months before she was set up with a bachelor in our ward named Russ. Only weeks later, he and my mom asked Chris and me if that would be okay with us if they got married. By this time, my biological father felt like a shadow, coming to my awareness only occasionally when the sun fell on me just right and I happened to look down.

Several months into their marriage, and long after I'd last heard from my first father, my parents flipped through the TV channels one afternoon, when suddenly Mom blurted, "Stop! Go back!" Returning to the previous channel, we watched as my biological father appeared on the screen with several other men, who sat on stools lined up in a row. They were discussing their lives as excommunicated, gay Mormons. We watched for just a minute when Mom said, "Okay. Turn it." Afterwards, my mom gave it to me straight again, and I learned what excommunication meant.

I hadn't seen or talked my biological father for more than two years by the time I found my nine-year-old self (in a new Gunne Sax dress my new dad helped me select) in a courtroom with too much dark wood paneling and not enough windows. Earlier, in the judge's chambers with our family's attorney, and a court recorder, the judge asked me, "Are you nervous?" and without pausing for my answer, "I only have one question for you—do you want Russ to be your dad?"

"Yes," I replied genuinely, careful not to add anything else, following the attorney's coaching from earlier that morning. The easy "yes" starkly contrasted the weight of the other concepts that day like "relinquished rights," and "adopted," as my new family legally formed.

Though the transition in real time occurred much more gradually, it was on my adoption day, and just like that, that I moved from one dad to another as if they were apartments—spaces to occupy and then vacate for some other space. Now, Russ became "Dad," and my biological dad became virtually unmentioned, requiring no title.

Over the next several years, I forgot about him mostly. Except when I didn't. Except when Mom would say wistfully, "You have your dad's smile." I forgot about him, except when I remembered him lying on his back on the shag carpet calling to me. I'd run and lay my stomach against his two feet, as he hoisted me up, holding my hands for balance, so I could fly.

I forgot about him, except for the times I'd wonder if he ever wondered about me. As I reached meaningful milestones, I'd long to send him graduation and wedding announcements. When my babies were born, I thought he should know. I stopped myself from acting on those longings. It felt too much like a betrayal of my adoptive dad—the dad who bought and fitted me with my first pair of roller skates , ate dinner with us every night, baptized me, attended all my performances, took us to the grocery store and mall every Saturday, and grounded me the one time I missed curfew.

Out of respect for my adoptive dad and with justice in mind for my mom, I once tried to be mad at my biological father, yet I couldn't. I didn't know him well enough for the

anger to work up inside me. Rather, I fantasized about how often I must cross his mind and what kind of cosmopolitan, liberal lifestyle he must lead.

Once (before the internet), my first husband and I took a vacation to San Francisco, and I looked up my biological father's name (Bob) in the phone book, not knowing what I'd do if I actually found it. I never had to find out, I couldn't find him. Years later, newly into my own second marriage and third baby, I answered a phone call from my brother, Chris (who'd lived in a different state or country from me since we had left home). After a short greeting, Chris zoomed straight to his point. "Do you think we should try to find Bob?"

He explained that while teaching pioneer stories in early morning seminary, he felt prompted to research our bloodline. What "tipped it" for him was finding a blog post where Bob had written that his last name wasn't his birth name, and that he, too, had been adopted by a stepfather. Stopped short by that missing last name, Chris wondered if the only two people on earth who knew that name were our birth father and his mother (if she yet lived).

With this new motive, my quiet, occasional hopes became validated, and I told Chris that I'd wanted to find our birth dad many times throughout my adult life, but never dared. Now felt right to the both of us, and exhilarated for the next several days, we delved further online and in directories, calling each other with each new bit of information. It appeared that Bob had last resided in and worked near Las Vegas, Nevada. We even found a few recent pictures of him singing in his local, Episcopal choir and a phone number.

With a very business-like family history goal, Chris reached Bob on the first try. As a parent, I've tried to imagine that moment—hearing my child's grown up voice after three decades of silence. I can't. In a brief conversation, Bob agreed to share any information he could to help us and invited us to set the terms for future contact. Essentially, he wanted whatever we wanted.

I wanted to call him right away, but I waited until I could sneak away from my noisy family and hide behind the door of our basement laundry room. I dialed the number, and a trembling voice promptly answered, "Hello?"

"Hi, Bob? It's Sherilyn," I mustered. *You know, your daughter?* I only thought.

"Sherilyn," he said slowly, drawing out every syllable, and I could hear him smile, "I always hoped you'd find me again."

In thirty minutes I somehow sailed through a narrative of highlights from nearly thirty years of life. The conversation flowed with ease, organic as our relationship. I returned to my family and my life with the full satisfaction of a recently fed, though, not yet sleeping baby.

Time passed by with weekly emails and an occasional phone call, at first all initiated by me or my brother. Chris and I would cc each other, each wanting full access after this long separation. We reconnected with Bob's mother and his sisters, and especially rekindled a relationship with his youngest sister, Barbie.

We collected ideas about our birth father in disconnected scraps, like a half-finished digital image, all pixels and distorted colors. I learned facts about him in bits and pieces from my mom, his emails, and my Aunt Barbie. We learned that he once belonged to Mensa (an organization for people with genius-level IQs) and engaged many with his charm and brilliance, but physical and mental illnesses gradually caused his decline.

After several months of correspondence, Bob told me he would be in Utah for a short stay, and we arranged a time and restaurant to meet as if it were just any other Saturday night.

I walked through the door exactly on time. Below the chalkboard sign with a hand-drawn fish and a list of that night's specials, sat a large, nearly sixty-year-old man, who at the sight of me and with some effort, stood up and held out his arms, again enunciating carefully each syllable of my name (almost breathing it in for himself while sound leaked out).

Next, with wonder in his tone, he voiced, "You look so much like your mother."

I went to him and put one cheek on his chest and my arms around as much of him as I could, searching, but failing, to recognize the feel of him. He smelled of expensive cologne, and wore a red, Ralph Lauren T-shirt under an unbuttoned, crisp, plaid shirt, with cargo shorts completing the look. He had told me that he was obese, and I had seen pictures, but I was still struck by his size and labored movement.

We ate and talked for over an hour. Several times during throughout the meal, it occurred to me that the significance of our meeting was completely lost on the surrounding diners. I wanted to shout, "This is my biological dad—who I haven't seen in decades!" I refrained, and Bob spoke slowly and with effort. He asked all the right questions, and kept me talking instead.

Driving away, I wondered just where Bob fit in my life. I didn't need him. I had a dad, and my kids had a grandpa. And yet, I experienced an undeniable pull toward Bob. I called Chris and rehashed the entire night's events to him during the long drive home.

While my connection with Aunt Barbie strengthened, my interactions with Bob became less frequent. He would wait longer to respond to my emails until gradually our contact slowed to mostly holiday phone calls and gifts.

Excited to finally introduce Bob to my husband and kids, one spring we stopped by his hometown en route to Disneyland, and met Bob and his partner. I liked Rick instantly, and the two would-be grandpas doted on our kids. Meeting him helped me understand the stories Aunt Barbie told me about how Rick had taken care of Bob throughout a lifetime of struggles.

I don't blame my mom for not finding the same peace about their relationship. I fretted over how to tell her we intentionally found the deserter again thirty years after she had moved on. Chris and I told them separately and very early on. When I took my turn, my parents reacted with surprise and questions about why we would want to after all these years. We still don't bring it up much, and when we do, I always hope it stings a little less for them. I earnestly try, but cannot begin to understand the special brand of

betrayal my mother suffered, just as she cannot feel the force that draws me into all of my history—not just the happy highlights.

I always knew I wouldn't have Bob again for long. On a cold night in January, just as I turned down the blankets, the home phone rang loudly. I rushed to answer and heard the distress in Aunt Barbie's voice right away.

"Sherilyn. I'm sorry to tell you, Bob is dead."

I accepted it immediately with no sadness for myself. I'd had plenty of preparation, and knew that we met Bob again in part to lose him with more perspective.

A few weeks later, Chris and I met in Las Vegas for Bob's memorial service. We left the hotel with enough time to arrive a few minutes early, then drove to the Episcopal church where Bob and Rick worshipped. As we pulled into the parking lot of a well-maintained strip mall, we spotted the sign for their parish. United, my brother and I hid our brimming curiosity with collected poise, and we made our way inside. Immediately, we realized that in wearing our dark-colored Sunday best, we looked as out of place as tuxedo-sporting picnic-goers. Our clothing choices punctuated the reality that Bob lived a life completely separate from ours.

Rick approached us right away, and I felt happy to see him and offer my condolences in person. I hugged him, wondering if I reminded him at all of his partner, and if so, did it evoke a pang, or comfort?

"We're a little overdressed," Chris quipped, admitting the obvious.

"Oh, you look fine. I'm wearing shorts in Bobby's honor. He lived in shorts," replied a casual and cheerful Rick.

Several of Bob's friends introduced themselves, as we moved toward a room unexpectedly like a typical Relief Society meeting area, except for the decorative cross that hung in the center of the front wall. Chris and I sat down not far from the front and off to the side. The priest opened the service and led the congregation in a series of prayers and songs. Partway through, he displayed a wooden box the size and shape of the pencil boxes I used to keep in my elementary school desk. His large hands placed it reverently onto the podium and by his nod towards the box when he mentioned Bob, I surmised that it contained his ashes. I marveled that it was all that was left of his once large and lively body.

At the end of the service, the priest invited anyone to come forward and speak about the deceased. I wondered nervously if anyone expected me (or Chris) to stand. Rick quickly rose first, and sans notes, narrated a perfectly crafted history and tribute to his life partner. He remarked that Chris and I remained Bob's pride and joy, and our reunification with him the highlight of his life, and I sensed heads turning in our direction. Aunt Barbie spoke too and tearfully honored her brother, and before long the service ended.

After a short reception and light luncheon in the foyer, Rick invited us back to their place. Circled tightly in their small apartment, ten of us gathered to more personally pay homage.

Shortly upon arrival, Rick ushered Chris and me into the bedroom, where he presented me with a detailed piece of framed artwork Bob brought home from Japan, the place where he and my Mom first met and served missions together some forty years before. He gave Chris a ring, originally belonging to our grandmother's father. "He would want you to have these things. You both meant the world to him," gushed Rick.

Bob once told me that he collected crystal, so I wondered to myself why Rick didn't return to us the many crystal pieces Chris and I sent him at every Christmas or birthday over the past several years. In fact, I looked around the apartment as inconspicuously as possible, and didn't see the pieces anywhere. Later, Rick would laugh and tell us, "I don't know why Bobby told you he collected crystal. You were the only ones who ever gave him anything like that."

Returning to the group, we settled in, laughing as Bob's eighty-plus-year-old mother entertained us. In fact, I remember us laughing much of the time, releasing loss with each guffaw. Chris and I posed questions to the eager audience, questions that seemed easier to ask now that Bob was gone. In turn, we willingly fielded questions about our lives, too, as the extended group therapy session stretched late into the night. Right there, in that small apartment, among Bob's things, and filled with his people, I was home. About the experience, Chris would later sum up, "I gained closure I never even knew I needed."

Bob was gone from us again.

"The heart of the children [turn] to their fathers" (Malachi 4:6) takes on a very literal meaning for me. I've had two fathers. There's Russ, who raised me and continues to support me and my family in all the paternal ways that count. I love him for marrying not just my Mom, but all three of us. I love him for the sister he and my Mom gave me after that. His name appears over the "father" line on my birth certificate, and it's him to whom I'm sealed through the eternities. Definitively, he's the only one I call "Dad."

Then, there's Bob—a figure who darted in and out at two different, relatively short, and uncannily, nearly equal periods in my life, but nonetheless, whose family I've acquired, and whose sociability and social consciousness I carry on.

Because of Bob, I learned about some of the hard stuff in life at an early age. I forged a bond with a brother, who feels more like a twin to me, with whom I shared a womb, and not just a childhood. I saw in my mom the possibility of independence and resiliency. Because of Bob, we gained Russ. I also discovered the inexplicable and unconditional power of biology. Owing to my early loss, I know better how to succor my own disconnected, adopted son. And because of Bob, I more fully sense the pull of my heavenly parents.

The last memory of my biological father echoes the tenderness of my first memory of him. He and I spoke over the phone the day after Christmas, and only a few short weeks before his death. I talked mostly, with his laughter my encouragement.

"You sound like you feel good," I told him, noticing a new steadiness in his speech.

"I do! I feel better than I have in long time. I'm on a new medication, which seems to be working," he offered.

We stayed on the line a little longer than usual that evening. Eventually sensing the natural end of the conversation I said, "Well, it was so good to talk to you."

"You, too." Bob paused, then added, "I love you."

"I love you, too," I responded—without the weight of baggage, or hint of awkwardness—a clean love of forgiveness and simplicity.

I touched the "end" button on my phone and smiled his smile.

TWICE REMOVED

COURTNEY MILLER SANTO

I know a fight is coming even before the children appear in front of me claiming wrongs and filing grievances. Like a dog hearing the clap of thunder forty miles off, I had sensed this argument from the moment the car doors opened and my children's best friends—also siblings—had spilled from their mother's car.

Altogether there are four of them. Two boys age nine and two girls age eleven. For the past five years, the Sutter children and mine have joined the same soccer teams, taken swimming and skiing lessons together, spent thousands of hours together in classrooms, at summer camps, and in each other's back yards.

I banish the boys to the back yard and the girls to the front. Strict instructions are given not to invade each other's territory. Threats are issued about future playdates. "Friends don't fight like this," I say.

"We're not friends," my daughter says pushing the boy who is not her brother. It's true. Somewhere along the way, our children abandoned the courtesies of friendship. They are the best of friends and the worst of enemies.

They fight like cousins.

How do I know this? Like my father, I am the oldest of seven siblings. By the time my father and his siblings were done they had thirty-five children between them. We were practically a platoon and like the conscripted, we spent hours, days, weeks in each other's company. Our parents needed no excuse to gather. Between them there was an avalanche of birthdays, holidays, anniversaries, achievements, and disappointments. These get-togethers weren't formal. Everyone brought food. They were arranged without so much as an hour's notice.

Once we were together, children old enough to walk were told to "go play." This became code for leave the adults alone. I remember almost no parental intervention. You ran wild with the cousins until you could drive and then according to some arbitrary rule, you were allowed to join the adults who spent their time telling stories on each other.

We staged epic battles over territory: the trampoline, the garage roof, the garden, the woods behind our grandparents' home. Competing armies could break along lines of family, gender, age, or even shirt color. We ran every version of tag known to playgrounds—freeze, movie, cartoon, robot. We taught each other the rules of basketball, the motions to our respective schools' cheers, techniques for holding longer handstands. Every activity that could be turned into a contest was. Who can climb the tree the farthest? Who can bounce the highest? Who can make their parents the angriest?

One of our longest-running contests had to do with who had the weirdest dad. After nearly two years of back and forth, we showed up at our Uncle Dan's house to find him wearing sweatpants with white tube socks safety pinned to the sides. No other father in the family would be so bold or so strange as to wear sock pockets. The winner (loser?) was declared that day.

We taught ourselves to catch orange- and blue- and green-striped garter snakes and then took them to the top of the hill near our grandparents' house and set them loose—watching to see which snake made it to the bottom first. When we grew tired of that game, we taught it to the younger cousins and then sat on the curb and watched them play while we talked about first kisses and whether or not we'd ever find a treasure map like Mikey and Chunk and Mouth.

During the thirteen or so years I spent embroiled in the chaos of cousin play, I learned how to take a punch and the joy that comes out of playing through the pain. I discovered that rules can change in the middle of a game and then learned how to take advantage of such mid-course corrections. I lost. I won. I played referee and walked the delicate jump rope of calling a close game.

It's true that often my siblings and I played in a similar manner, but it was different between us. We not only shared DNA, we also shared parents. We were in direct competition for affection, trust, time. Our places (oldest, youngest, whiniest, bravest) in the family were set in stone. When it was just our mom, she could end play at any moment and assign us chores. If a sibling bled, or was forced to eat cat food, he tattled and there were punishments.

When we were let loose with the cousins, none of these restrictions were in place. Parents are loath to punish a child who isn't theirs.

In these conditions, unexpected heroes arise. My brother Bolen, long known to be a faker and agitator, hurled a long string of insults at my cousin Alyson, who had six inches and sixty pounds on him. When he crawled over to the adults complaining about being beat up, we banded together and spoke on Alyson's behalf, recounting how she'd been required to defend her honor and worked to convince our parents that sometimes the bigger person was the bigger person.

My own children have experienced very little of this. We live a thousand miles from my husband's immediate family and two thousand from mine. Given the distance and the time it took my own siblings to start procreating, it wasn't until last summer that my own children had their first taste of cousin play.

Where my parents live now in Washington state, they are surrounded by relatives. Within a stone's throw are two aunts, two grandmothers, and my own sister. Inevitably whenever we travel there from out of state, most of my own cousins come for visits and during the onslaught of relatives and unscheduled visits, my childhood returns to me.

At one of these impromptu gatherings, I walked my children through the small patch of trees that separates my father's property from his sister's. The trampoline bulged with

towheaded children taking tentative bounces. I greeted my cousin, Doug, and his wife and cooed admiringly over their adorable kids.

"Go play," I said, expecting my kids to clamber up and start a game of crack the egg. They remained solidly by my side. "It's okay," I said, "You're related."

They didn't budge.

"We're cousins," Doug said, putting his arm around me.

"That makes them your—" I stumbled trying to figure out the relationship. "—second cousins? First cousins twice removed?"

"Cousins," his wife said. She is an English teacher and knows about words having more than one meaning. Technically our children, because they share great-grandparents, are second cousins.

My kids remained unimpressed. Had it been this difficult for my parents at first? When they'd all started having children had they been forced to endure such awkwardness? I didn't think so. They'd all grown up around each other, and their children had been born practically on top of one another. I couldn't remember a time when I hadn't known my cousins. Looking at Doug, I thought about the time he and my brothers discovered you could jump from the garage roof onto the trampoline.

"You love bouncing," I said, sort of pushing my daughter toward the trampoline.

"I don't know them," my son whispered.

"You don't have to," I said, grasping for some way to explain how difficult they were making an easy thing. I could see then that the idea of cousins was as foreign to them as my trying to explain that when I was a kid you peed during commercial breaks because there was no pausing television.

I saw it then, the way out: "They're like the Sutters," I said and within a moment my children had climbed on the trampoline and started playing.

The adults watched them bounce for a few minutes and then drifted to my parents' porch, which overlooks the pool. We told stories on one another that made our spouses double with laughter and once in a while one of us would get up to go and check on our kids.

Back in Memphis now, there is suddenly silence. I set aside my work and step to the window that overlooks our front yard. All four of the children are gathered around the tree swing whispering to each other. I step out onto the stoop. "What are you doing?" I ask in my most adult voice. "I told you to stay away from each other."

"Please," they say in unison. And then speaking over one another they make promises that they won't fight ever again and they hug each other to show how they've made up. I see their mother's Mazda turn the corner and I know that if I let them play a while longer we'll have a chance to catch up on gossip. I nod and they dash to the sixty-year-old magnolia tree on our neighbor's property to hide from their mother.

She walks over and I wave. "How were they?" she asks because this is what we always ask each other.

"No trouble," I say.

"Did they fight?"

I shrug because they always fight and because while the word cousin came to us from the Romans trying to explain the specific condition of being a mother's sister's child, it has been used over the years as shorthand to describe the people in your life who are something more than friends, but less than siblings.

Once when I picked the four of them up from swimming lessons, the coach had asked me if they were cousins. Behind her, the children were poking at each other and threatening to shove one or the other into the water towels and all.

"Twice removed," I answered, reaching around her to pull my daughter and my son's best friend apart.

We talk about work and about motherhood and about our husbands and then walk the short distance to find our children in a competition to see who can climb the farthest up the tree.

I thought then that the fighting never worries me because I know that they also love, like cousins.

JESUS IS HERE

LISA GARFIELD

I am sixteen years old. It's Christmas time—December 23rd, to be precise. I am in the car with my boyfriend, Matt, driving to the Santa Rosa Stake Center. I'm getting baptized tonight. I can't stop smiling. I feel enveloped in a bubble of peace as deep as that of the first Christmas night. I'm getting baptized tonight!

When we arrive at the Stake Center, I find that many of my seminary friends are already there. I am surprised to see so many. People I don't even know crowd the edges of the room. It's my first Mormon baptism. The missionaries have explained the process, but still, I don't know what to expect. I don't really know much at all about the details of Mormon doctrine, but I know this: Jesus is here. This is His church. This is my path.

It was my mother who first introduced me to Jesus. She taught me to pray: Now I lay me down to sleep, I pray the Lord my soul to keep. On Saturday nights, my sister and I went to bed with pink foam curlers in our hair, our patent leather shoes—made shiny clean with fingernail polish remover—ready at the foot of our beds. Military nomads, we attended whichever local Protestant church my parents picked—Methodist, Presbyterian, Congregational. I loved going to church, a few coins for the offering tied up in the corner of my handkerchief. I loved to hear stories from the Bible—Abraham, Gideon, Esther, Mary, Paul. I loved singing:

> *Yes, Jesus loves me!*
> *Yes, Jesus loves me!*
> *Yes, Jesus loves me!*
> *The Bible tells me so.*

I didn't just sing the words; I sang to witness that I knew Jesus loved me. Me! I felt Him stir in my soul with my very earliest memories, as if He'd stowed away in my heart when I came to earth.

At thirteen, I became a bona fide Christian. I had studied the materials Billy Graham sent, I had listened and learned and prayed all those years of my early youth. One night, a friend invited me to "Father's House" where a group of local youth met weekly to praise the Lord together. There must have been some sort of evangelical leadership, but I didn't need converting, so I paid them little heed, other than to notice quiet conversations in corners, witnessing, praying, tears, joy. What moved me most was the big prayer circle we formed, linking arms, sharing our prayer requests, uniting in faith as we lifted our

hearts to heaven. I knew Jesus loved me, but did He know I loved Him? I felt the deep pull of sacred commitment, of covenant. That night, linked in prayer with fellow believers, I closed my eyes and quietly and absolutely gave my heart to Jesus. I accepted without reservation that He was my Savior, that I was lost without Him, that I would follow Him for the rest of my life.

From that day on, I have been a committed disciple of Jesus Christ. I longed for Truth, though, and as my faith in Christ grew, I realized that for me, Protestant doctrine had too many holes in it. I couldn't make sense of it, beyond the deep reality of Jesus as Lord. So when Matt came along a few years later, with his equally fervent love for the Lord and real answers to my real questions, I knew I had found my religious home. Matt and the missionaries taught me solid Christian doctrine, put the pieces of the gospel together into a framework that I knew would support my deepest inquiries, withstand my fiercest doubt.

And tonight, I'm getting baptized. Someone helps me dress in white, leads me to a chair in the front row. I turn around to see my family walk in, dressed in their Sunday best. I look at my dad and my eyes fill, because I know that he is worried about me. It took him all day to sign the permission form allowing me to be baptized as a minor. The missionaries called midday: Maybe we should wait. And Matt: Do you think we should wait? That pervasive bubble of peace has been with me all day, though: No. Don't worry. It will be fine. My family is here because, despite their concern, they love me. They are willing to trust that I can see my way to the Savior.

When I enter the warm water, Matt holds his hand out, leads me into position. He raises his right hand and speaks my name. My spirit floats, like a bird on the water, waiting. I dip into the water and it washes me, washes me clear through—skin and bone and sinew—darkness, grime and sin gone. I am gone. There is a moment of utter stillness and I hold my breath in wonderment. He is here, here underwater, here in me. And there in the light above. The water floods behind me as I rise up, drink in the sweet air of new life. My face points heavenward, homeward.

A short time later, I sit in a folding metal chair, facing my family and friends. Matt's dad places his hands on my damp head and speaks my name. I hear him say: *Receive the Holy Ghost.* No one had warned me of this—this wild rush of power that suddenly pours through me from head to foot like a flash flood. I gasp. I hear Matt's dad speaking, but I am intent on survival, on somehow absorbing this electric, possessive Spirit. Slowly, it settles and I tingle everywhere. He is here, here in the very cells and atoms of my body, here in all the freshly flushed spaces of my soul.

Decades later, He is still here, a constant movement of love and light inside me, like blood and breath. He leads me still, through all the dark doubt, the disappointments and dissolutions of a life lived on the pulsing edge, through all the wondrous surprise and soul-consuming glory. Every year on December 23rd, the magnitude of that long-ago night burns like the Christmas star, expanding my understanding and my awe. Jesus is here.

That was forty years ago. Every year on December 23rd, the magnitude of that long-ago night expands my understanding and my awe. The memory of its magnitude burns, glowing with light like the coming Christmas Star.

I'm sitting here writing this now, it's Christmas Eve, waiting for the dark to settle. That star will shine and I will remember this night and always. Jesus is here.

BECOMING GRANDMA

DALENE ROWLEY

When I was a child visiting the ranch where my father grew up, my paternal grandmother used to give us small bunches of dough and let each of us make our own mini loaves of bread. When I was a little older, my mom's mother would send me ten cents for every book I read over summer vacation. I watched as my own mother formed bonds with each one of her grandchildren, sometimes sharing similar interests, often discovering new ones. As I observe others, I've often thought about the grandmother I'd like to become. One of my friends makes fabulous handmade Halloween costumes for each of her grandchildren each year. Another friend loves to take her grandchildren skiing—waterskiing in the summer and snow skiing in the winter.

I want to be The Book Grandma. I've already been preparing. The board-book version of one of my favorite childhood stories, *Corduroy*, has been tucked away at the bottom of a drawer for ages. Nestled next to it are a few copies of a couple of my other favorites—*Mandy* by Julie Edwards Andrews, and *From the Mixed-up Files of Mrs. Basil E. Frankweiler* by E.L. Konigsburg. Why two copies? One to keep and one to loan out. I have tried over the years to keep intact my sets of *The Chronicles of Prydain*, *The Chronicles of Narnia*, and the Riddle-Master trilogy, along with multiple hardback copies of *Harry Potter*. In addition to reading with my grandchildren—just as I did with my own kids—and providing an informal lending library of sorts, I look forward to spending time each birthday and Christmas considering the perfect sympathetic protagonist or exciting new world to introduce to my grandchildren through the gift of a good book.

I'm well old enough to be a grandmother. Most of my peers and several of my younger friends are already grandparents. My husband—the oldest of seven—is the only one besides his youngest brother who is not a grandparent. True, I may have procrastinated the upper-body strength training I know will be required to heft a growing toddler or two ... or three ... over the next few years, but along with my book collection, my heart is ready.

Luke was the first to marry. He and Emily have been married for a couple of years now. While their siblings have been pressuring them for a niece or a nephew, my own anticipation is of the patient sort. These milestones are personal. I vowed when they married that I would wait for the right time for them without throwing any hints their way about how wonderful it would be to have grandchildren.

A year ago November, I dared get my hopes up when Luke called me at work and asked if he could come see me. Since it's unusual for him to visit me at work, I wondered

if perhaps he had an exciting announcement to make. As it turned out, he'd come to tell me in that his beloved pet, Baby Cat, had died. Instead of exclaiming for joy and hugging him over the prospect of a new little life, I found myself crying with him over the loss of a kitten. Not at all what I'd been expecting, but I knew my moment of joy would come.

Then, Saturday, February 28 arrives.

Luke calls me on my cell phone. "When will Dad be home?" he asks

"I'm not sure, why?"

"We wanted to stop by."

Luke and Emily are both still students at BYU and both work in Provo. But they live twenty miles north, so our home often serves as home base throughout the week. But this isn't a weekday; neither of them have school or work. And normally they would just stop by unannounced, regardless of who is home.

Dare I hope?

I sense a new energy as they walk upstairs, drop bags and coats, and make themselves at home.

I overhear as Luke is trying to talk my daughter Lindsay into talking me into taking us all out to lunch.

"What if we had something to celebrate?" Luke asks.

Lindsay grasps the situation right away. "I'm going to be an aunt!" she squeals.

Kyle, fifteen, walks up the stairs with a big grin on his face.

Somehow, I think we all just knew.

We scream. We cry. We badger Emily with a million questions. "When are you due?" "How do you feel?" "When did you find out?" "When will you announce it on Facebook?" And we gather together the rest of the family to celebrate with Luke's favorite Americanized Chinese food.

Almost immediately after Luke and Emily's announcement, Luke's three siblings sear the due date into memory. Two of them download apps to track their niece or nephew's growth. They discuss potential names—some silly, some actual names. Among the more serious: Jackson, Samuel, Parker, Peter, James, and Ethan.

They set their calendars on their phones and ask for permission to skip school so they can be at the hospital when the baby arrives.

Details of the pregnancy are both randomly and frequently the topic of conversation, particularly at meal times or at the end of the day, when we are most likely to be together. One afternoon I am working on something from the comfort of the leather recliner I got for Mother's Day during one of my pregnancies, when Kyle walks upstairs to abruptly announce, "Did you know Emily's baby is the size of an avocado?"

Over the next few months we wait for signs of the already beloved addition. We watch for the first hint of a baby bump and ask for a report after each prenatal doctor's visit. As Emily's pregnancy progresses, I often think about my own favorite aspects of

pregnancy—among them hearing the baby's heartbeat and feeling the baby move within my womb. One night, Luke and Emily break out the Doppler so we can all have a listen. The familiar "whoosh whoosh whoosh" takes me right back to the numerous times I heard the beat of my own babies' fetal hearts. This baby is most active at night, which makes it difficult for any of the rest of us to feel movement. One day, after Sunday dinner, Emily is sitting on the sofa, and she calls me over. I place my hand on the right side of her belly and feel the baby's head move slightly. The sensation is subtle, but certain. "This is beginning to become real!" I think. And yet, feeling this baby stretch and move is definitely not the same as feeling elbows, knees, and feet from within.

I purchase border and binding fabric for the animal alphabet panel that will—eventually—become a quilt, crochet hook and thread for a flannel airplane burp cloth, and bright purple, blue, and green flannel dinosaurs for matching receiving blanket and burp cloths. Suddenly, soft and sweet baby clothes keep making their way to my cart at Costco. During a return visit to Finland in the summer, my husband makes the mistake of leaving me unattended in the town square of Hameenlinna, and bright-colored patterns of Marimekko find themselves being charged to my credit card and carefully transported home in my carry-on. When it comes time for Emily's baby shower, I consider some of the sweetest moments of a child's day—bath time and bedtime—and buy a baby bathtub and a mattress for the baby's crib.

Each anticipatory event is a celebration of life and love. On the day Luke and Emily are to announce the baby's gender, in the interest of being prepared, I bring two packages—one pink and one blue—to the family barbeque at Emily's house, where Luke and Emily eventually open a giant box of blue balloons. "It's a boy!" we all shout. We can't wait to meet him.

It is Wednesday, September 30, 2015, two weeks from the baby's due date, this much-anticipated first grandchild on both sides of two families, once strangers, now bonded through marriage.

It is also the exact date these two expectant parents have determined is the target by which to have everything ready. Cloud-gray walls freshly painted. Changing table at the ready, stocked with bulk wipes and tiny, seemingly doll-sized diapers. Hand-painted strokes of yellows and blues form rockets and stars and thoughts of "Twinkle Twinkle Little Star" and "Dream Big Little One." A stack of quilts, crocheted afghans, and receiving blankets fill the new crib. We've been teasing Luke, because the shiny new car seat has been securely strapped into their four-door sedan for a couple of weeks.

And it is the deadline for a crucial project of mine at work, the object of intense focus, long days, and sleepless nights that have driven me for the past two months. At this final stage, I am editing narratives and assessments as fast as my colleague can write and send them to me.

My cell phone vibrates from somewhere within a stack of papers on my desk. It is Luke. I can't have known it's him, but the rush of adrenaline surges as I pick up the phone.

"What are you doing?" he asks me.

"Finishing up this project."

"You should probably leave work and come to the hospital. We're having the baby!"

I pepper him for details.

"Emily's blood pressure was high and she hasn't been feeling well, so they are going to induce her. We are on our way now."

Preeclampsia.

I'm not too worried. Since the baby is still breach, a Cesarean section is likely anyway. And he is only two weeks early. I call my husband, Shane, and the rest of our kids while scooping my laptop and a handful of papers into my bag, only stopping long enough to tell my boss where I will be if they absolutely need me. But my priorities are evident.

I drop by our house, where Kyle is waiting outside. Shane and Lindsay will meet us at the hospital when they can. Zack is in New York City and won't be back until Sunday. He will have to experience this event vicariously through text messages and images from my iPhone.

Kyle and I arrive just in time to hear the doctor summarize the situation. He explains the details of the health status of both Emily and the baby. The options are turning the baby—cephalic version (ECV)—and inducing labor, which might ultimately result in a C-section, or directly performing the C-section. After discussing the risks and pros and cons of both, Luke and Emily opt for the C-section.

The waiting is the hardest part. We wait until they take Emily back to the OR. And then we wait again. They told us to plan on about thirty minutes, but those minutes are feeling like hours. We wait in the waiting room with other expectant families who, as it turns out, will wait the more typical hours for labor, transition, and delivery. We return to Emily's room and wait some more.

I don't know how we missed it, but at some point Shane realizes the rectangle windows in the double doors just outside Emily's room look into the OR corridor, from which the corner windows of the OR are visible. Through them we watch as Luke—gowned, masked, and capped in disposable white—gazes upon a tiny bundled newborn. My mind flashes to the moment I watched my husband hold Luke as a newborn. Now here we are watching our baby hold his baby. Our joy expands into a new dimension.

My cell phone records digital memories of a dozen scenes over the next hour as we press ourselves against the double doors into the OR straining for a look, part as they wheel Emily and this new baby boy back into the delivery room, and gather closely around her hospital bed for our first look, anticipating even more the first chance to embrace this new link in our family line.

Lindsay has a championship softball game to play, so she gets to hold the baby first. I text Zack and my own siblings a first look while the rest of us wait for our turn. I let Kyle, then Emily's mother hold him next, and then eventually our sweet baby boy is passed to me. And he is in my arms. Eyes scrunched closed against the foreign sensation of light.

Tiny. Fragile. New. Perfect. I pull him close to me, nuzzle his soft head, and breathe in his new-baby scent. Until this moment, I had no idea how immediately and deeply I could love another mother's child. But the bond between us is almost palpable.

"Who does he look like?" we ask. I can see Luke in the baby's eyes. Yet they are dark, like his mother's. He also has his mother's mouth. His breach baby "frog legs" remain tucked up close to his chest. He is theirs, I think. But because they are ours, he is also ours.

"What will he call you?" Luke asks. I have friends who are Nanas and Gigis and anything but Grandma. One of my own grandmothers was insistent on being called "Grandmother," as if the "ma" were somehow slang. I think about how my kids called my own mother Grandma Janet to distinguish her from her mother-in-law.

I don't mind what he calls me, I decide. He will call me whatever he wants. I am simply happy to have a role in his life that merits its own name.

Despite my intense focus on work the past several weeks, I have no desire to be anywhere but the hospital. The dull ache of an abscessed tooth grows to a fiery roar, but it doesn't stop me from being at the hospital every moment I can. The day after delivery, Emily is diagnosed with HELLP syndrome, a life-threatening complication of preeclampsia. Her blood pressure remains dangerously high and her labs—blood work and liver enzymes—are not yet improving. So we pray. And pack ourselves into the small hospital room. And (mostly) patiently wait for Emily's blood pressure to come down and her labs to improve. I work mornings, then drive out to the hospital each afternoon to bring Luke something to eat and hold the baby while they both sleep. When no one is looking, Emily's mom and I cry and hug and reassure each other, "She's going to be fine." "Everything will be ok."

We are still at the hospital. Lindsay is standing by the bassinet. I'm sitting in the rocking chair by the window. Luke is on the sofa that converts into a bed. I watch as Luke rocks the baby, still officially unnamed—but we all call him James—to comfort him back to sleep.

"I don't get it," Lindsay says.

"What?"

"Luke has always been terrible with babies. But he's not two days into being a dad and he's already pro!"

She's right. We witnessed months of physical preparations. Now we watch Luke's rhythmic rocking and hear the soothing gentle words Luke and Emily speak to their son. See the soft, loving, caresses to sooth. Love expanded.

Six days after James's birth, Emily's vitals and labs are improved enough that they can finally go home.

Throughout the month of October, it becomes my habit to drive out to the border of Alpine and take a Sunday nap with James while his parents go to church. One Sunday, after one such nap, I stretch out James—still sleeping—along the sofa for a photograph. For the first time, I notice what he is wearing: a tiny, long-sleeved T-shirt that reads, "Grandpa's little sidekick." And for the first time, it hits me: this Grandma is married to a Grandpa!

My new Grandma status continues to surprise and delight me. This evening we're at my house. Luke and Emily dropped by for dinner, and are now out running errands together. I'm in the worn, leather recliner. James is sprawled out in a deep and relaxed sleep along my chest. A stack of children's books one of my friends, who is also a grandmother, brought for grandma's house, rests nearby. Sandra Boynton's *Barnyard Dance*, touchy-feely book *That's Not My Dinosaur*, and an anniversary edition of *Guess How Much I Love You*. I smile as picture myself and James working our way through all of my favorites, book by book, while also discovering his favorites together.

When my babies were little, I used to pull them tightly to my chest, close my eyes, inhale deeply the soft scent of infant-ness, and will time to suspend and sear the memory of that moment of joy into my heart. Those babies now are all taller than me. At least half of them no longer want to be hugged. Yet now I snuggle a sleeping baby, born to another mother, every chance I get. A baby who belongs to someone else, but who also belongs to me.

As James slumbers, tiny baby breaths and sighs accompanying the synchronous beating of our related hearts, I inhale deeply. And will this moment of transcendence not to end.

AN UNFAMILIAR GRIEF

HEATHER BENNETT OMAN

I was sitting in sacrament meeting when my daughter broke my necklace. It was a long beaded thing that dangled, and she had been playing with it while I was still wearing it. Annoyed at the movement and tugging, I slipped it off, up and around my head, and handed it to her. She was delighted, and turned away to play with it on her own. I sighed, relieved to be free of her paws on my neck, and wrapped my arms around my body, holding tightly, using the pressure to hold myself together.

It was the first Sacrament meeting I had attended in my own ward since my father's death.

My father was diagnosed with pancreatic cancer a little over a year ago. A month before his death, he had a stroke. My mother texted me, "Dad just had a stroke. On the way to GW hospital. Send it on. Doesn't seem too bad but will let you know."

I dutifully texted my siblings on a group family text. I texted back to my mother, "Sent it on. Should I come up today? I can."

"If you can, yes."

"Okay, I will leave as soon as I can."

My hands shaking, I called my older sister, who lives overseas and is thus not on our family group texts.

"What do I do?" I asked her, holding the phone to my ear, pacing my bedroom.

"I don't know," she said.

This was the first of many *I don't know*s uttered by my family. How bad is it? I don't know. How long does he have? I don't know. What should we do? What does he need? How can we help? Should I stay at the hospital or should I go home?

I don't know I don't know I don't know I don't know.

"What do I bring? Do I pack a bag? A change of clothes? For how many days?"

My sister advised me to bring clothes for a few days, just in case. We still didn't know what we were dealing with. Maybe I would be back home tomorrow. Mom had said it didn't seem too bad, but I might have to spend the night. I packed enough clothing for three days.

I wore those clothes for three weeks.

The stroke turned out to be bad.

I live two and a half hours from my parents' house. In the three weeks from my father's stroke to the day he died, I commuted from one house to the other, stretching myself between my two families, trying to be both daughter and mother, failing to be

completely present for either. I held myself together as I helped my mother and siblings care for my father. I held myself together as I went to work and mothered my children and I cried in the endless hours in the car, alone.

I never had time to unpack or repack that bag. When my father died, two and a half hours from my home, I had no clothing for his viewing or his funeral. So my sisters and I went shopping.

How do you shop for funeral clothing?

I don't know.

What kind of clothes are you supposed to wear at your own father's funeral?

I don't know.

I shopped, purchased, went home, tried everything on again, went back, returned most of it, and shopped again. We spent what felt like hours in the clothing store, incapable of making decisions. The clerks called us by name as they brought dresses and skirts and tops, expressing sympathy, knowing we were fragile, trying to walk an appropriate line between courtesy and commission. Finally, finally, we were all comfortable with what we were going to wear. I purchased a black dress and a long, dangling necklace.

How do you describe what it feels like to bury your father?

I don't know.

In some ways, the funeral felt familiar. Mormons don't have a lot of rituals, we gather and speak about gospel doctrine at every occasion. The doctrine preached from the pulpit above my father's casket felt familiar. The stories about my father felt familiar, the family felt familiar, the funeral potatoes and ham in the cultural hall after the funeral—familiar.

It is the grief that is unfamiliar.

And so, a week or so after we buried our father, after the family dispersed, after the ham had been eaten, I wore my new necklace to church. I handed it to my daughter to play with and she innocently broke it. The beads sprayed everywhere, bouncing off the metal legs of the chairs with soft pings.

Even my arms wrapped around my body could not hold me together as I felt myself come apart into a million pieces, my soul fragmenting with the beads on my necklace, pinging off the metal legs of the chairs with the same sound in my head. It was an overwhelming, unfamiliar feeling. I took in a long sucking breath and grabbed my hair in fistfuls, an unfamiliar movement for me. I started hissing at my daughter to clean it up. My son, alerted by my tone, dropped to the floor to help his sobbing sister gather the shiny beads. An envelope miraculously appeared from behind me, an offering from a gentle friend and mother who was sitting at my back and watched me come apart with my necklace. I painstakingly put every last bead into the envelope, willing myself not to hurt my family further with my words, and reminded myself and my daughter that it is just a necklace, that she is more important than jewelry. I pulled her to me, trying to put us both back together, but it was not enough. Sacrament meeting ended and I sent her off to primary, then left the chapel to sob in the parking lot.

My husband asked, "How can I help you?"

I don't know.

At home, we examined the beads and the string that broke. He said, "This is easy to fix. We can restring it, and it will be fine. I can do that for you."

Last Saturday, I went to Michael's, envelope in hand, looking for ways to repair the necklace. I handed the whole mess to a woman in a red vest and asked her for help. She walked me through what I could do to repair it and then asked, "What did it look like before?"

I don't know.

"Do you have a picture? Can you go online? Can you go back to the store where you bought it and take a picture of the same necklace?"

I explained that I had tried all of those things and had been unsuccessful. So I was going to try to restring it from memory.

"Or you could just make up a new pattern. It will still look nice."

Nice. But not the same.

I went home and my husband and my daughter and I set up a re-stringing station. We counted, we measured, we planned, and we restrung the necklace. I texted a picture of the completed project to my sisters, who proclaimed it Good As New! and that it looked great.

I hung it from a hook and stared at it. It did look similar. It still sparkled. It was impossible to tell that it had been fractured and then rearranged. But parts of it were still unfamiliar, and although I had tried to pick up all the beads, we had lost a few. It would never be the same.

And I remembered something that I read, somewhere, something that crossed into my haze as I searched for comfort in my grief:

There are some things in life that can never be fixed. They can only be carried.

I stroked the beads, and laid the necklace gently into my jewelry box. I looked at it again, same but different, together but missing bits, whole but rearranged. I stretched it out along the velvet, and softly closed the lid.

TO MY CHILDREN, WHO WILL BE ASKED WHAT THEY ARE

ELIZABETH CRANFORD GARCIA

I have never been taken by the hand, led to a room
of crow-haired people who flutter Spanish.

Never had a nurse put H where Race should go.
Never been pinned Japanese by the Guatemalan yard man

because I had "squinty" eyes, or been clapped on the shoulder
by an Indian software architect, all smiles,

who's thrilled to meet a Mexican in his line of work.
Only your father can warn you what their faces will do

when they try to guess your parents' continents, their blood. But I—
I will give you the shape of land they walked across

to find each other, the rocks that arced their feet,
the waves that hammered out their frames,

the wind that flamed their hair, burning down to char,
to glowing ember. I will give you the sound of caves

within their voices, the plates of earth that overlapped,
the angles that they made together to make you.

CONNECTION

SALT WATER

JENNIE LaFORTUNE

We parked on the side of the street and walked a few hundred feet through a parking lot, our bodies stiff after a six-hour drive to Las Vegas followed by a red-eye flight across an ocean.

"We can't check in until three, and it's only ten, so let's just go to the beach?" Marianne suggested.

"Did I hear a question at the end of that sentence?" Melissa joked. "Why would you raise your voice at the end like it was a question?"

The three of us had the same beach and vacation rhythm, making being together on an island ideal. It was our second trip and we vowed it had to become a tradition. Our rules were simple. We could book this trip if:

1. We could find air fare and lodging for a thousand dollars or less.
2. We were fine wasting away on the beach for multiple days in a row. No crazy driving or all day excursions if it ate up a beach day.
3. We were willing to stop counting how much sugar and diet coke we consumed while off the mainland.

One year prior I called my girlfriends with a blink-and-you'd-miss-it deal that set the standards for any future trips. Unexpected and fully indulgent, the bronze expanse of sand and crashing water became our unintended sanctuary, our rite of spring and shedding our winter-tired skin. Comfortable hours spent staring off into the ocean without hearing or speaking a word, followed by hours of sharing deep unguarded secrets. Laughter and silence sat side by side. Even though the beach as a whole had not been undiscovered land, the separate parts of sand, sun, and water awed us. We would pick up handfuls of newly washed grains, and let the mixture drip through our fingers and splatter onto our legs as we marveled at the shiny particles nourished and worn down by water and sun. Somehow touching the earth, feeling the rays, and tasting the brine on our lips allowed reality and peace to settle among and between us. We wanted to rewind and repeat the trip before it ended. We left, promising to return to the salt water again for a healing as soon as the chance came.

After we found our beach and parked, we dug through our bags comprised of more swimsuits than clothes. The magic air and location tricked us into forgetting high-maintenance habits

and anti-camping vows. Stripped of our worries, appointments, and inhibitions from the Motherland, we rolled the windows down enough to trap a towel and create a makeshift dressing room. Shirts came off, pants were thrown, and the acrobatic feat of pulling Lycra on over sticky bodies ensued. We dumped sunscreen, books, and water bottles à la yours, mine, and ours into a beach bag still littered with sand pieces from last year. The chairs we bought at Kmart minutes earlier swung, clanking against our backs. The weight of the bags, and chairs distracted me from realizing I had bare legs and hardly anything covering my chubby pale winter legs.

A second flight across the ocean; nervous anticipation. We longed for a repeat reprieve. As we crossed the street from the car to the alley leading to the beach, I saw a brown dumpster in a corner next to huge flowering bushes. It felt odd to have such a practical utility amidst natural beauty. Round and brown little bathing suit kids buzzed around the dumpster as they threw popsicle wrappers inside; only half the wrappers making it in.

"Don't you wish it was still cute to be chubby and have rolls on your thighs at this age?" Marianne sighed.

Melissa and I played along, and pulled our jersey beach dresses up to make them even shorter and kept walking.

As the beat of our flip-flops searched for sand, a familiar general store with green wooden letters and an A-shaped awning appeared on our right. This store would soon provide our daily sustenance. Natural Cheetos and Diet Coke. As the three of us filed past, our arms full and backs red from straps of chairs, our eyes met each other and we silently knew our traditional beach habits had commenced. Our brightly painted toes sprouted from the hot damp sand as we shuffled to find our spot.

Our lethargic movements looked like a modern dance; our slow annual glide familiar, and almost in perfect unison. The colors of green and turquoise glass roared their siren call, soon we would answer, but now look before the surf, sand grit beneath our nails, we stood at attention. Salt-bidden, worshipful release.

UNLEAVING

LUISA M. PERKINS

"Margaret, are you grieving
Over Goldengrove unleaving?"
—Gerard Manley Hopkins

"When we depart, we shall hail ...
all whom we love,
who have fallen asleep in Jesus."
—Joseph Smith

When Margie was little, she prayed to die before she turned eight.

At Primary, she'd heard that kids who died before they got baptized went straight to the Celestial Kingdom. It seemed like a pretty good deal, a guaranteed shot straight into the arms of the Lord—better than a Disneyland FastPass.

So, amidst the hugs and smiles and testimonies on the day of her baptism, she was secretly a little miffed. Her life stretched ahead of her, shaping up to be one long, hard slog. Fasting, being nice to people you didn't like, working, paying tithing—she sighed. Apparently, that was God's plan for her. It seemed so unfair.

Forty years later, Margie realizes life has zipped by. And now she wants to slow it all down, even rewind it like a reel of film. The day she met Greg, bumping into him at the Wilkinson Center when they were both freshmen. Their missions, each waiting for the other. The morning they got married in the Salt Lake Temple, and then two days later, when he got food poisoning on their honeymoon, and she rubbed his back while he threw up endlessly into the Bridal Suite toilet. Yes, the slogs, but the summits, too. The kisses and the financial stress and the homemade ice cream and the boredom and the feverish kids and the Christmas mornings. All the hills, every valley. They were sweet to her.

She stares at the familiar wallpaper at the Keck Cancer Center. She had hoped never to see it again, but the cancer is back, and therefore so is she. The nurses and phlebotomists have tried everything to find a vein for this round of chemo, with no luck. She's drunk water until her belly is tight and round; Jeremy the Giant, Margie's second favorite nurse, has brought her hot towels straight out of the warmer to wrap around her

arms and legs. Still, no vein. Finally, Jenna, Margie's favorite nurse, comes in and sits on the gurney next to her.

"PICC line or port, sweetie? It's gotta be one or the other."

Talk about a devil's choice. Catheter into her heart or permanent reservoir under her collarbone? Both have advantages, but both have serious drawbacks, as well.

Margie clamps her lips together and shakes her head. "Nope. Not happening. Give me a few minutes and then try my ankle again. Or the top of my right foot. It worked last time."

But she knows the chemo has blown out all the veins that used to work. This is the third set of her fourth round, and Margie's body isn't responding the way it used to.

Margie also knows she's holding up the whole shift right now; they can't leave until her treatment is over. These people are like family to her, the kind and caring family she would rather not have. She wishes she knew less about their lives, all the stories they've told her in an effort to entertain and distract her during the painful, humiliating treatments. These people who have taken care of her, they want to go home to their real families now. So why is she dragging this out?

Jenna squeezes Margie's hand. As if reading Margie's mind, she says, "I'm not trying to talk you into this to make my life easier. It's to make your life easier."

Margie's eyes burn, and she rubs her forehead. "I know, I know." She lets out a trembling breath. "Okay. Port it is."

"Good choice." Jenna stands up and gives Margie a brief hug. "I'll let Dr. Luymes know. We'll get the procedure scheduled for Thursday, and then all this?" she waves her hand around the chemo equipment. "Gets a lot simpler."

Margie nods and presses her lips together so she doesn't cry in front of Jenna. Once the nurse is gone, though, she can't hold back.

After a couple of silent sobs, she blows her nose and texts Greg.

Treatment fail. Getting a port Thursday. Come get me?

I'll be there asap, he answers.

Greg works a few minutes away, just on the other side of the 110. But after Margie finishes her paperwork, he's still not there. She sits outside the hospital doors on a bench in the sunshine.

After the airless depths of the Center, the cool breeze feels like a blessing.

I don't want to die.

But she can feel it coming, a stealing coldness, a darkening around the edges of her life. It's waiting. All the chemicals and radiation—they're only delaying the inevitable.

Cars come into the roundabout in front of her, dropping off and picking up. No Greg, not yet.

She gazes at the people as they go in and out of the Center. One girl gets her attention; she looks about nine, but clutches her mother's hand like a toddler would. She's dressed as if for a formal party, in a black velvet dress with a lace collar. Her matching headband holds back her long, straight, blond hair. Her mother wears more casual clothes. The girl looks so familiar; Margie wonders where she's seen her before. Maybe she's a student at Catherine's school.

The girl must sense Margie's stare, because she looks over at her as they pass the bench. She gives a smile of recognition and a little half wave before the sliding glass doors swish open to admit them.

With a jolt, Margie recognizes the girl. The snaggle-toothed grin, the bright blue eyes. It's Wendy.

Margie gasps and stares after her. But it can't be Wendy, because Margie's best friend in third grade died almost forty years ago.

A lightly tapped horn startles Margie out of the shock and grief that have welled up as fresh as if it weren't decades later. Greg's at the curb. When their eyes meet, he gets out of the car and walks quickly to her.

Margie stands and dissolves into tears when his arms fold around her. He squeezes her, rocking side to side, and then pats her back.

"C'mon, babe. Let's get you home. We're blocking traffic." He helps her into the car and gets in on his side. As they drive away, Margie sees the little girl who looks like Wendy gazing at her through the glass double doors of the Center. She smiles and waves again, and Margie gets a chill.

They pull up to their house in Pasadena a half hour later. Margie looks at it as if she hasn't seen it daily for almost twenty years. Ranch style, azaleas and camellias dressing up the front, blending in harmoniously with the rest of the neighborhood. It's funny: the house itself is nondescript, almost generic. But placed in context with the rest of the street, it contributes to a gracious whole. Margie feels sure there's a gospel metaphor in there, somewhere.

Greg rushes around and opens the car door for her, and Margie pushes away the urge to snap at him. She's not dying yet. But he's just being kind, and she shouldn't pick a fight just because she's miserable. She goes inside while Greg brings in the garbage cans.

Catherine and Todd are at the kitchen table doing their homework. They look up when she walks in, love but also wariness in their eyes.

"How'd it go?" Todd asks.

"It didn't. I'll have to go back Thursday to get a port put in, and then next week, I can do another round of chemo."

Todd pales; he's always been a bit squeamish.

Catherine gets up and hugs her mother. "I know you didn't want this," she says.

Margie hugs her youngest child back. "Nope. But it's not about what I want, is it?"

"I guess not."

Then Todd has his arms around her, and when Greg enters the kitchen, he joins in. Even though Alice and Josh aren't there, in this moment, Margie feels whole, complete. *Please don't take this away from me*, she whispers to God.

She hears no response.

That night, Margie dreams about Wendy, and it's really just a replay of an old memory. They are skipping around the rain-wet asphalt of the playground at recess, singing songs that suit the puddle-splattering rhythm. Margie's grandma will have a fit when she sees Margie's muddy tights, but the game is too exhilarating to stop. They finish all the verses of "Reuben, Reuben," and then get stuck trying to think of a new song that will fit.

"I know a perfect one," Margie cries after a brief pause. She launches into the first verse of "Far, Far Away on Judea's Plains," but when Wendy doesn't join in, she stops and looks at her best friend.

"I don't know that song," Wendy says.

"Really?" Margie's jaw drops. "It's my favorite Christmas carol."

She teaches it to Wendy, and the girls resume their game.

Margie wakes up with tears running down her cheeks. Of course Wendy hadn't known "Far, Far Away," she realizes. It's a Mormon hymn.

She lies in bed, staring into the dark, and thinks about her friend, who drowned in an irrigation canal while visiting her grandparents the summer after third grade. Wendy's was the first funeral Margie ever attended; it was also the first time Margie went inside a church other than her own.

Margie wonders what happened to Wendy's parents; Wendy had been their only child. Now a mother herself, Margie can't imagine the pain of losing any one of her children; she counts herself lucky that her only remotely similar experience was a miscarriage, long ago, between Alice and Josh.

Then she realizes something that makes her heart clench. If she doesn't survive this bout with cancer, her own mother and father will suffer the same loss that Wendy's parents did.

Thursday arrives, and Margie stares at the ceiling of the pre-op room. She bitterly regrets having agreed to the port. She knows it's the right thing to do, but she'd give a lot not to have to go through with it. She'll be under conscious sedation with anesthesia, a combination that has worked well for her before. Jenna will stay with her throughout the procedure, monitoring her vital signs and level of responsiveness.

The medication's languor steals over her limbs, and her body grows heavy against the gurney. Jenna squeezes her hand and talks softly to her, telling her about her son's most recent Little League game. Margie rides the gentle rhythm of the nurse's voice until a tap comes on her shoulder.

She turns her head and opens her eyes; Wendy is standing at her side, her blue eyes just level with Margie's own. Margie is too relaxed to be surprised or fearful; she just smiles at her old friend, a few tears leaking out of the sides of her eyes.

Wendy grins back. "I missed you."

"Me, too," Margie murmurs.

"Do you remember our skipping game?"

Margie tries to sit up a little, but her body won't let her. "I do! I just dreamed about it the other night."

"I know." She holds out her hand. "Play again?"

"I would love that. I—"

But an urgent voice interrupts Margie, which she finds annoying.

"What?" Margie's voice is suddenly thick. She wants to bat away the distraction like a fly.

"Margie? Stay with me." It's Jenna.

"I'm right here," she protests, but the words don't come out right. Why is she mumbling?

"What happened?" She stares into her favorite nurse's deep brown eyes.

"You, uh, tried to leave us." Jenna's usually smooth voice is shaking. "But we're not going to let you go, not yet." She lets out a little laugh. "You've got to get some mileage out of that brand new port first."

So it's over; Margie hadn't even noticed. She looks back to where Wendy was standing, but her childhood friend is gone.

That night at home, Todd brings her dinner on a tray. "I heard you tried to skip out on us today during your surgery."

Margie winces. Skip out. But of course Todd has no idea. She wishes Greg hadn't mentioned it. "I'm sorry Dad told you."

"I'd rather know than not," Todd says, sitting on the edge of her bed. "Don't worry; Catherine didn't hear. I think Dad was just freaked and needed to talk to somebody."

Margie looks at her boy. He's so grown up, so strong and mature. When did her chubby baby turn into a tall, lean high school senior?

"Thanks for listening to him," she chokes out. She goes through the motions of getting ready to eat, but she has no appetite and pushes the food around on her plate.

"Where's Dad?" she asks. Greg has been avoiding her all afternoon.

"Catherine needed some help on her social studies project. I guess it's due tomorrow." Todd looks at her as if there's something on his mind.

"Anything you want to talk about?" she prompts gently.

He takes a minute to answer. "This round of your treatment. It feels different. It seems like ... like you're not working to beat this like you did before."

Margie leans back on her pillow and berates herself for not being more cheerful, more sassy. She's just been so tired, and Todd's right. The fight just isn't in her anymore, and even faking it has felt impossible.

"I'm sorry," she whispers. "I'll try harder."

"Mom, no. There's nothing to apologize for. That's not what I meant. I just ... noticed, that's all."

"I'm not going anywhere." But even as she says it, the promise rings hollow in her ears.

Todd nods. He gets up, kisses her cheek, and walks out. Margie knows he doesn't believe her, either.

In fact, it's worse. Days later, Margie still can barely leave her bed. Just the round trip to the bathroom exhausts her. When she gazes into the mirror, she doesn't recognize the woman looking back at her. Greg picks up the slack—cooking, cleaning—in addition to putting in his usual long hours at the firm. The kids help, but it's Greg who has to carry the burden of running the house, because Margie is just too tired.

It's Friday, and something nags at Margie. Was she supposed to do something? Is there something on her calendar that she's not remembering? But she finds herself too dull and foggy to care. The kids can make themselves macaroni and cheese, like they always do on Date Night. Margie pushes away the vague worry and goes back to sleep.

At six o'clock, Greg rushes in from work, handsome in his suit, with his tie already at half-mast. He stops when he sees that Margie's still in bed. His face darkens as he takes in her pajamas and messy hair.

"Did you forget?" His words are clipped.

Margie's nausea increases as she realizes what was bothering her. Tonight is Catherine's concert. She promised two days ago that she'd do her best to be there. Catherine has a solo, her first.

Margie tries to sit up, but stops when the whole room spins like a carnival ride. She puts her hand over her eyes.

Greg comes to her side. "Honey, I know you're miserable, but Catherine is counting on you. Can't you rally, just for a half hour? We'll take the wheelchair. I'll bring you straight home after her solo. This means so much to her."

She shakes her head weakly, which makes the room reel again. She sinks back onto her pillow with a sigh.

"Margie." Greg says her name through gritted teeth. "Get. Up. Now. Your daughter needs you. I need you."

"I want to, but I just can't. I'm so dizzy. I don't even think I'd make it to the bathroom."

"Oh, I'm sure you'd manage. You always do when it comes to your own pain."

Margie cannot believe what she's hearing. She's too shocked to cry. "Nice going, honey," she manages. "Kick the dog while she's down, why don't you."

Greg's eyes falter, and he takes a breath. Margie expects he'll apologize. But then something in his jaw hardens. "This isn't just happening to you," he says. "It's happening to all of us, too."

Margie just stares. Greg has never burst out like this, not through the diagnosis process, not through all the treatment, not through the repeated bad news that the cancer was back. A tiny part of her knows he's not mad at her, but still. It hurts. He has been her rock, but the sand has just shifted.

"It's not my fault, Greg. I didn't choose this."

"You might not have chosen cancer, but you've stopped choosing your family," he barks, and leaves the room.

Margie lies there, rehearsing in her head all the ways the conversation could have gone differently. She hears the kitchen door slam and the garage door open and close again. She's alone.

She falls into a doze, but startles awake when she hears someone humming. It's Wendy at her bedside, and the tune is "Far, Far Away on Judea's Plains."

Her friend's eyes sparkle. "Come on. Let's go!"

Margie shrinks away. Now she knows why Wendy is here. "I can't, not right now. I need to talk to Greg first. Can you come back later?"

Wendy smiles and shakes her head. Her face radiates joy, along with something else that Margie can't name. It's solemn and mystical and lovely and outside the normal human experience. What would it be like to feel it, she wonders?

Margie sighs heavily and looks away. In the setting sun's golden light, the breeze-stirred lemon tree outside the window casts dancing shadows on the far wall. The light will fade soon, which makes the play of the ever-shifting shadows all the more beautiful. She watches them in awe.

Wasn't she angry and frustrated just a few minutes ago? She can no longer remember why.

Now she's buoyant, as light as the motes of dust in the air, which she can see with perfect clarity.

And now she realizes that her life hasn't been like a reel of film, running in one direction; instead, it's been an interplay of light and dark just like the shadows on the wall, an intricate pattern that goes on forever. Everything she once saw as difficult or tedious now seems wondrous; all of it has brought her to this point of peace and reverence and reconciliation.

Margie turns back to her friend and grins. Wendy reaches out again, and this time, Margie takes her hand.

BREAKING CHARACTER

CHRISTIE CLARK RASMUSSEN

SCENE 1

A brisk March evening. Cody and Christie stand on a sidewalk
near the Provo Library. They have just finished a walk around
the neighborhood and are loitering beneath a buzzing
streetlamp. Both are tense and have not spoken for a while.

> **CHRISTIE**
> ... Do you *want* to date me anymore?

> **CODY**
> I don't know—it changes. Some days I think,
> "Christie is the best thing that has happened to
> me; I need to marry her," and some days I think,
> "I like Christie, but I don't know."

> **CHRISTIE**
> You know you don't have to decide anything about
> marriage at this point, right? We don't have to
> broach that subject. I just need to know if you
> still want to be around me.

Cody shifts to avoid her face. Silence stretches as Christie
stuffs her hands in her pockets.

> **CODY**
> How would you feel about taking a break?

 CHRISTIE
 ... A break?

 CODY
 Just for a few weeks. We'll see how we feel later
 on and determine whether we want to make it
 permanent.

Cody searches her face for a moment before Christie looks
away.

 CHRISTIE
 No. If we break up, we break up. I love you,
 Cody; I don't want to just take a break.

Cody draws a breath as though he were about to speak, but
nothing comes out.

 CHRISTIE
 If you finally figure out what you want, let me
 know, but I can't wait around.

I hope you'll forgive me for the slightly theatrical format. I was an acting major in college
and my memories play like scenes from a play in my head. It only makes sense to hash
them out in a similar fashion as I ruminate on relationships and the transitions between
them.

 Throughout college, I was determined to date someone that fit my perception of a
perfect match. Someone with similar drive and an ambition to match my own. I wanted
prestige—a doctor or lawyer, preferably. As I dated these would-be doctoral candidates,
however, I always found the relationships wanting. Some relationships felt more like a
neverending debate, while others felt like I was being psychoanalyzed, my responses
carefully sorted into boxes. With Cody, I fell hard. I thought I had finally found the right
fit. He was tall and handsome with a strong jawline. More attractive, though, was his
determination to go to medical school. We'd study together on the floor of my living
room, him poring over biology textbooks and me memorizing scenes and monologues for
my contemporary theatre class. He took me to his family's place for Thanksgiving. We

spent hours in his beat-up truck talking about politics, our families, and what we wanted the future to look like. Christmas passed and we started talking about what we wanted our future to look like.

As the months went by, though, I wanted to talk more and saw our future taking shape. Cody was less sure. He had had commitment issues in the past and did not feel like our relationship was progressing much differently. He stopped telling me that he loved me and became less responsive when I reached out. He said he needed time so I gave him time. I finally had someone that felt right, that checked all of my boxes, but it wasn't enough. I told him he didn't have to know everything now, but it still wasn't enough. As painful as it was to break up, I couldn't justify being in a relationship so imbalanced. I retreated to lick my wounds and try my hand in a new city as I started a new job.

SCENE 2

Christie and Chad sit on a grassy hill in Salt Lake City's Liberty Park munching on egg salad sandwiches. Chad, lying on his back, looks up at the cloudless July sky in faded blue jeans and a polo. A perfect moment, if not for the conversation.

 CHRISTIE
 What if I don't feel the same way about you as
 you feel about me? I don't want to lead you on.

 CHAD
 (Rolling to his side to look at her) I know how
 you feel. Why do you think you have to match how
 much I like you? Where is this pressure coming
 from?"

 CHRISTIE
 Myself, mostly. I just want us to be on the same
 page.

> **CHAD**
> If I know how you feel and I'm fine with it, then
> what's wrong? I'm the one who could be hurt,
> right? Why not let me decide instead of deciding
> for me?

Considering, they chew on sandwiches and let the conversation
turn to more mundane topics.

Chad and I had been fairly good friends for years—before, during, and beyond my season with Cody. At times we tried extending friendship with dating, but each time we got to a point of commitment, I fled. It turned into an almost annual tradition: Chad and I would be friends, we'd go on a few casual dates, I'd realize that he wanted to seriously date me, and I'd decide I'd rather be friends and tell him so. Chad felt chemistry and knew, just knew we'd be good together. Still he listened to my reasons, quietly disagreed with all of them, and watched me go pursue others. Even when I moved away from my apartment across the street from his, he texted me occasionally, asking me how I was doing and what I was up to.

So it happened that after I moved forty-five minutes north for my new job, Chad casually reached out to see if I needed help unpacking. Hungry for a familiar face, I took him up on the offer. We chatted effortlessly as we worked. I wouldn't find out until months later that his trip to Salt Lake was fabricated so he could see me. What would have come off as stalkerish or clingy a few months ago now seemed sweet and familiar. When he invited me to dinner, I accepted. I couldn't explain what had changed from the almost three years since we had first met, but it felt different. I knew dinner was more than just an offer from friend to friend. I had a feeling there would be strings attached, but I accepted, the feeling that the timing was finally right ebbing over my forever fear he wasn't the "right person" or type for me.

Our relationship progressed. He was so earnestly sweet and I felt lucky. But good timing and good luck didn't feel like enough. I felt deceitful as I casually observed him falling for me in a way I couldn't replicate.

SCENE 3

Christie and Chad lie on the living room floor of Chad's
apartment. Glimpses of snow can be seen falling outside
through the window.

 CHAD
 I love you.

 CHRISTIE
 (*Freezing*)

A full minute passes.

 CHRISTIE
 (*The best she can do, given the circumstances*) I
 know... Is it okay if I can't say "I love you"
 yet?

 CHAD
 Yeah. I know. But I love you and I want you to
 know that. Is it okay if I keep saying it?

 CHRISTIE
 Yeah.

That night in November wasn't the first time Chad told me he loved me, but the earlier
instances had been accidents. It had slipped out once on a hike and we both kept walking
and talking as though the words had simply floated away. Unacknowledged, we did not
discuss it and kept a silent pact to keep it that way. November was different. He was
deliberate and I was still uncertain, my fears circling back.

 We kept up the tenuous dance. It wasn't all terse conversations or unreturned
declarations of love. We kissed and laughed and held hands. We cuddled and talked
about what-ifs and vague plans for the future, attempting to not tip our hands too much.
Chad trying to rein in his feelings so he wouldn't scare me off, and me trying to see if
what I felt would be enough. Me trying to judge whether it was fair to him.

 Sometime in March, I decided it wasn't enough. Chad was diligent and kind, but he
did not have the same drive for accomplishment as me. Instead of being alpha male, he
refused to compete with others and preferred to walk out of an argument than engage in
the verbal fray. He was content to stay in Utah and clock in a forty-hour workweek,

potentially coaching soccer on the side. His mildness ran contrary to my expectations of a motivated, career-driven partner. I worried that we were too dissimilar. I prayed for God to tell me if it was right, if Chad was the right match for me. I didn't feel anything. I interpreted the silence as a stupor of thought. If the heavens were closed, I had to go with what logically made sense. I loved Chad and had recently told him how I felt, but I was unsure whether I could ever match the depth of his feelings. It was difficult to definitively break it off—he was my best friend and my source of comfort when I was uneasy or upset. And I needed some comfort now.

SCENE 4

Christie and Chad sit on his bed in a half-lit room. He hums faintly while doodling with his finger on her arm. She is reserved, however, searching for the courage to speak.

 CHRISTIE
 We need to talk.

Chad slowly exhales.

 CHRISTIE
 I can't find answers, no matter how hard I try.

 CHAD
 I told you, you don't need to have any answers
 right now. I'm not asking for any answers.

 CHRISTIE
 But I am. I can't keep doing this to you. I love
 spending time with you, but I don't know where
 it's going. I need to know where I'm going. I
 pray and I don't hear anything.

Chad doesn't answer and instead turns to look down the vacant hallway.

> ### CHRISTIE
> (*Talking to fill the space*) I'm afraid it's a
> stupor of thought... What if we just take some
> time. Just a week? Let's take a break and see how
> we feel.

Long silence.

> ### CHAD
> (*Looking at Christie and holding her gaze*) ...
> Christie, I've wanted to ask you this for a long
> time and I'm not sure if I'll be able to have the
> chance again, so here goes—will you marry me?

This is not what she expects. More silence as Christie looks
away and tightly shuts her eyes to think.

> ### CHRISTIE
> ...

> ### CHAD
> (*Cautiously taking her hand*) Christie?

Finally, she opens her eyes and meets his gaze.

> ### CHRISTIE
> Yes.

Believe me, that was not the answer I expected to give. I don't think anyone was more surprised than me that I decided to marry Chad. I was so certain how that evening would go. I had made a decision and was trying to be responsible and stop hurting him the way Cody had hurt me. The question dangled, unanswered, for what seemed like ages. My mind raced as different possibilities unfolded before me. Inexplicably, I wanted to say yes. I had approached the relationship so carefully and, in that moment, I wanted to stop thinking and just say yes. I said a prayer while my eyes were closed and felt washed with

peace. In that moment, I knew marriage wasn't the only option. Fate was not involved and I could take a different path, but it was my choice to make. I had tried pushing my decisions off and I finally had to choose.

Although I accepted, it was not without some conditions. I asked for it to remain between us until I had time to think and pray. I asked for a week to myself to make sure it really was what I wanted. Ever accommodating, Chad gave me space as I dove into the scriptures and meditated on the decision. The peace I felt the night of the proposal sustained me as I reconciled my head and heart. I let go of the expectations I had set for myself, the checklist I crafted years ago. I let go of the rusted memories of Cody that still tore at me and drew unwanted parallels. I stopped trying to force God's hand and prayed to know if my decision would bring me joy. After five days, I finally felt more certain that my gut response had weight. We started discussing the wedding in more final terms and began slowly leaking the news to friends.

Almost three years later from that crucial "yes," I still go through spells of doubt and wonder whether I gave the choice enough thought. I think back on that night, watching from an invisible catwalk above the scene. I see those two bodies perched on the bed in the dimmed light. As much as I wonder what would happen if I were to rewrite, recast the part of "fiancé" and the eventual "husband," I can't imagine it any other way. I'm past that point of considering. I made my choice when I married him, but that wasn't the last one. I get to choose every day to love. Rather than worrying if I found the perfect match, I concentrate on perfecting the match I cast.

EBBING TOWARD THE VEIL: THREE GENERATIONS

LARA YATES NIEDERMEYER

I'm chill inside as if on the promontory,
alone, hollowed out.
I have a different life
to go back to.
Two weeks, then I'm home—
never enough time to more than give
a cursory lift to my mother's load.

I pack and leave my mother
to mother hers.

It is my privilege (millstone)
that I can cede
this time of disremembering,
the shading that keeps Gram
suspicious of our love,
seething when our help reminds her
that she was self-
sufficient,
that she was
the caretaker
for as long as she
remembers.

When I come to town
I drive,
the offense at being ferried has skipped
a generation—
I scrub her bathroom floor,
clean the mirror,
bring in the Christmas tree.
I bend—hold—carry
and it's allowed.

There is a sideways wind that lets us
walk a sheltered shore
so she and I avoid the steeper slope,
where instead my mother slides with hers
through tumbling shale, bluff clay,
and the aged sediment
of being read to by the one
you taught to read,
eyesight beyond recovery.

Gram's thoughts crest and ebb
as the winter storms begin
to rive and beach their driftwood legacies.

Within this cold coil,
this shorn forgetting,
my mother calls to tell me:

Every day she asks if I
have to go to work, and
both parts of this plea kill me—
her loneliness and
she doesn't recall
I do this
every
day.

The last word
bites off, shard-like,
with open longing
for the years of Gram's warm sun around us,
wit and charm,
the wisdom she shared by
the paths she walked.

Oh, how do we weather this frigid tide
and keep our hearts intact?

How does this end?

This natural injury,
this loss of life,
without death?

MEMORY OF PLACE

ROSALYN EVES

The red rocks of Capitol Reef loom over us, at once imposing and fragile, the sandstone fragmenting in oddly symmetrical sheets.

We've come to Capitol Reef many times in our marriage: for us, it's come to represent a place of refuge and retreat, a place for family renewal—and a place for grief.

I'm convinced that places have memories: both the sacred grove and Gettysburg carry a gravitas in their landscape, as if what happened there is impressed onto the surfaces. Beyond that, I believe that places have a significant dimension in our own memories. The Romans, who were among the first to study *ars memoriae*, or the art of memory, called the mental storage places of memory *loci*, the same root in our word location. Memories take place, both literally and figuratively.

Driving into Capitol Reef on the fringes of a thunderstorm in mid-September, all the linked memories of the place come flooding back to me, forming a kind of spiritual palimpsest over the rock and sage landscape.

JULY 2003

My husband and I are three days into our honeymoon. We spend our mornings hiking along trails where the light refracts off sheer rock, our afternoons swimming in the hotel pool. Mostly, we're puzzling through the exquisite strangeness that is newly married life—the way someone can be familiar and foreign, the way eternity seems both a terrifying omen and a gift.

AUGUST 2011

I look out the window at the hills behind our hotel, at the green boulder-strewn rise meeting abruptly with the fortress-like wall of the red rock. Above, the sky is so blue it hurts. My children tumble around the room behind me, excited by the promise of vacation, but I am still. I am waiting.

We take our kids hiking in the heart of the park—well, walking might be more apt for our three- and five-year-old children. We scuff our feet in the dust, listen to the call of a rock wren, and watch an eagle soaring overhead. My oldest clambers up a small mound of rocks and crows at me, king of the mountain.

That night, when darkness textures our room and my children and husband sleep, I

go into the bathroom and I bleed. The baby I knew I was miscarrying passes, and I sit silent vigil beneath the bright fluorescent lights.

SEPTEMBER 2013

Driving into Loa for what has become a bi-annual family reunion, we hit a deer. The kids (there are three now) are traumatized; my husband and I are relieved the car still drives.

We don't let the accident shadow our weekend, though. We drive the dented minivan into a campsite where our extended family exclaims over it, glad we're safe. We eat grilled quesadillas in the long shadows of the bluffs, and hike along the riverbed to a pool where my toddler baptizes himself.

When the reunion is over, we drive our flagging car home to face the damage: one deductible and two weeks later, we get our van back. Trauma and tragedy are softened by family and woven back into the thread of everyday life.

SEPTEMBER 2014

Like most family gatherings, this one is mixed. Some of our favorite people are missing. The food is excellent. My youngest wears blisters on his feet before I notice. And while nothing can dampen the grandeur of the surroundings, the relentless rain on the last morning creates a somber atmosphere.

But there's something about this place that I can't shake—something beyond the red mud now ground into the carpet of my car. Something in the bones of the rock, the way the hills beyond the red walls are crowned with white, the way the trail beside the Freemont River grows thick with yellow flowers and plants as high as my head, incongruous in an arid region. I suppose I could call it numen, that inexplicable sense of the sacred that sometimes obtrudes itself into mundane routines.

One line of research into theories of place explores what makes places sacred. Ideas range from human ritual, beliefs, even the shape of the landscape. But part of what makes individual places numinous are the memories that light it, layers and layers like a fine patina adding depth and richness to the landscape of our lives. When we drive into Capitol Reef again this September, I won't see only the rock and shadows. I will see all of our shared history: the hope and love, the blood and grief, the blisters and embraces, the tears and laughter, all carved along the rocks and ridges. I can't experience this landscape independent of my memories of it, and I wouldn't want to. The hills store and refract the memories back at me like so much light; under the weight of all those pasts—shaken, pressed down, softened by time—the landscape blazes before me, my fire in the desert. Whether I walk under sun or in shadow, I enter sacred ground.

ACKNOWLEDGMENTS

This anthology was born from the prose and poetry of the *Segullah* staff and select past contributors. *Segullah* publications: a literary journal, blog, and previous two anthologies, have been a unique place where Mormon women write the spectrum of precious and peculiar truths that shape us into art. We thank the *Segullah* staff past and present, both featured in the book and not, for contributions of talent, time, and listening. Several staffers went the extra mile with editorial support, making our work so much lighter.

Many thanks to the talented team at *Peculiar Pages* for taking this book on because they believed it mattered. The hard-working and hawk-eyed Elizabeth Beeton made our words condense from cloud to copy.

This book is dressed in Leslie Whyte Graff's brilliant, vibrant art. She generously said, "Take what you want." We did. Elizabeth Cranford Garcia's poetic acumen made this book more creative and certain. Final lap anchors Sherilyn Olsen and Linda Hoffman Kimball did what needed to be done to get the good word out. The creative, resourceful, and eloquent women who wrote *Segullah* into being twelve years ago: Justine Dorton, Kylie Turley, Kathy Lynard, and other early members. To the community of readers and writers who make *Segullah* matter, thank you: This book is for and because of you. Thank you is not enough.

Finally, to our families and friends, acknowledgment and a loud, brassy appreciation for encouraging and allowing the space this took up; deep dredges of love.

CONTRIBUTORS

CLAIRE ÅKEBRAND is a Swede who grew up in Germany and Utah. Her poetry has appeared in the *Manchester Review*, BOAAT, the *Beloit Poetry Journal*, and elsewhere. Her debut poetry collection *What Was Left of the Stars* is forthcoming with Serpent Club Press in Summer 2017 and her novel *The Field is White* is forthcoming from Kernpunkt Press in Autumn 2017. She is a Poetry MFA student at the University of Utah. She lives in Provo with the poet Michael Lavers and their two children.

CATHERINE KEDDINGTON ARVESETH is mother to five children, including two sets of twins. Exercise physiologist by profession, writer by passion. She and her husband, Doug, live in Salt Lake City, Utah. She blogs about life, books, and raising children at wildnprecious.com.

TERESA TL BRUCE savors the scent of cut wood—even after designing and constructing a massive loft bed. In her pesticide-free garden (where her rescue dog ignores new-trick lessons), critters feast without fear. By day (and night) Teresa shapes words for her clients and herself, but she's most proud of raising three dynamic daughters. Drawing on experiences of young widowhood, she explains "What to Say When Someone Dies" at TealAshes.com.

MELONIE CANNON is a poet, a lover of words, nature, thick socks, and all things mystical. She lives near the mountains with four brilliant children and one patient husband. She received her MEd from the University of Utah while teaching school. She is currently working on her first YA novel and blogs during the equinoxes at meloniesmind.blogspot.com or when something funny happens to her, which she wishes was more often.

JESSIE CHRISTENSEN lives in Utah with her three children, one cat, and a fluctuating number of fish. She works for a university library, and in her free time enjoys reading, playing piano, and going for bike rides with her kids.

EMILY CLYDE CURTIS is a former editor of the magazine, *Exponent II* and lives in Phoenix, Arizona. She has a Masters in Theological Studies from Harvard Divinity School and works in non-profit management.

JES S. CURTIS lives and writes on the banks of the Potomac in Alexandria, Virginia. She has been published in *Literary Mama* and *Segullah*, and got her MA in Creative Writing from Brigham Young University. When she isn't throwing starfish back into the sea, she works as an editor for The Salvation Army.

MELISSA DALTON-BRADFORD is an award-winning author (*Global Mom: A Memoir*, named AML's Best Memoir of 2013, and *On Loss & Living Onward*), anthologized essayist, poet, blogger, wife, and mother of four. A global citizen, she has resided in Salzburg, Vienna, Hong Kong, the greater New York City area, Oslo, Versailles, Paris, Munich, Singapore, Geneva, and now lives with her family outside of Frankfurt. The tragic but heroic death of her eighteen-year-old firstborn, Parker, inspires her published writing, public speaking, and above all her private living of the gospel of Jesus Christ.

TRESA BROWN EDMUNDS is a writer and all-around internet content creator based out of California. She runs a popular blog at ReeseDixon.com and a YouTube channel at youtube.com/reesedixon, where you can see her doing everything from talking about mental illness to teaching how to make sugar cookies shaped like BB-8. She's been published all over but is particularly proud of being published in both *Bitch Magazine* and *Better Homes and Gardens*.

ROSALYN EVES grew up in the Rocky Mountains, dividing her time between reading books and bossing her siblings into performing her dramatic scripts. As an adult, the telling and reading of stories is still one of her favorite things to do. When she's not reading, writing, or teaching writing at a local university, she enjoys spending time with her chemistry professor husband and three children, watching British period pieces, or hiking through the splendid landscape of southern Utah, where she lives. She dislikes housework on principle. Her first novel, *Blood Rose Rebellion*, first in a YA historical fantasy trilogy, is available now from Knopf/Random House.

GLADYS CLARK FARMER FETZER grew up in a family of six boys in Georgetown, Idaho—a small farming community that her pioneer ancestors helped settle. She received degrees from Brigham Young University and Denver University, and taught English composition at Brigham Young University for twenty years. She and her first husband, James Farmer, raised five children in Provo, Utah. Since retirement and widowhood, she has lived in Boston; London; Qingdao, China; Kensington, Maryland; and Salt Lake City, Utah. She and her new husband have accepted a mission call to the Nauvoo Temple.

ELIZABETH CRANFORD GARCIA's work has appeared in *Boxcar Poetry Review*, *491 Magazine*, *Yellow Chair Review*, *Autumn Sky Review*, *Irreantum*, *Penwood Review*,

Poets and Artists, and *Red River Review*, among others, as well as two anthologies, *Fire in the Pasture: 21st Century Mormon Poets*, and *Stone, River, Sky: An Anthology of Georgia Poems*. She currently serves as Poetry Editor for *Segullah Literary Journal*, and is a past editor of *The Reach of Song*, the anthology for the Georgia Poetry Society. Her first chapbook, *Stunt Double*, is available through Finishing Line Press. She spends most of her time being mommy to two toddlers and keeping up with *Walking Dead* episodes with her husband in Acworth, Georgia.

LISA MEADOWS GARFIELD is an award-winning poet and author of *For Love of a Child: Stories of Adoption*. An explorer at heart, she loves to travel, discuss deep theology and play with her grandkids. Never one to fear transition, Lisa will change her hair color or her home address with equal abandon. She finds her deepest joy and meaning in her relationship with Jesus Christ.

LESLIE M. W. GRAFF holds BS and MS degrees from Brigham Young University. A child life specialist and former college faculty, she spends most of her time now exploring lights and darks in her studio as a professional artist. Her artwork is held in private and institutional collections around the world, and has been featured in Forbes.com, the *Boston Globe*, various books and magazines, in universities, galleries, and museum exhibits. She owes it all to those marble Greek nudes. She lives in Massachusetts with her husband, Allen, and three sons.

ANGELA HALLSTROM is a writer, reader, editor, and mother of four who lives in Minnesota. She received an MFA in creative writing from Hamline University and has taught English to students ranging in age from 14 to 74, most recently at the University of Wisconsin-River Falls. Currently, she works as a writer for the LDS Church History Department. Her novel, *Bound on Earth*, won the 2008 Whitney Award for Best Novel by a New Writer. She has also worked as an editor, compiling a collection of short stories by LDS authors, *Dispensation: Latter-day Fiction*, and has served on the editorial boards of *Irreantum*, *BYU Studies*, and *Segullah*. She is grateful for autumn in Minnesota, a husband who likes to go to the movies, and her moody Siberian cat, Kodiak.

Since Fall 2000, **LISA RUMSEY HARRIS** has taught both honors and advanced writing courses at Brigham Young University. In 2006, she won Segullah's Heather Campbell Personal Essay Contest with her entry "Honor in the Ordinary." In 2013, she wrote the titular essay for the beauty anthology "Why I Don't Hide My Freckles Anymore," released by Deseret Book. Her first novel, *The Unlikely Gift of Treasure Blume*, was released in 2012. She lives with her husband, children, and giant dog in Orem, Utah. Right now (in between raising four daughters and teaching classes) she is polishing her YA fantasy novel, *The Phoenix Sisters*.

After several harrowing life experiences, **TERESA HIRST** is now a recovering perfectionist who practices relaxation. She recently moved with her husband to London, England, where she embraces an empty nest, scones with clotted cream, and walks along the Thames. She is the author of *Flowers of Grace*, a novel inspired by a true story, and *Twelve Stones to Remember Him*, a collection of true stories of individuals who survived the Great Recession with faith.

SANDRA CLARK JERGENSEN's writing (most often about food) has been published in *Gastronomica, Apartment Therapy, The Exponent*, and at Segullah, where she serves as Co-Editor-in-Chief. Sandra geeked out on food and writing as a master's student food studies at University of Texas, Arlington. She makes her home in California where she runs without shoes, foster parents, teaches cooking, develops recipes, and struggles to take pictures with her eyes open, and sometimes all at the same time. She is the owner and creator of thekitchennatural.com.

Originally from New Mexico, **HEATHER R. KIMBALL** left the southwest to attend Carleton College in Minnesota, then traveled further afield as a Peace Corps Volunteer in Kazakhstan. Heather now lives in Washington, DC, where she is pursuing a Master's in higher education administration from the University of Maryland. She rides a purple bicycle around the city and dreams of a time after grad school when she will finally read for fun again.

LINDA HOFFMAN KIMBALL enjoys writing when it comes smoothly and creating art when she's in the zone. At other times they are vexations that never seem to leave her alone. She loves travel, on-stage drama (as opposed to the interpersonal kind), and dogs. Her novels, essays, poetry, and illustrations have appeared in books published by Houghton Mifflin; Random House; Albert Whitman; Deseret Book; Cedar Fort; Signature Books and others. LindaHoffmanKimball.com

JENNIE LaFORTUNE lives in Salt Lake City and is in love with the ocean, green grass, dark chocolate, fresh raspberries, her friends' babies, going to the movies, farmer's markets, and good books. She teaches high school English, which has taught her many things, including how to sing the parts of speech and break up hall fights, but perhaps most importantly, spending her days with words and writing continually reinforces their power.

JULIA BLUE La MAR recently married a hunky Aussie who has turned her world completely upside down (this is a good thing). They have a flock of kids and chickens and life is never boring. For work, she flies around the world taking care of passengers and checking that seat belts are fastened. Her life has experienced an 8,118% increase in happiness since writing her essay.

ANNA SAM LEHNARDT loves books, dancing in the kitchen, and her husband Ben. She did not serve a mission, but thinks it's cool if you did. She has a Master of Arts Degree in Comparative Literature from the University of Utah, where she also received majors in English, French, and German because frankly, she has no self-control.

MICHELLE LEHNARDT is the kind of mom who drives through mud puddles, throws pumpkins off the roof and lets the kids move the ping-pong table into the kitchen for the summer. Despite (or probably, because of) her immaturity, her five sons and one daughter are happy, thriving, funny people. She'd climb a mountain with you, jump into a freezing lake hand-in-hand, or just sit with you while you cry. She believes the Gospel of Jesus Christ will heal the earth. She is the founder of RubyGirl.org.

TRACY McKAY was raised on old orchard land just south of San Francisco. Her childhood memories are equally anchored by the sting of salted fog on her lips, and the scent of apricots ripe for harvest. When she became a mother, she and her husband relocated to Washington State, where the bulk of The Burning Point, her recently released memoir, takes place. Tracy attended Eastern Washington University before moving to the Washington, DC area, where she currently resides with her husband, Jonathan. They are raising their combined family of five children and one very large dog. She's still not sure how she feels about warm humidity, rather than the chilly fog of her childhood.

MELISSA McQUARRIE is a writer, editor, wife, and mother of four. She spent her childhood in Emu Plains, Australia, where she roamed the bush and swam in the Nepean River every summer, and now lives in Provo, Utah, with her family. She has a BA and MA in English from Brigham Young University and has published essays in Dialogue, Irreantum, Segullah, and several anthologies. She loves to read, write, walk her dog, spend time by the ocean, and watch movies while eating kettle corn.

EMILY BISHOP MILNER lives with her husband and five children in Utah. She enjoys reading, yoga, reading, meditating, writing, and also reading. She appreciates her Kindle as it facilitates her book addiction without adding to her clutter. She refuses to KonMari any of her books (or, for that matter, old papers from college that prove she used to be smart).

SHELAH MASTNY MINER thought she was nearing the end of the "kids in your bed" stage of parenthood when she wrote this essay, but went on to adopt two babies from China in the next year. She sometimes resorts to sleeping in the closet when her bed gets too crowded. Now the mom of six, she is thankful for the lock on her bedroom door, which allows her to work in relative peace to grade papers for her Brigham Young University writing and literature courses, and to read while she pretends she's working.

JULIE K. NELSON is a mother of five, author of two books, and wife of one patient husband. She received a master's degree from Utah State University and currently teaches at Utah Valley University. Her research and creative writing have been published in journals, anthologies, and other media outlets and she is a contributing expert on radio and television. Find her at aspoonfulofparenting.com where she writes on the triumphs, challenges, and the power of parenting.

MELODY NEWEY's poems have appeared in Segullah, *Exponent II, Irreantum, Utah Sings*, and elsewhere. She is the current poetry editor for *Exponent II* magazine. When she's not writing, you can find her working as a registered nurse, fluffing an empty nest with her husband, and building sheet forts with grandchildren.

LARA YATES NIEDERMEYER writes to savor and connect. Her poetry took first place in the 2009 Segullah contest, and an honorable mention in the 2011 Sue C. Boynton Poetry Contest. *Segullah* Poetry Editor from 2012 – 2016, she loves ballet, genealogy, television, throwing killer parties, and smelling the roses. A bicentennial baby born in Oregon, she now lives in Washington State with her husband, two children, and a new cat named after Eliza R. Snow.

BECCA OGDEN is originally from Seattle, WA. She holds an MA in English and an MFA in Creative Writing, both from Brigham Young University. She's had essays published in several journals and anthologies, but mostly she writes young adult fiction and a few lengthy Instagram hashtags. Becca lives in a crumbly 1890s pioneer house with her husband and their two young boys. Their house may also be home to a WWII-era ghost, which the family has nicknamed "Father Lawrence," as that's the name they found on the gravestone set in the driveway.

Author and speaker SHERILYN OLSEN wrote the five-star-reviewed memoir, *Searched the World Over for Elie: An International Adoption Story*. Featured in *Segullah*, her essays on family and faith earned her a position as a Prose Editor for the journal. She graduated with a BA in psychology and English from Weber State University and presents workshops for The Department of Workforce Services. Sherilyn lives in South Ogden, Utah with her husband and four children.

HEATHER BENNETT OMAN is a Speech Language Pathologist who spends most of her time making sure her own children say please and thank you. She lives in southern Virginia and works with kids with disabilities in a therapeutic horseback riding center. She is a lover of horses and dogs (cats, not so much). She contributes as a Prose Board member and blogger at Segullah.

LUISA M. PERKINS is the author of the novels *Dispirited* and *The Book of Jer3miah* and the cookbook *Comfortably Yum*. Her short novel *Prayers in Bath* was published in March 2017 by Mormon Artists Group. She graduated from Brigham Young University and is now pursuing an MFA in Writing at Vermont College of Fine Arts. She served a full-time mission to Montreal, Canada. She currently teaches early-morning seminary. She and her husband Patrick have six children, a foster daughter, and a Welsh corgi named Moneypenny. They live in a small town in Southern California.

KEL PURCILL spends too much time imagining, not enough time vacuuming, and writes whenever possible. Happily introverted, Kel will emerge to discuss books, puns, boots, and assorted insanities, especially if dessert is involved.

JENNIFER QUIST is a novelist, critic, journalist, blogger, and raiser of boys. Her second book was named best novel of 2015 by the Association for Mormon Letters. She studies Comparative Literature and Chinese at the University of Alberta, and may have accidentally practiced Canadian criminal law without a license.

CHRISTIE CLARK RASMUSSEN has a BA in Communications and an MBA, both from Brigham Young University. A marketer by trade, she manages publicity for Segullah and also contributes to the blog. Outside of work, you can find Christie memorizing lines for a theatre production, curled up with a novel, or dabbling in the fine art of pop-up cards.

DALENE ROWLEY is delighted to be a first-time grandmother, although (on a good day) she still remembers being twenty. She hails from the Northwest, but has lived longer in the comfort of the Wasatch mountains of Utah, so that is also home. Married to a third-grade teacher, and mother of four, Dalene enjoys making soap, baking homemade pies, and editorializing in hashtags on her Instagram account, but loathes writing about herself in third person. If she could fit one more thing into her busy life as wife, mom, grandma, and instructional designer at a local university, Dalene would go back to school and major in everything.

COURTNEY MILLER SANTO teaches creative writing at the University of Memphis. Her novels, published by HarperCollins, include *Three Story House* and *The Roots of the Olive Tree*. She lives in Tennessee with her husband, two children, and two retired racing greyhounds.

KATIE NELSON STIRLING has a Masters in Comparative Literature from Brigham Young University and works as a contract editor and evaluator. She discovered her love of portrait photography with her first child and now owns a photography studio in Heber City, Utah. She and her husband love the outdoors and enjoy taking their four sons river rafting in the summers and skiing in the winters.

KYLIE NIELSON TURLEY is a full-time mother of five and a part-time teacher of composition and literature courses at Brigham Young University. She enjoys writing about LDS literature and history, though her favorite topic for essays may well be herself, her husband, her five children, and anyone else around her (all of whom have veto power over her words about them).

TERRESA WELLBORN is a student of poetry, dark chocolate, and mutability. She has a Bachelor of Arts in English Literature and a Master of Library and Information Science. She reads faster than she hikes, runs faster than she writes, and has been mistaken for Miss Frizzle, most often by kindergartners. Her writing has been published in various journals and anthologies. When not on a mountaintop, she prefers to dwell in possibility.

DARLENE YOUNG teaches Creative Writing at Brigham Young University. Her poem "Horizon" originally appeared in *BYU Studies*. "How Long" originally appeared in *Irreantum*, then again in Peculiar Pages' poetry anthology. She has published other poetry and essays in journals such as *Atlanta Review* and anthologies such as *Fire in the Pasture: 21st Century Mormon Poets*. She lives in South Jordan with her husband and sons.

MELISSA YOUNG currently lives in the Provo area with her husband and four children. She has an MA in Teaching English to Speakers of Other Languages (TESOL) and enjoys working in a multicultural environment with students from all over the world. She enjoys running and gardening, and takes more pictures than she should on her phone.

CPSIA information can be obtained
at www.ICGtesting.com
Printed in the USA
FFOW03n1349270218
45347420-46009FF